DANNY,

I KNOW YOU APPRECIATE ART.

HAPPY BIRTHDAY AND YOU'RE WELCOME.

5/28/21

FROM MATT ORNSTEIN ON THE OCCAISION
OF DANNY'S 40TH BIRTHDAY AND ONE
OF THE FIRST POST PANDEMIC SOCIAL EVENTS

WEIRD

BLAC

WHI

WEI

ALL OVER

THE LOST PHOTOGRAPHS OF
"WEIRD AL" YANKOVIC '83 - '86

JON
"BERMUDA"
SCHWARTZ

FOREWORD BY
"WEIRD AL"
YANKOVIC

THIS BOOK IS
DEDICATED TO
WEIRD AL'S FANS,
WHO HAVE PATIENTLY
WAITED MORE THAN
30 YEARS FOR THESE
PHOTOS TO SURFACE.

CONTENTS

INTRODUCTION

When I was a teen in the early '70s, I bought my first nice 35mm camera – a used Minolta SRT-101 – from one of the guys in my first band. I quickly caught the photography bug; I bought black-and-white film in large spools, loaded my own rolls, and even set up a darkroom at home. Shooting, developing, and printing was economical, and I relentlessly documented *everything* and *everyone* in my life. I also shot color film as an occasional treat, but when I left my parents' house – and my darkroom – I settled into the convenience of color exclusively.

Soon after meeting Weird Al in 1980, the photo opportunities became more frequent and more interesting, and it seemed like I always had the camera with me. Although I had been shooting color, I felt that the 1983 "Ricky" video – Al's first – was a photo-op that demanded the texture and vibe that black and white possessed. There were a few more such occasions that I captured in black and white, the last being the "Living With A Hernia" video in 1986. And for no apparent reason, I never shot black and white again.

With the advent of digital photography, my film cameras slowly took a back seat. I shot my last roll of film in 2006 at the photo shoot for the *Straight Outta Lynwood* album. Eventually, my digital cameras were replaced by a smartphone as the camera of choice.

I've taken about 20,000 color shots of Al and the band – in the studio, at video and photo shoots, at airports, on the tour bus, backstage, on stage from behind my drums, walking down the street, in restaurants – you get the picture. Probably a thousand of them have appeared online and in various publications. But those early black-and-white shots existed only as contact sheets, filed away, out of sight and out of mind for over 30 years. Aside from a handful of "Ricky" and "I Love Rocky Road" video shots that previously appeared in *The Authorized Al*, the *Permanent Record* booklet, *Weird Al: The Book* and the *Squeeze Box* book, the rest have remained unseen by anyone.

Until now.

The idea for this book started in July 2017 when I asked Al if he minded my looking into publishing those particular photos, to which he replied, "Go for it!" I then made a post in the Close Personal Friends of Al group on Facebook asking, "Should I publish a book of my old photos?" The response was an overwhelming yes.

With the few exceptions noted, the old photos in this book will be new to you. I think they hold up well after more than 30 years, and I hope you'll find them as interesting and enjoyable as I have while re-discovering them myself.

JON SCHWARTZ

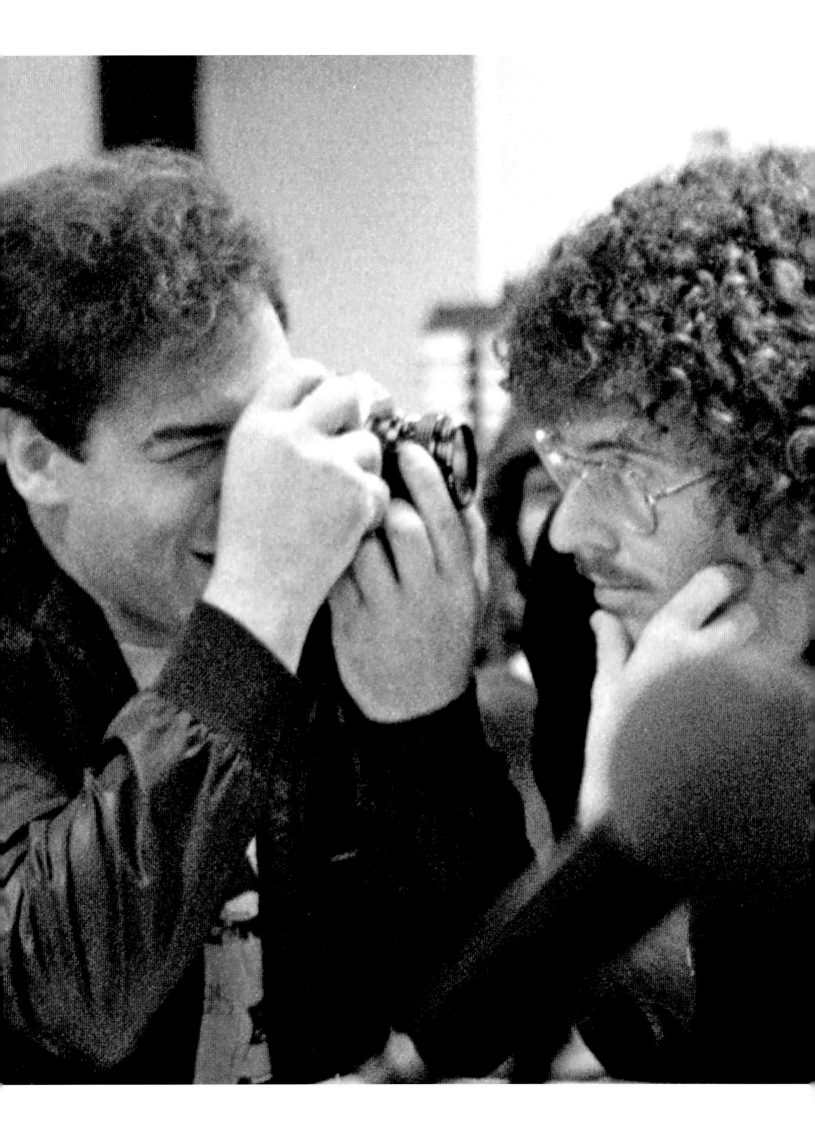

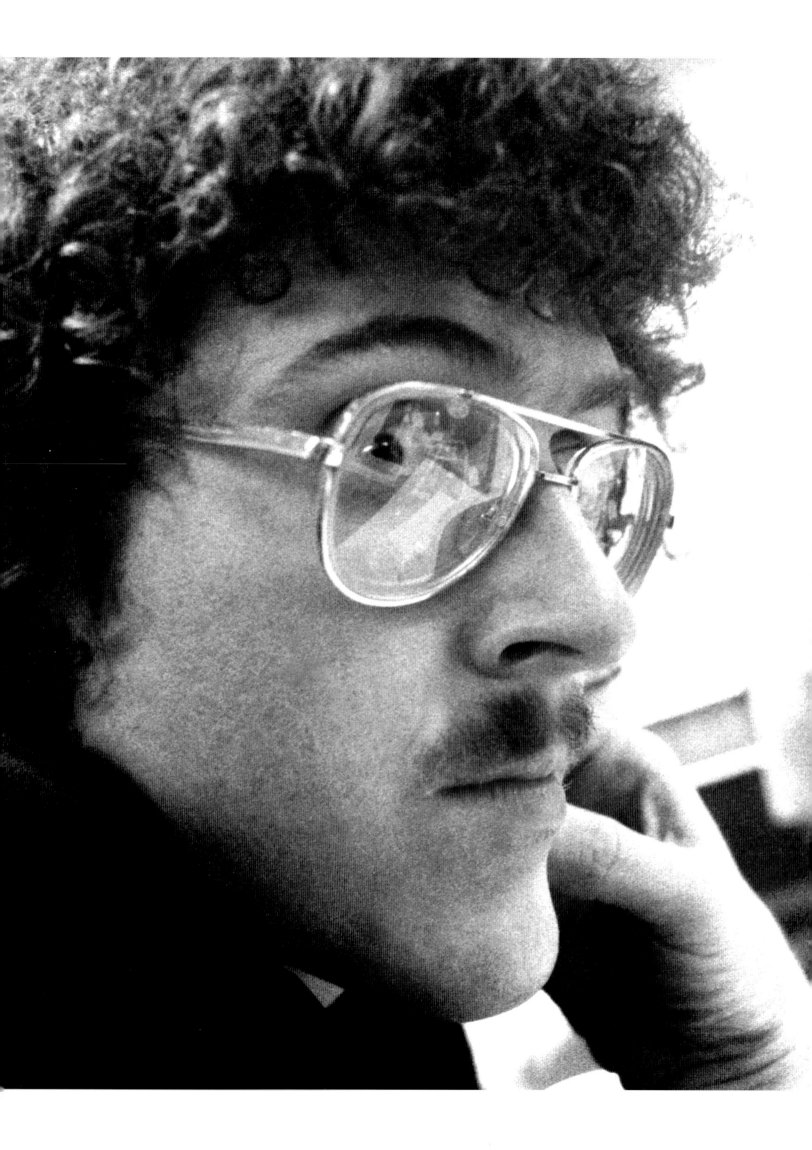

FORE WORD

Jon Schwartz has been my drummer since September 14, 1980. I remember that date clearly because it's the night I played "Another One Rides the Bus" on the *Dr. Demento Radio Show* for the very first time, and Jon just happened to be there. I announced that I needed someone to bang on my accordion case for percussion, and Jon (who claimed to be a drummer) eagerly volunteered his services. He's had the job ever since.

The original "band" was just the two of us – a real power duo. I didn't want Jon to be the only one in the group without a dumb nickname, so I dubbed him "Bermuda Schwartz" – and as nicknames have a tendency to do, it just kinda stuck.

The last several decades have been an amazing ride. More than once – an annoying number of times, actually – Bermuda has warned me, "Someday I'm going to write a book about all this!" It became a bit of a running joke: whenever Jon would try to give me a stupid unsolicited idea, I'd roll my eyes and say, "Yeah, why don't you just put that in your *book*!" But now, he's actually made good on the threat. Granted, this is not some kind of tell-all biography (we're not exactly Mötley Crüe on the road, so it wouldn't have made for very salacious reading anyway). But it's a fine snapshot (actually, several hundred snapshots) of what life was like for us in the '80s – all those early recording sessions and low-budget music video shoots.

This book will undoubtedly appeal to both Weird Al completists and those who enjoy black-and-white photographs taken by drummers. And if you're just looking to have every book by Jon "Bermuda" Schwartz in your personal collection – buy this, and congratulations, you're done!

Most of these photos have never been seen by anyone before. In fact, Jon demanded that the publisher not *actually look* at any of these photos while working on this book, so please forgive them if any happen to be printed crooked or upside-down. But all the secrecy was well worth it. For the literally *dozens* of people who have been waiting for a book just like this, I think you're in for a real treat.

Thanks for being my drummer, Mr. Schwartz.

And here's to the NEXT 40 years!
(Ha ha, just kidding, we'll be dead soon.)

AL YANKOVIC

1

RICKY VIDEO SHOOT

PRIVATE RESIDENCE,
ARLETA, CA

Al's first video was the beginning of a rewarding relationship with a then-new MTV, and was the launching pad for directorJanet Greek, who went on to direct episodes of *St. Elsewhere*, *L.A. Law*, *Melrose Place*, *Babylon 5*, and several other television shows. Voice actor Tress MacNeille sang the part of Lucy Ricardo on the recording and was equally convincing when she reprised her role in the video.

The first scenes shot that day were Al and the band playing in the bedroom. Once finished, Al shaved off his moustache to transform into his Ricky character. Although the first 2:15 is black and white to convey the look of the original television show, the entire video was shot in color. (I'm not aware of a full-color version of the video, so don't hold your breath.)

The list of extras includes Steve Jay, Jim West and myself, Dr. Demento, Hamilton Cloud playing a Djembe with Al's friend Joel Miller on bongos, Joel's dad Larry Miller appeared (partially) as Fred Mertz, and the part of Little Ricky was played by Sacha (my apologies for not recalling his last name). In the final dance scene, there were an additional eight extras and a harpist, however that's *not* Dorothy Remsen from the recording. When you add the cost of the crew, equipment rental, props, meals, house rental and editing, it's remarkable that the video was made for only $3,800!

Only six images in this chapter have been seen before, all taken from prints made by Joel Miller. They appear here in superior quality, sourced for the first time directly from the original negatives. The first of them ever published was a shot of Al adjusting his bowtie. (Don't worry, it's not the one seen here!) That image appeared in *TV Guide* and I was paid $25, which I thought was a pretty good deal at the time. In hindsight, I probably should have held out for $30.

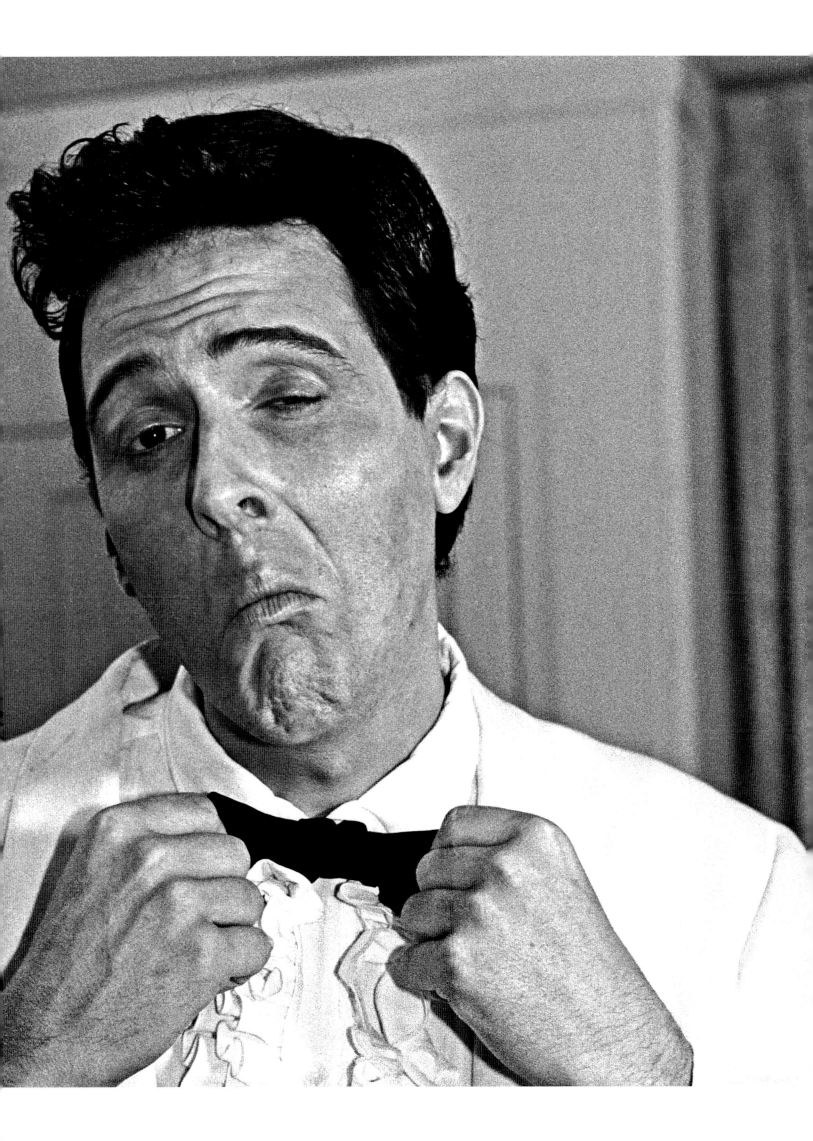

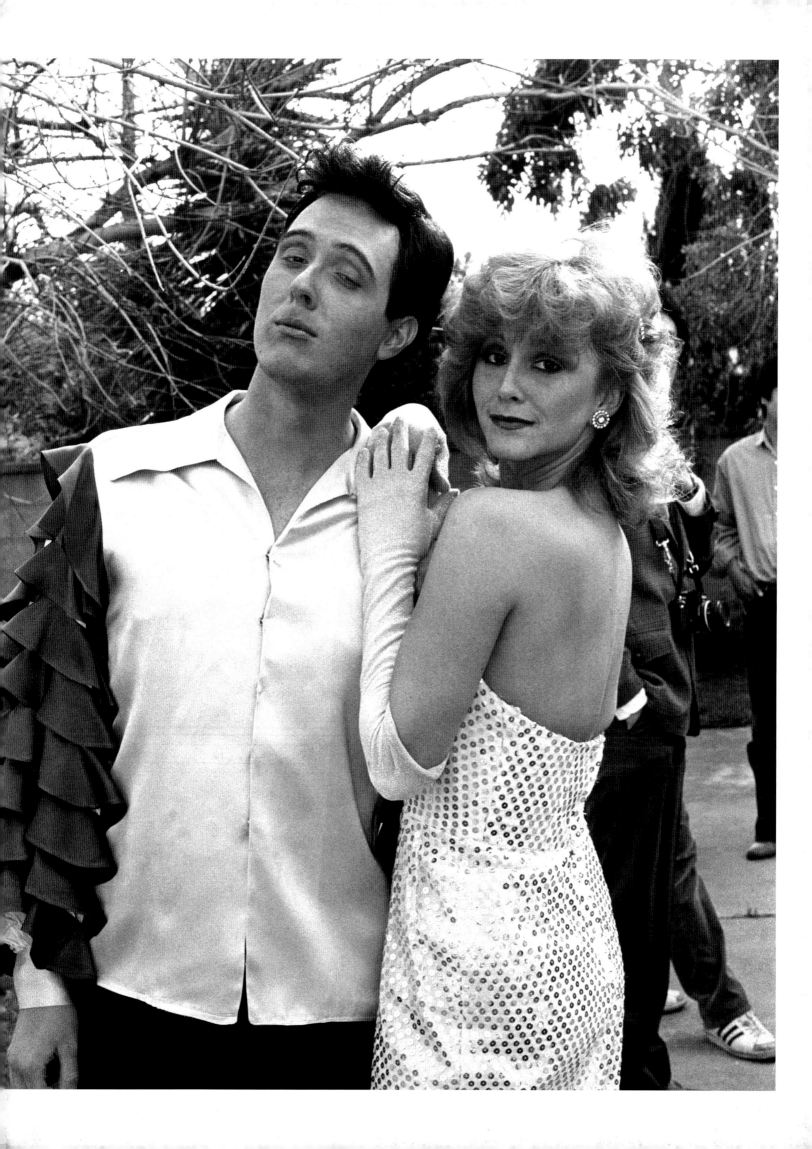

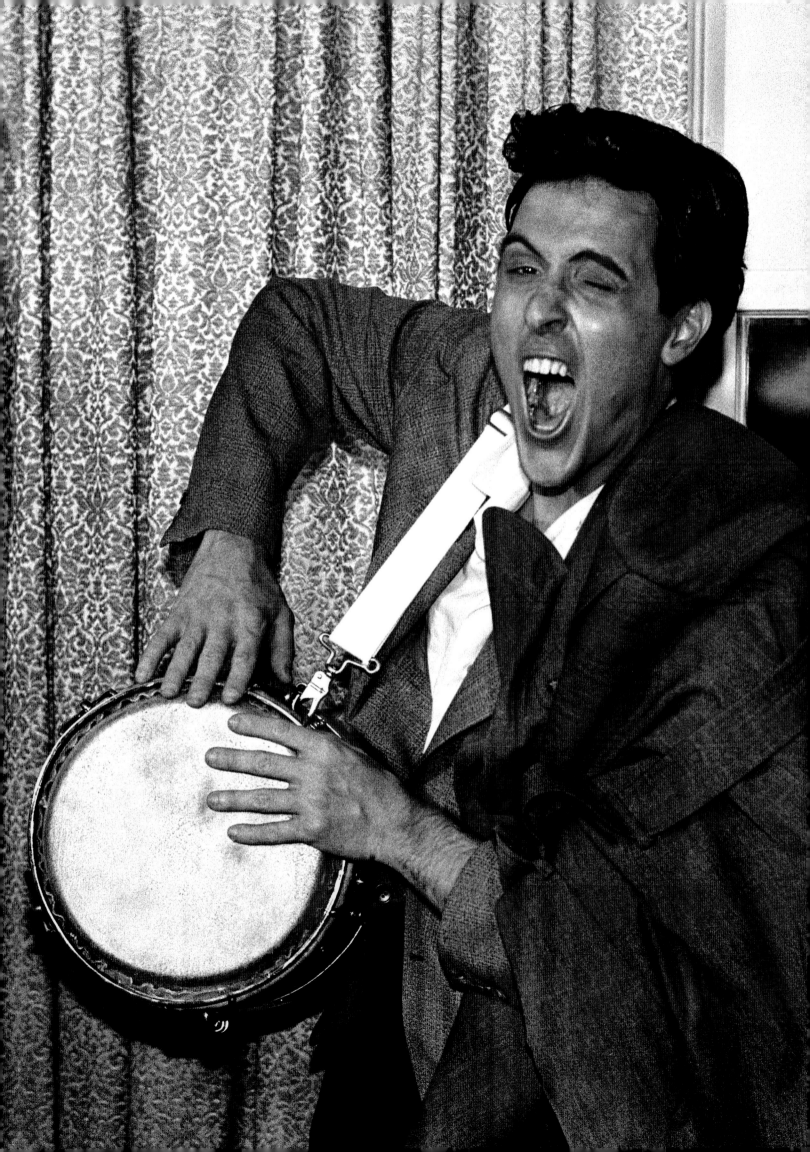

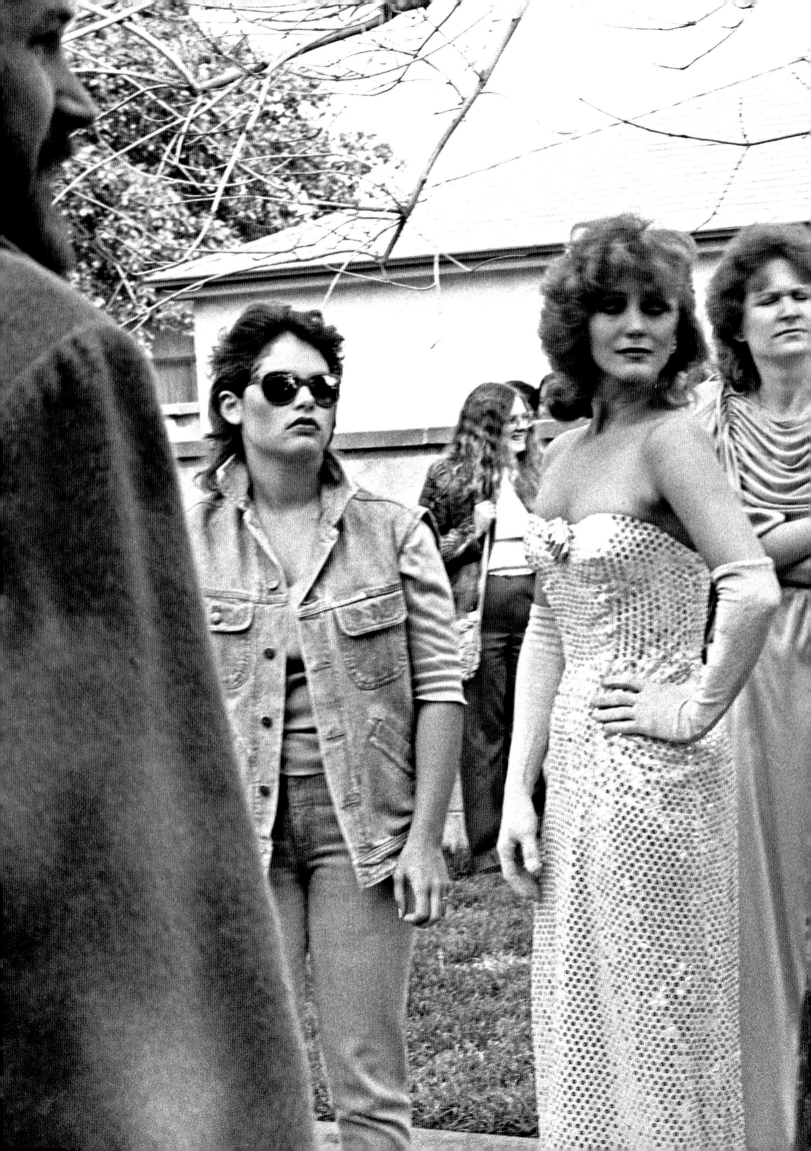

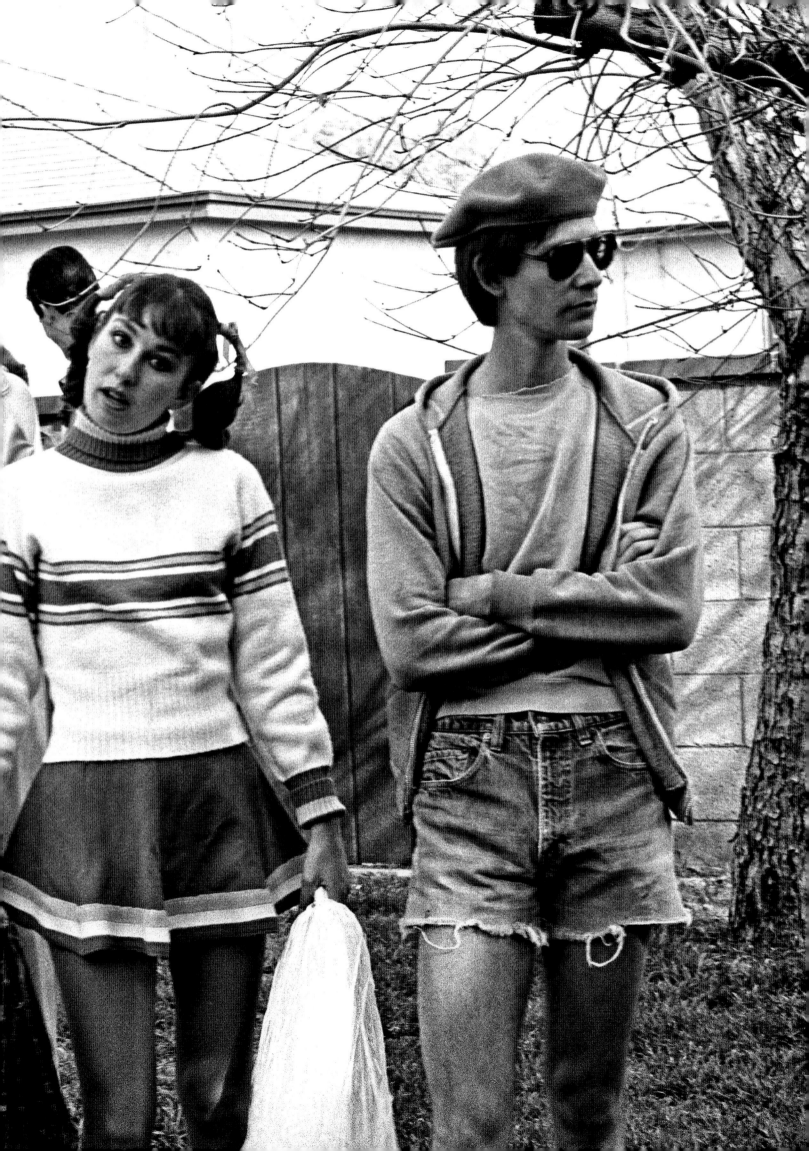

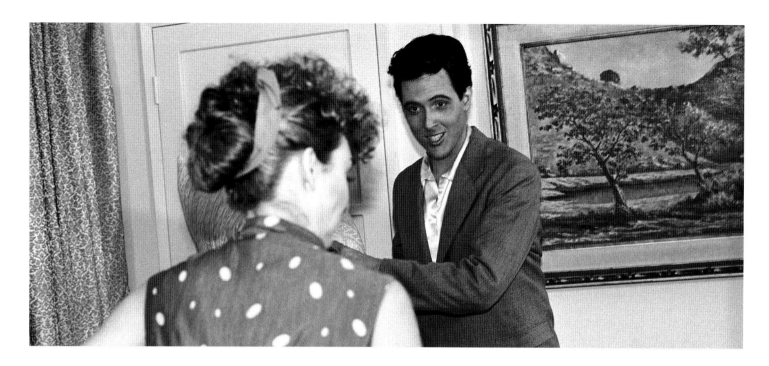

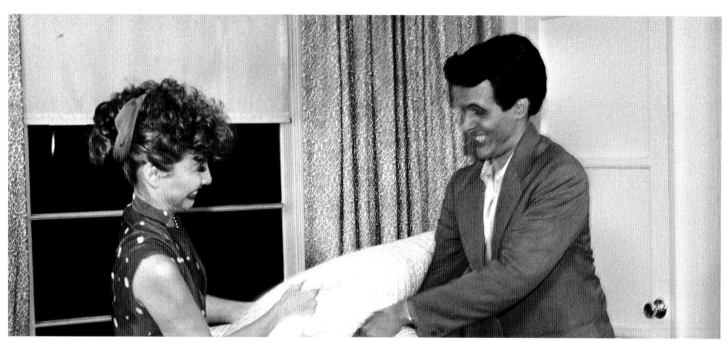

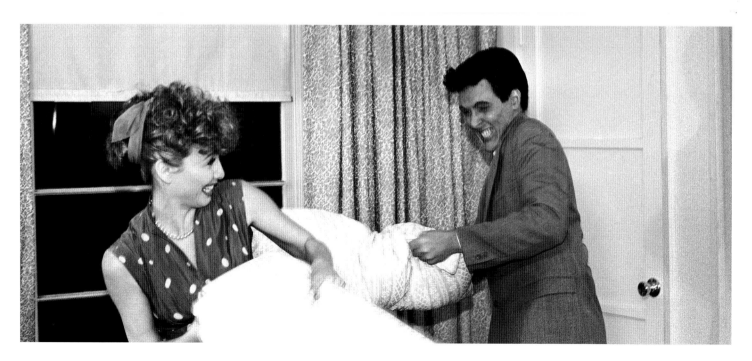

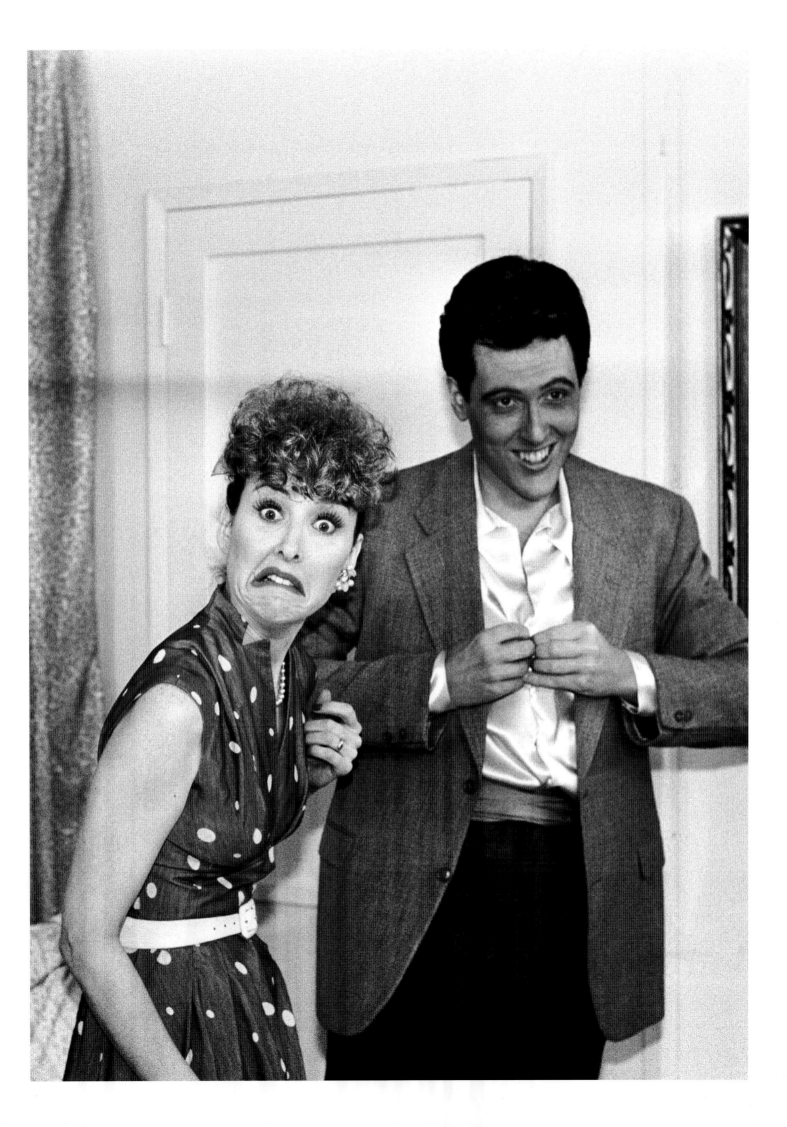

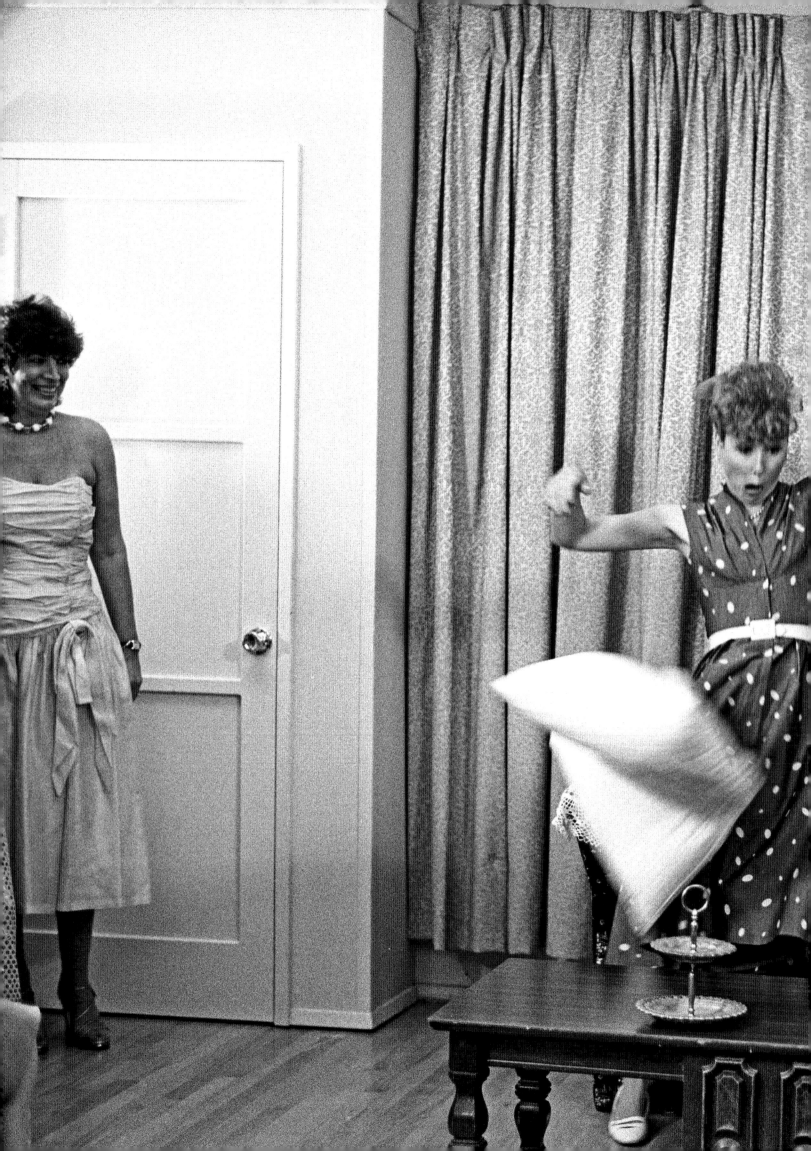

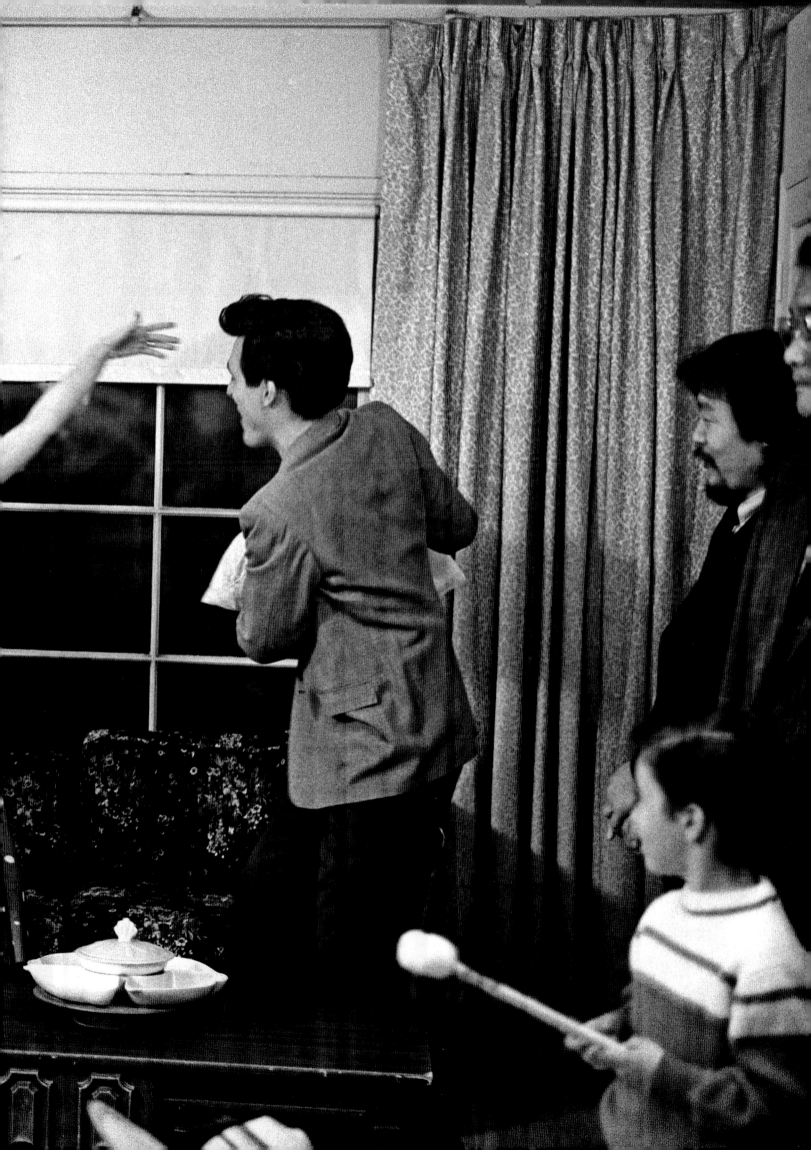

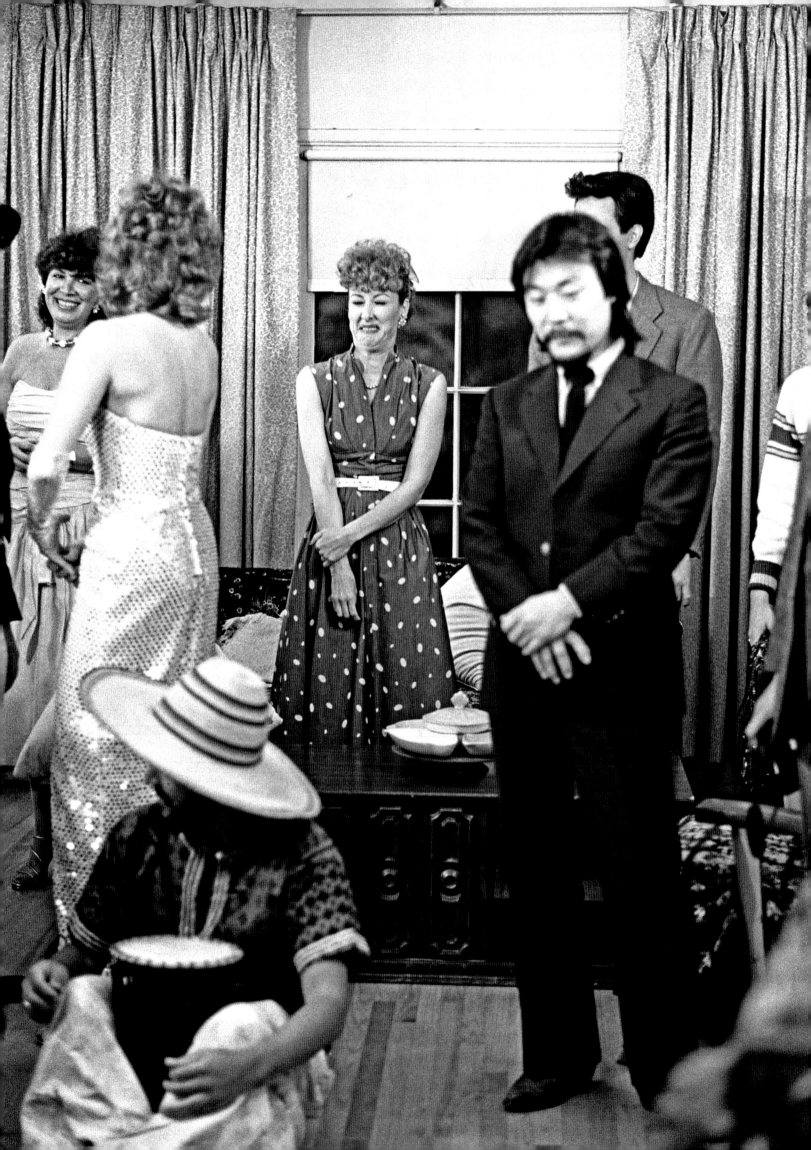

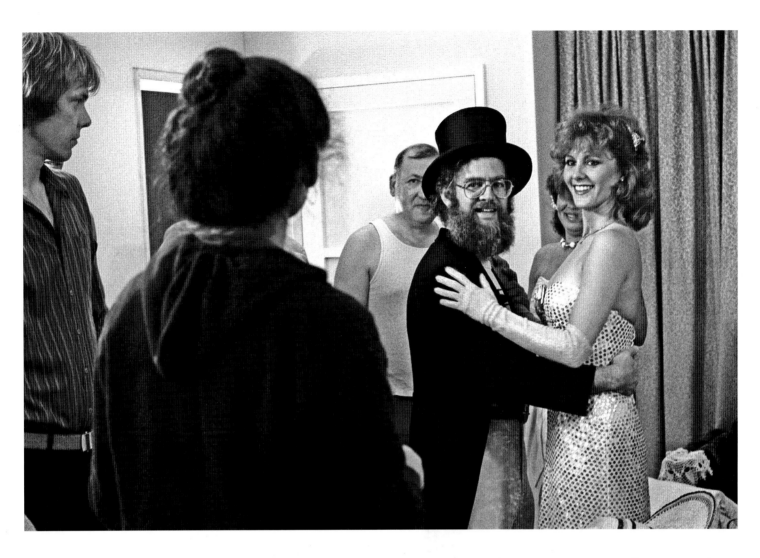

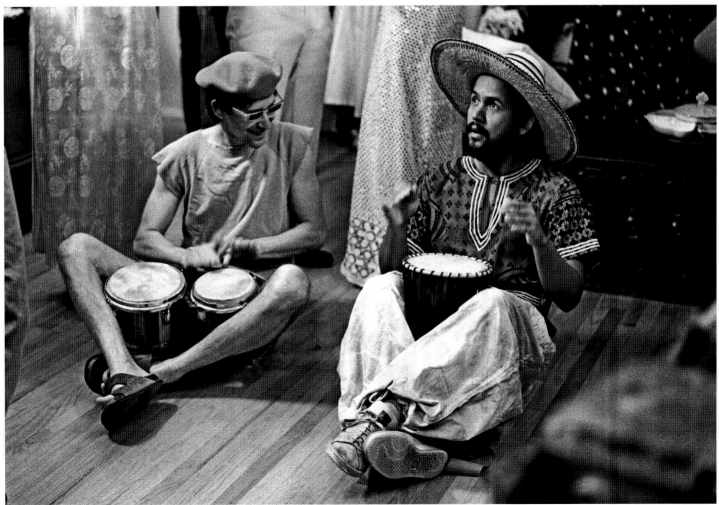

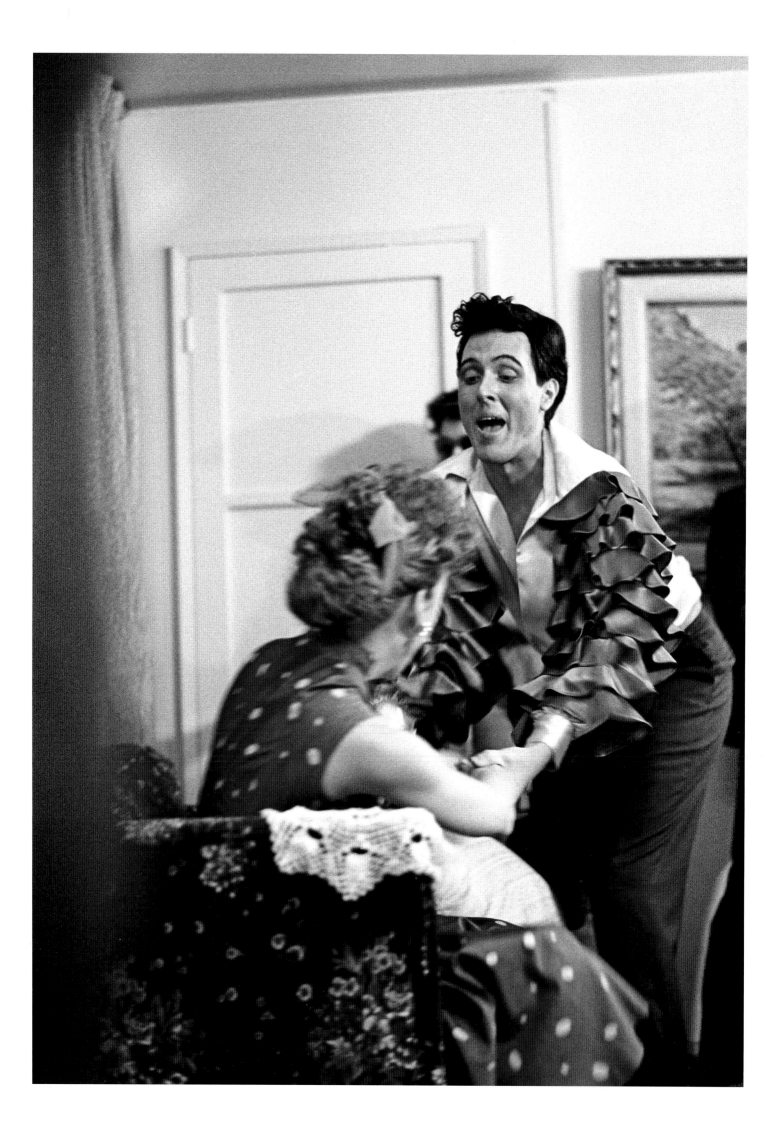

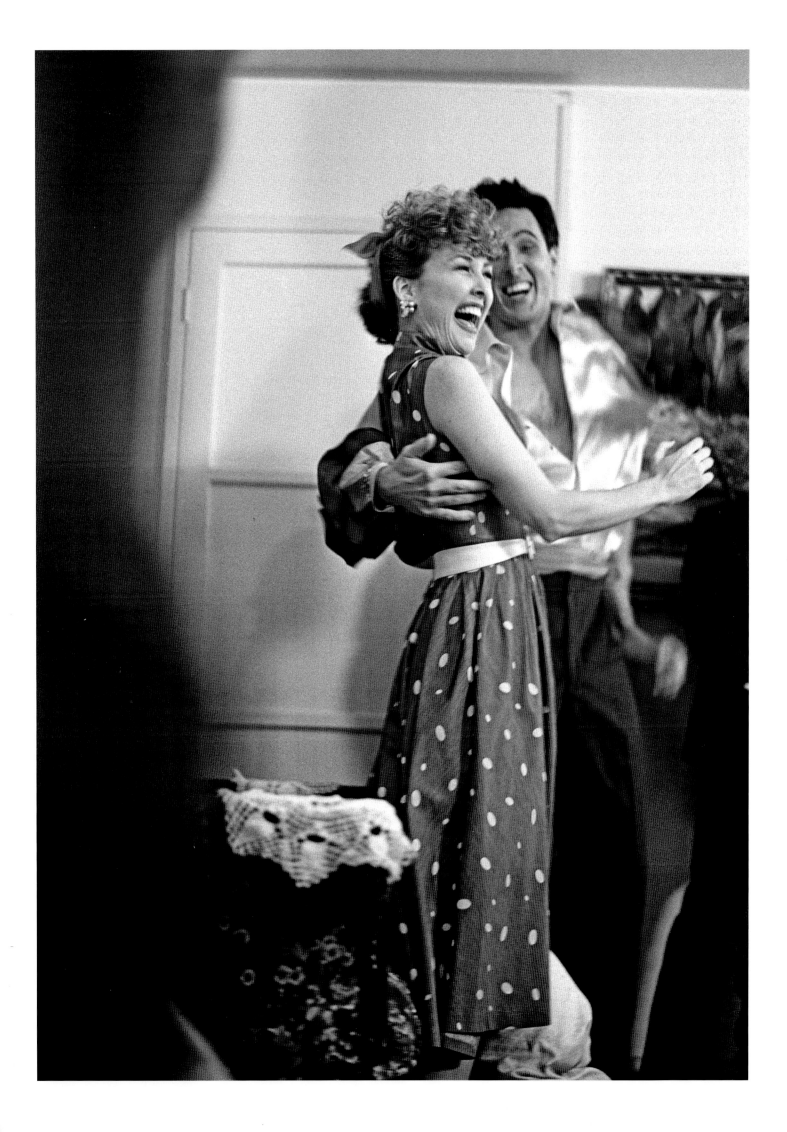

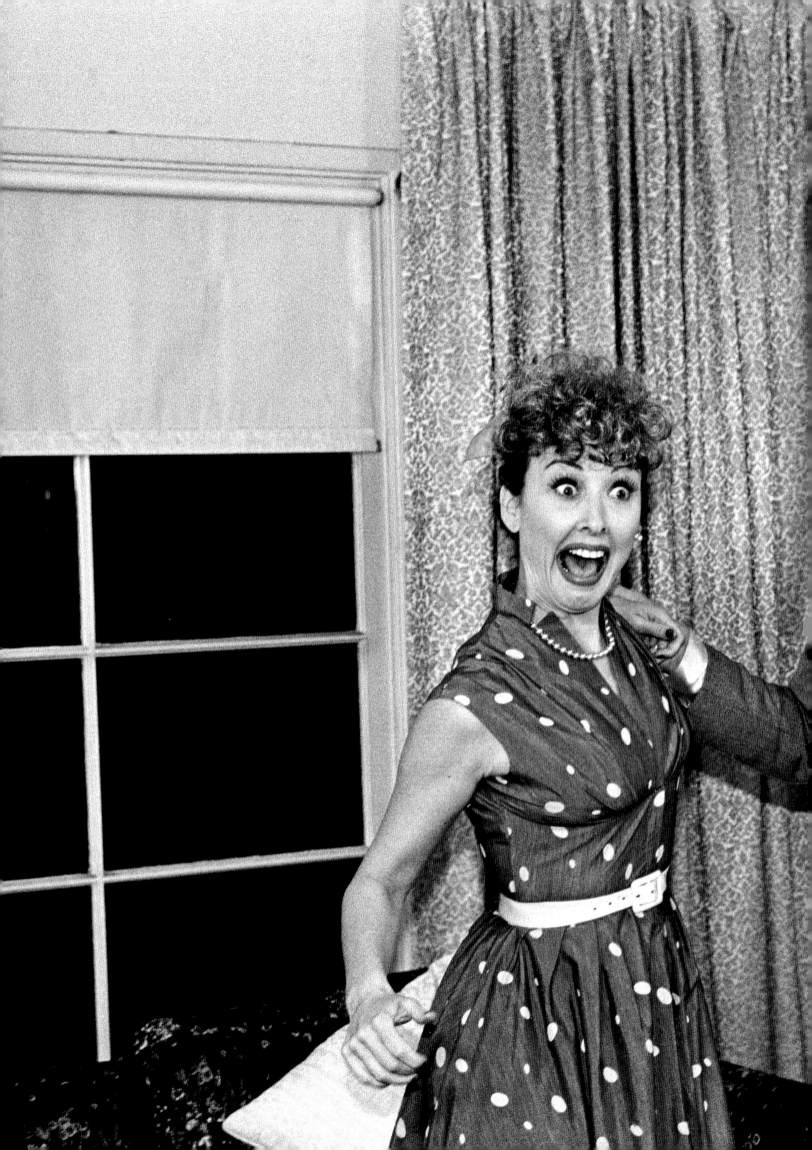

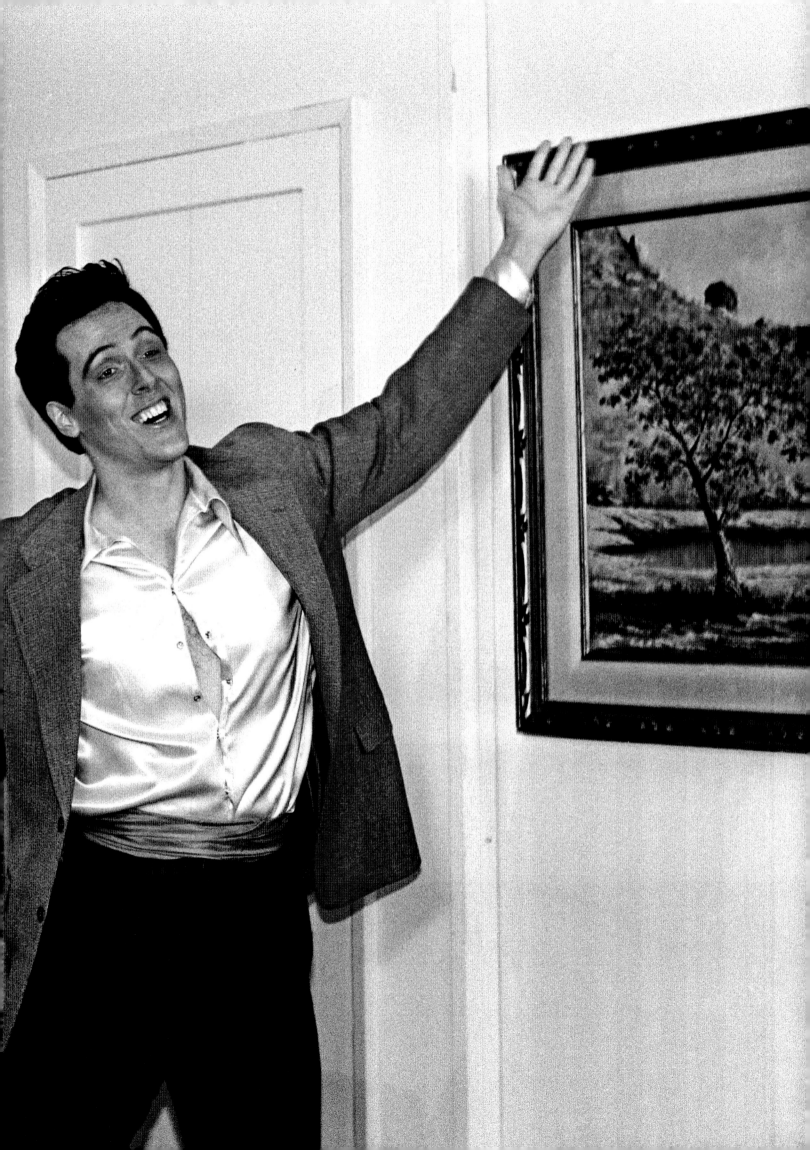

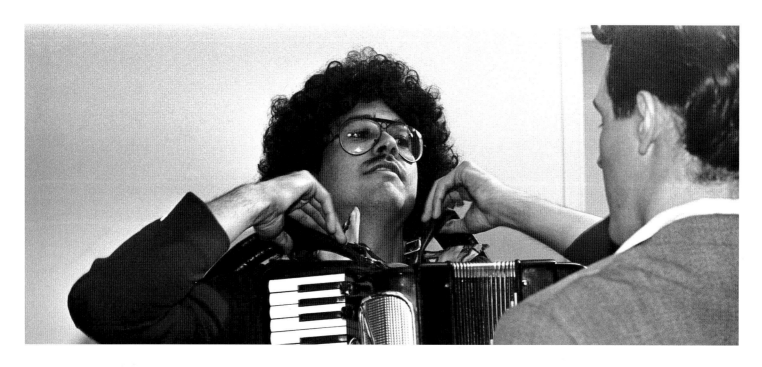

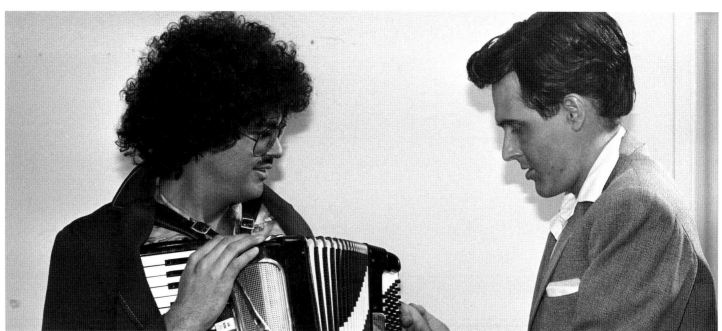

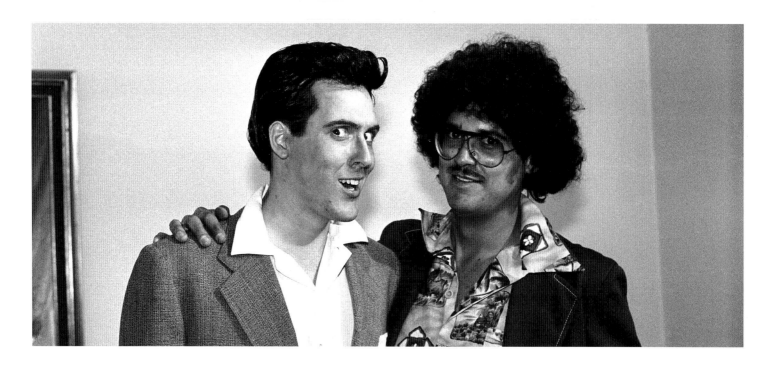

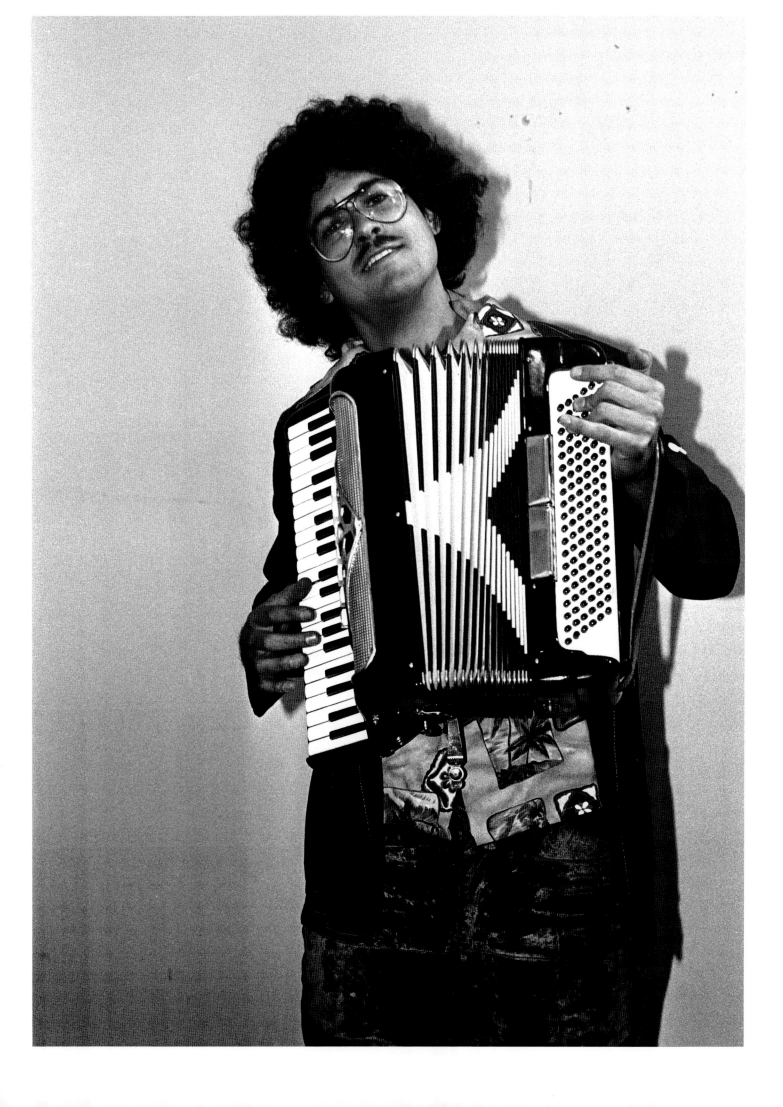

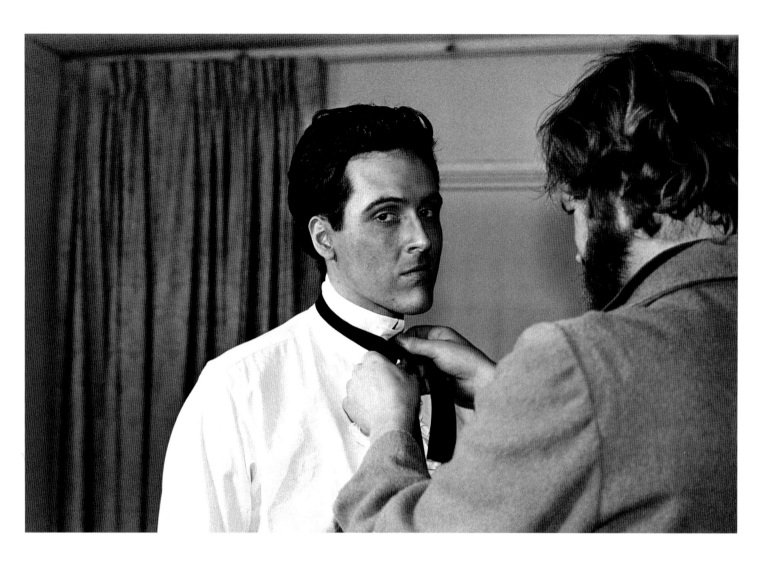

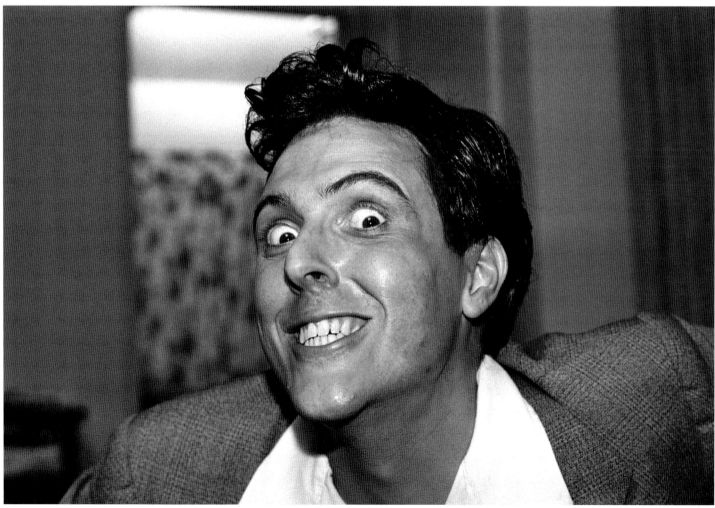

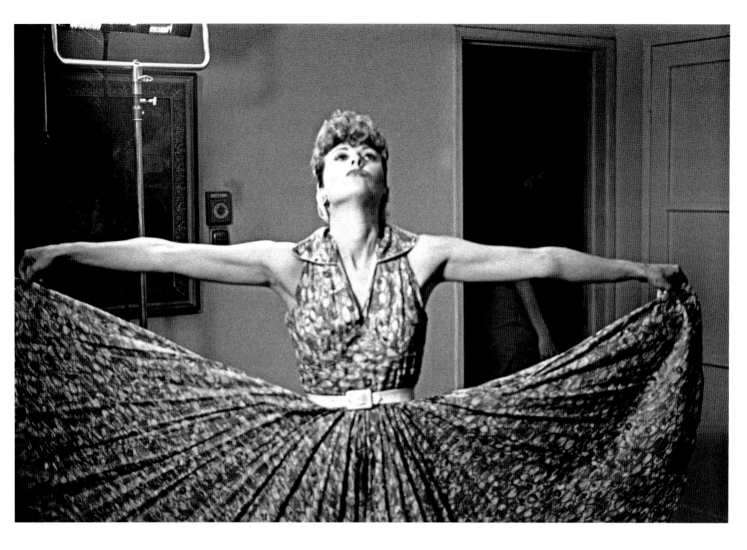
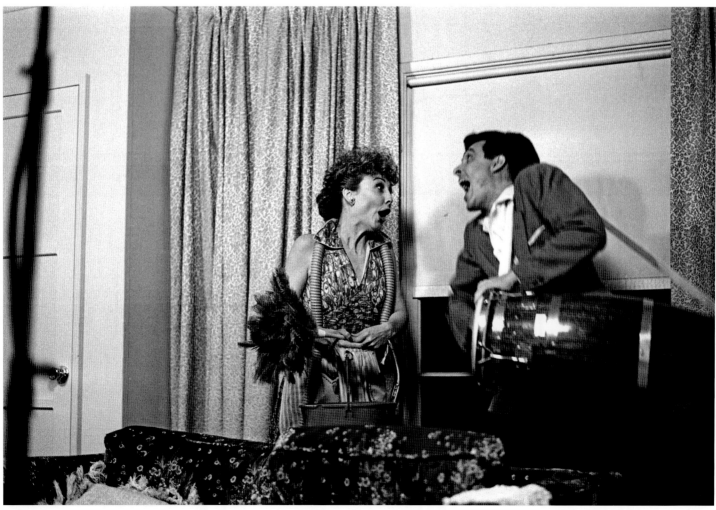

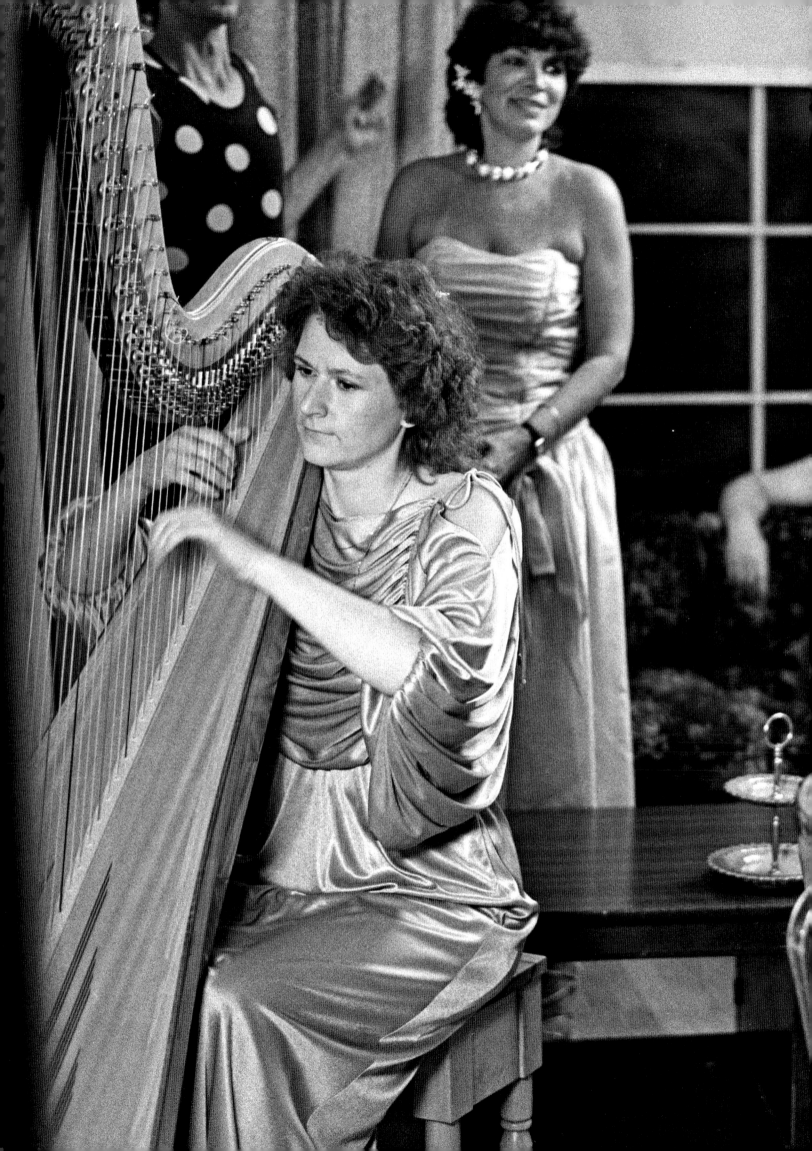

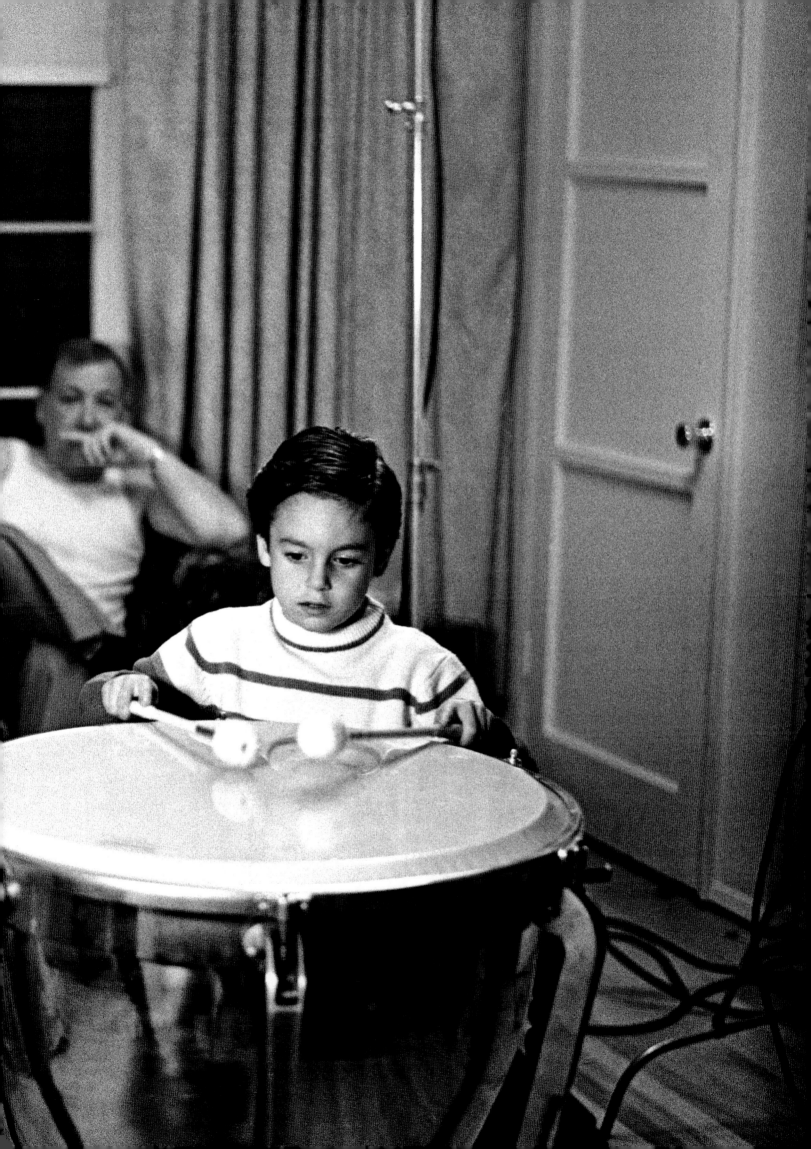

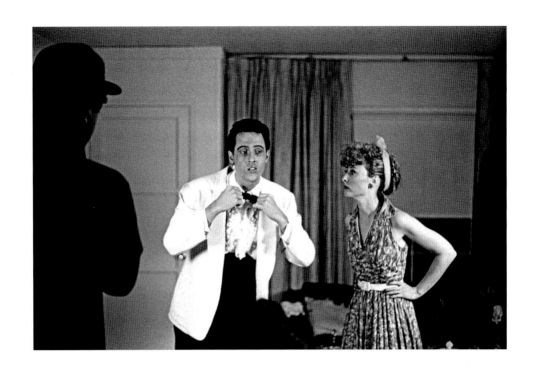

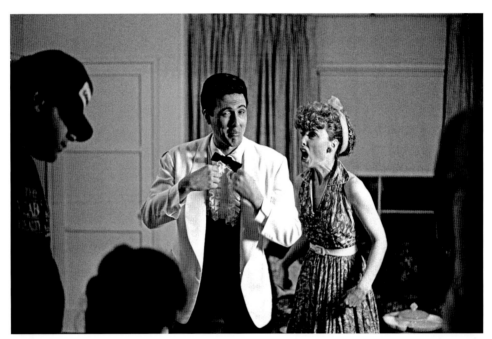

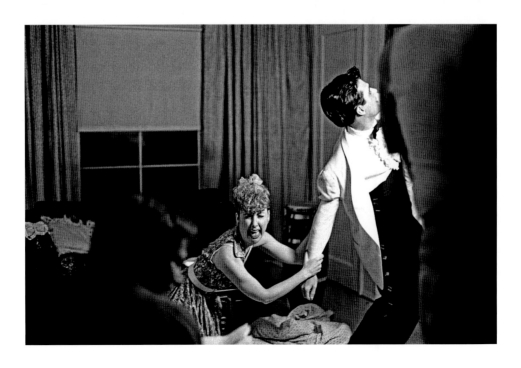

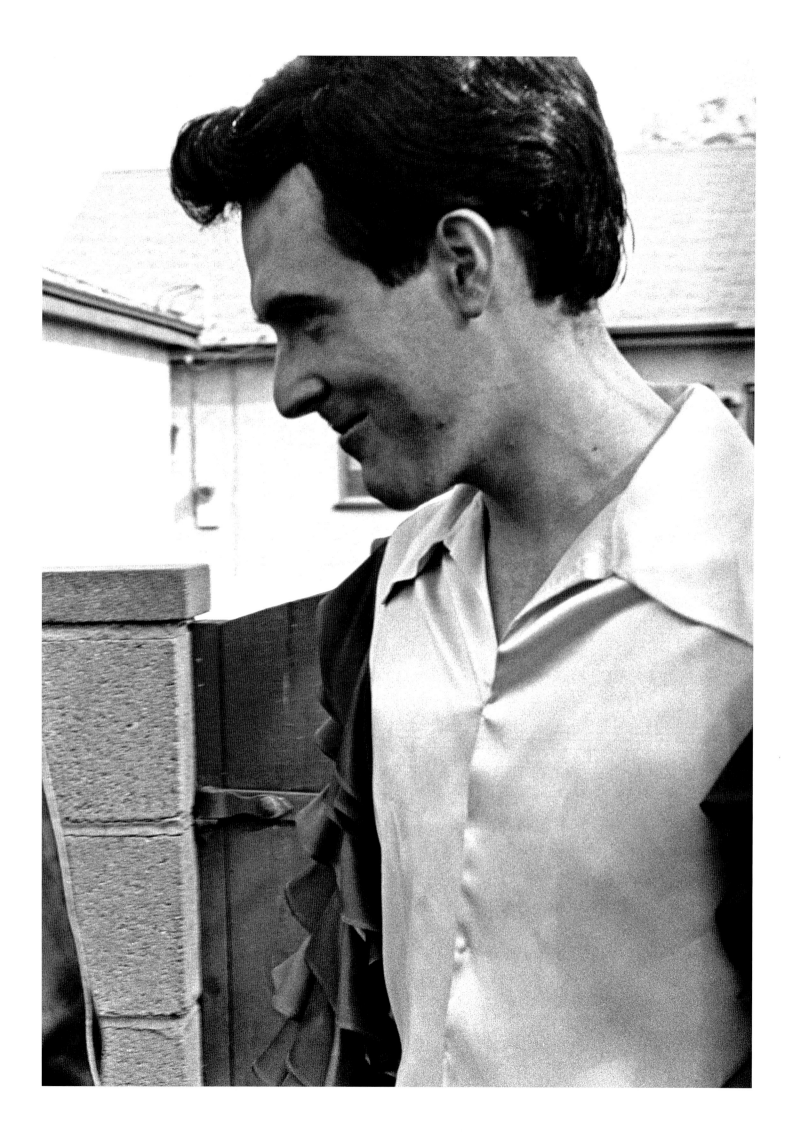

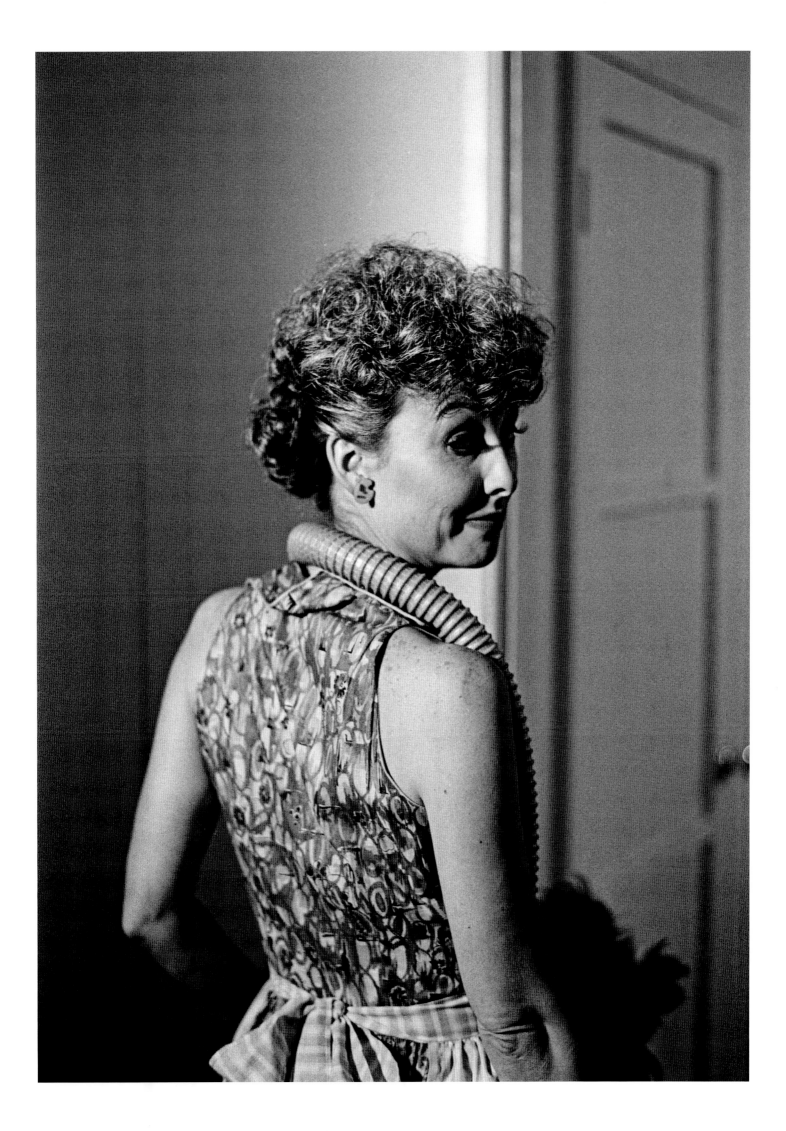

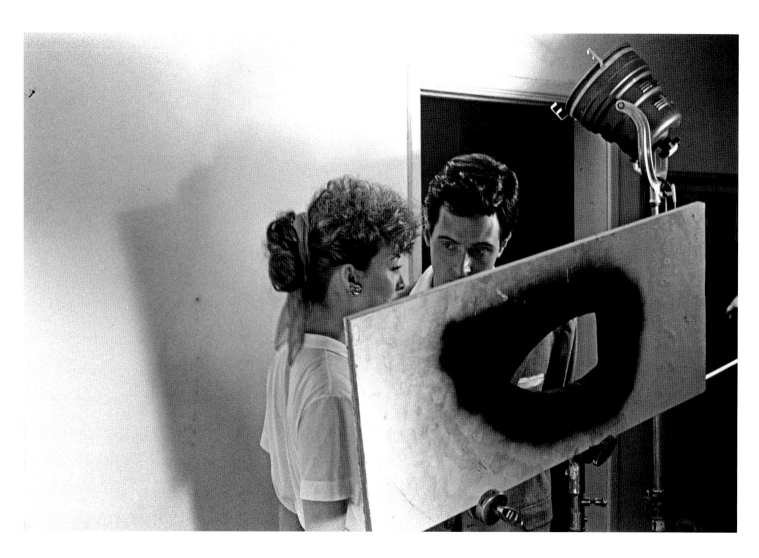

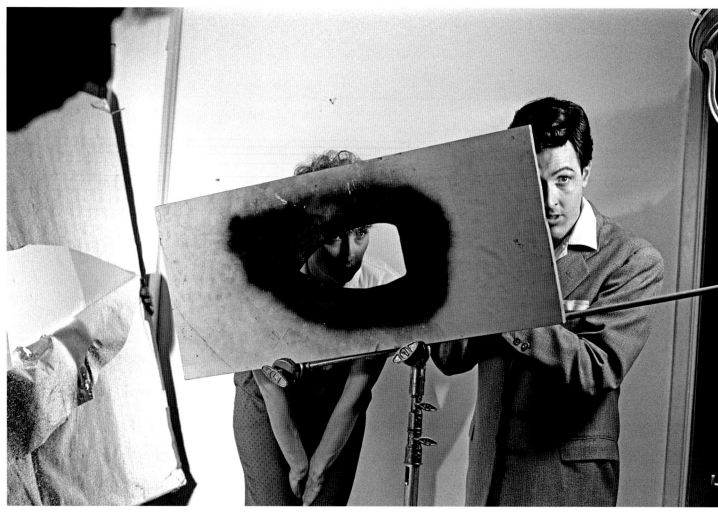

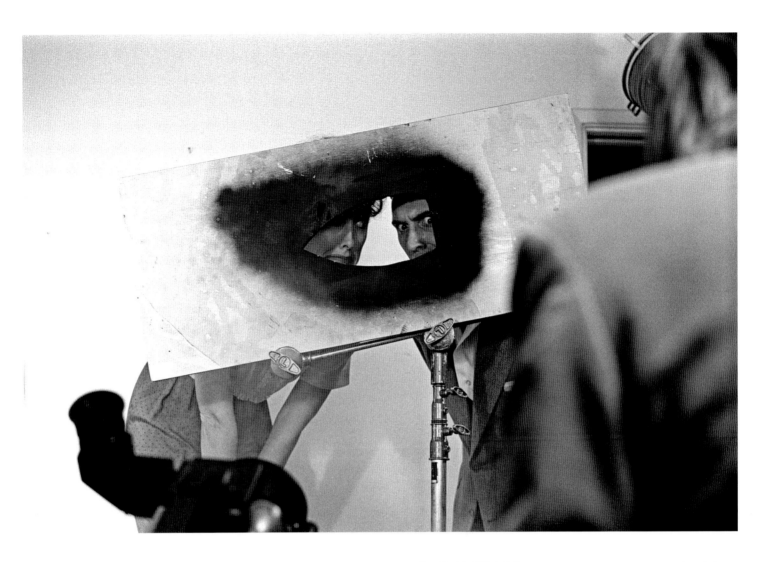

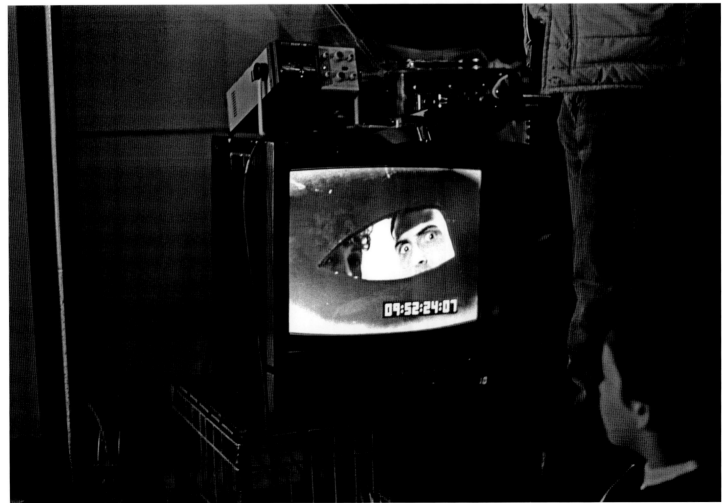

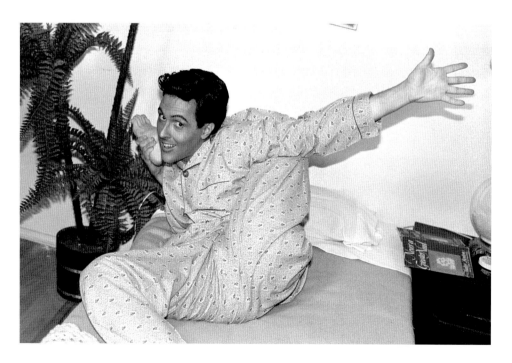

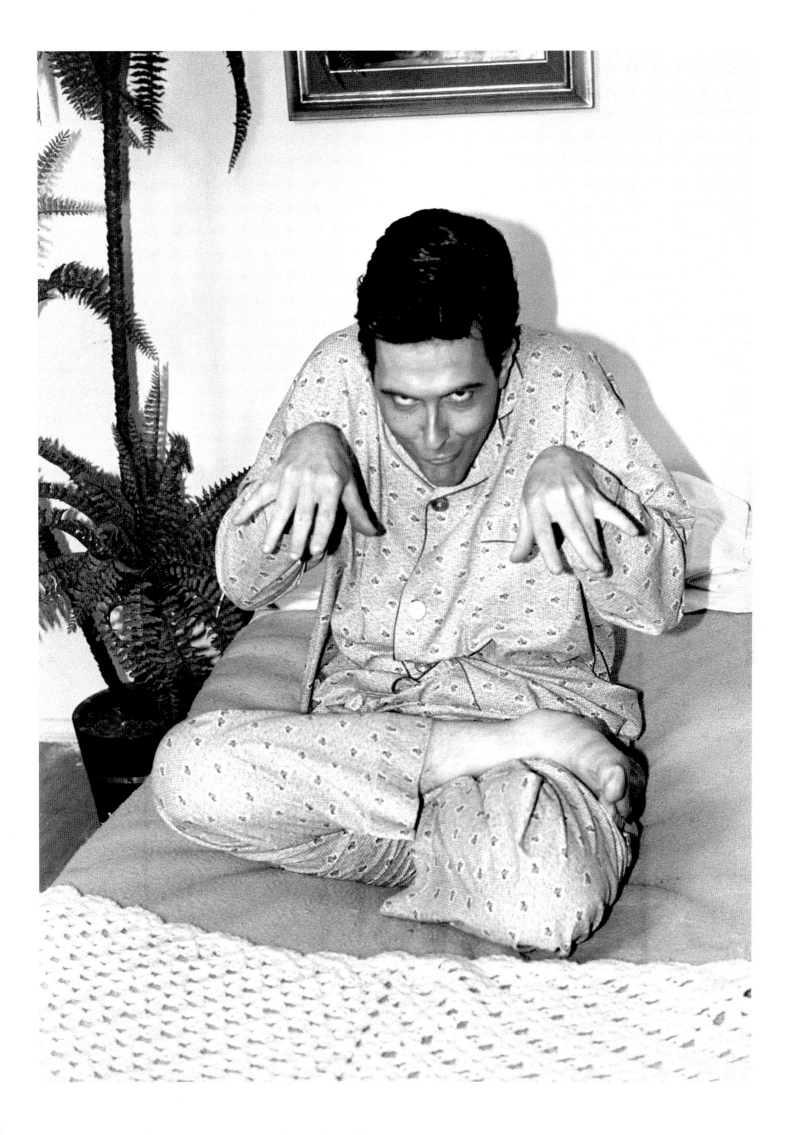

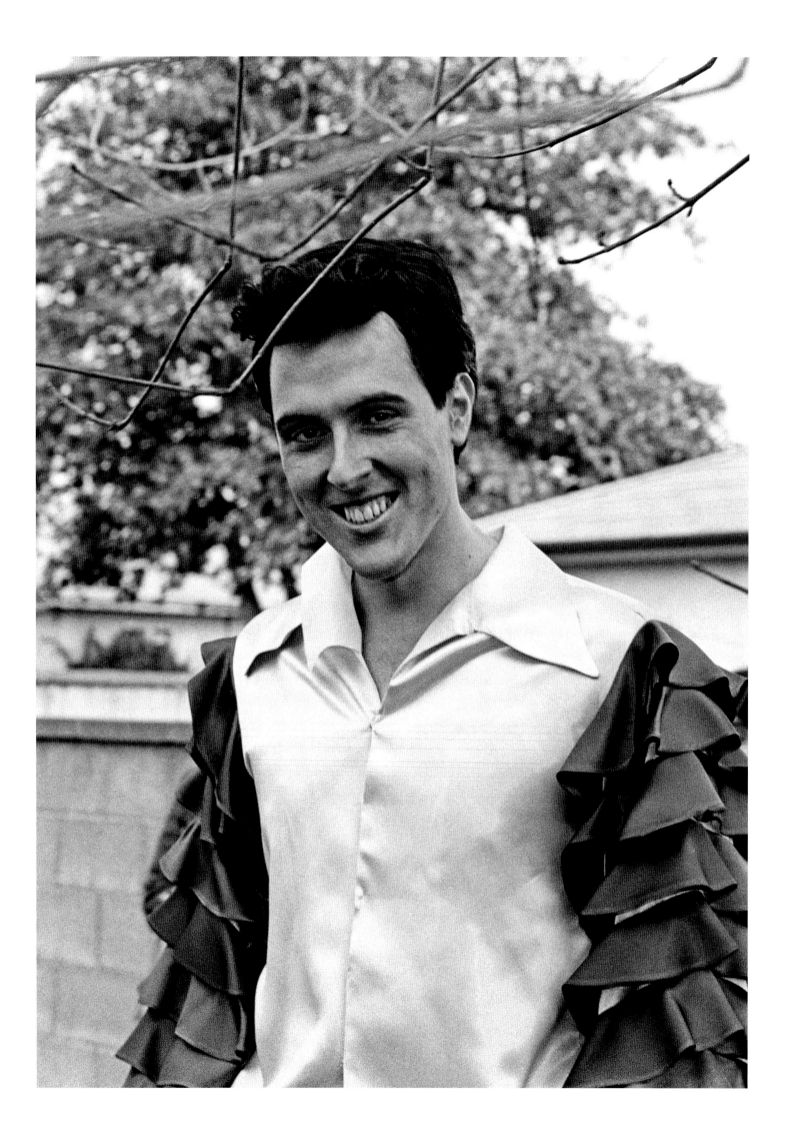

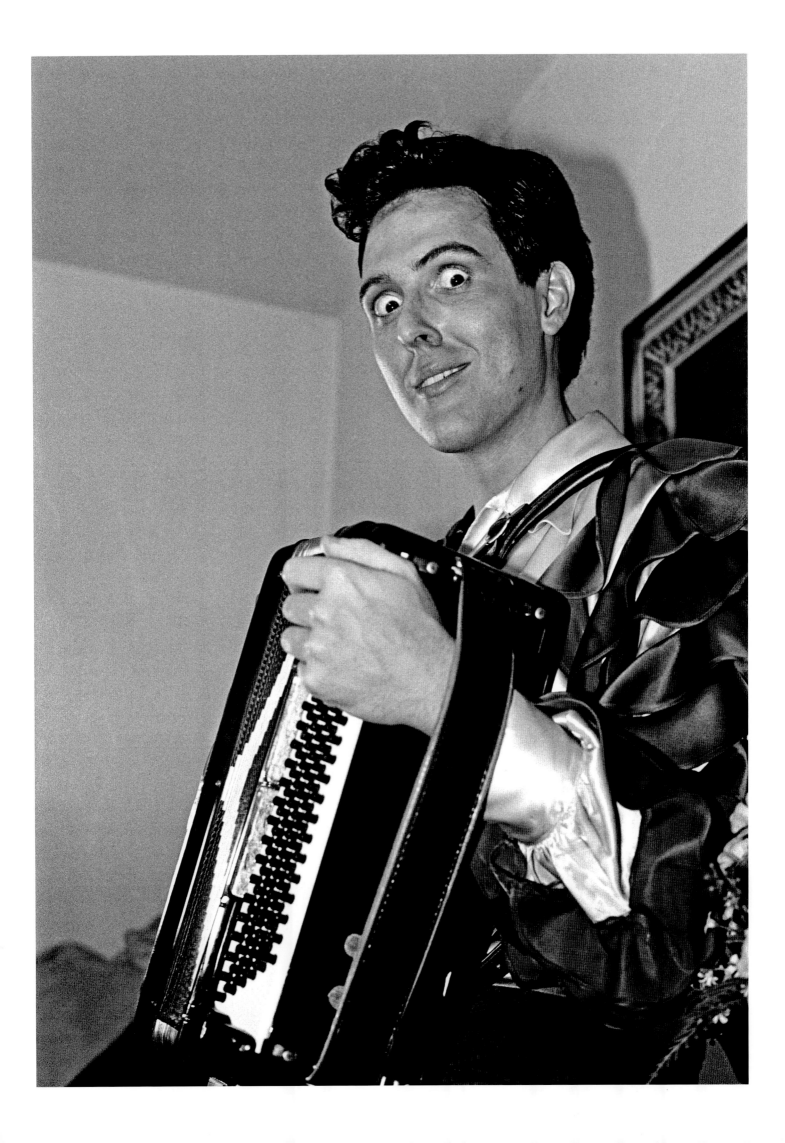

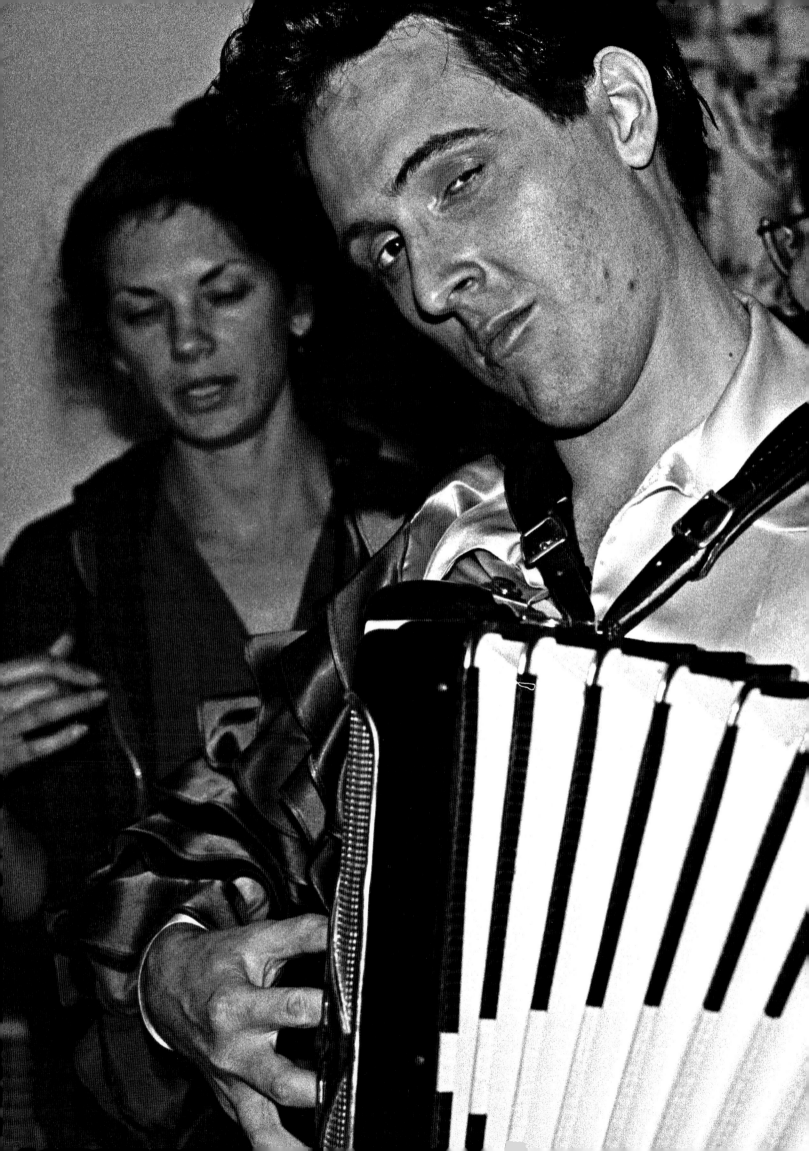

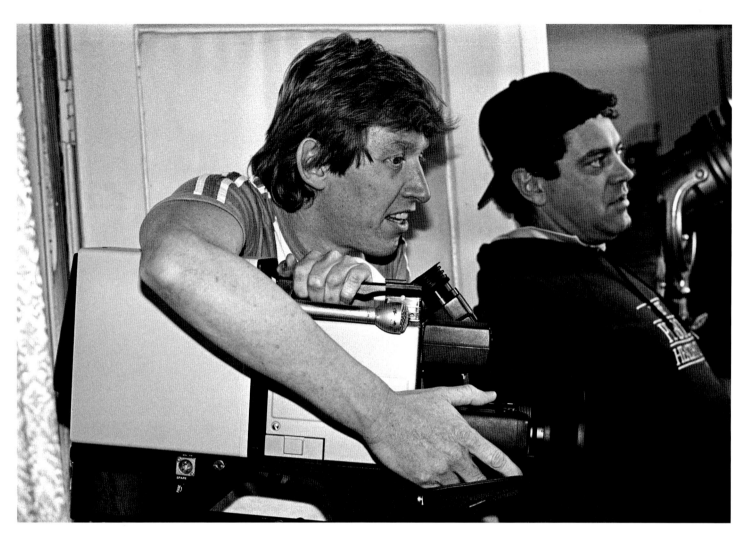

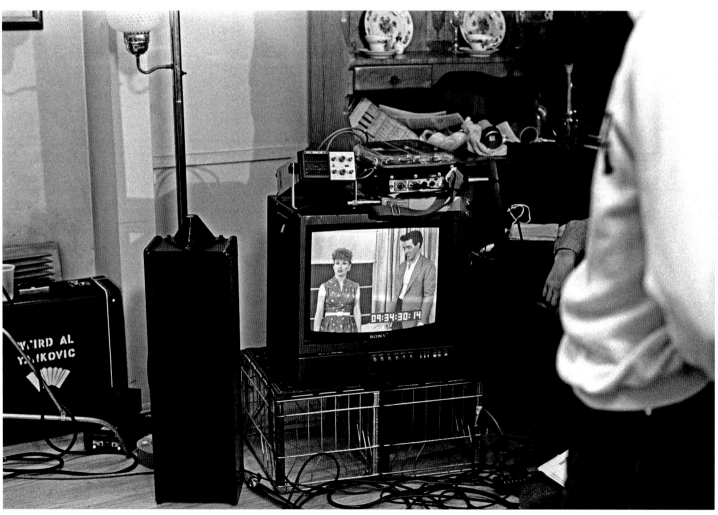

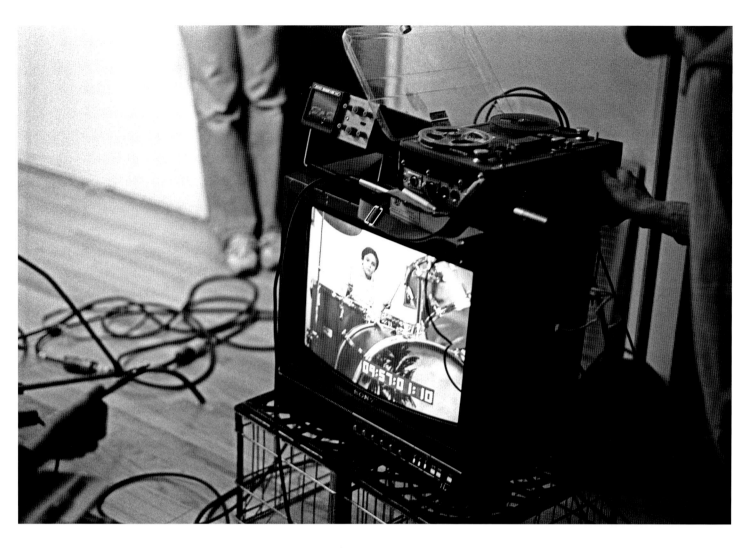

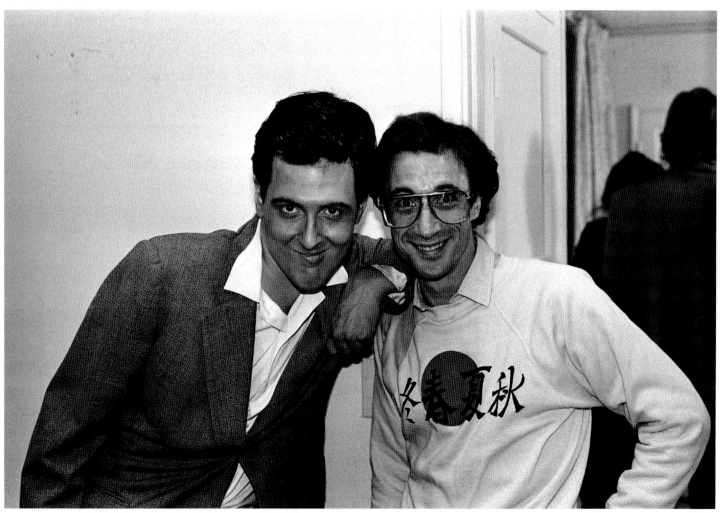

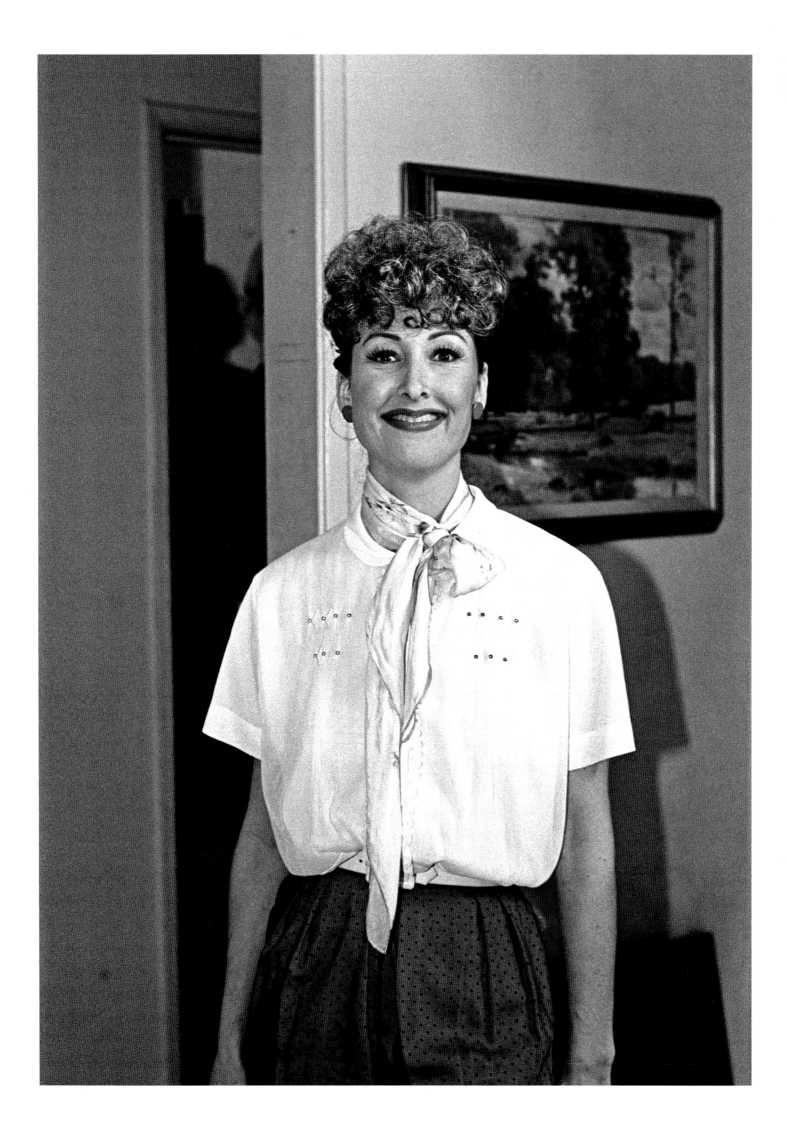

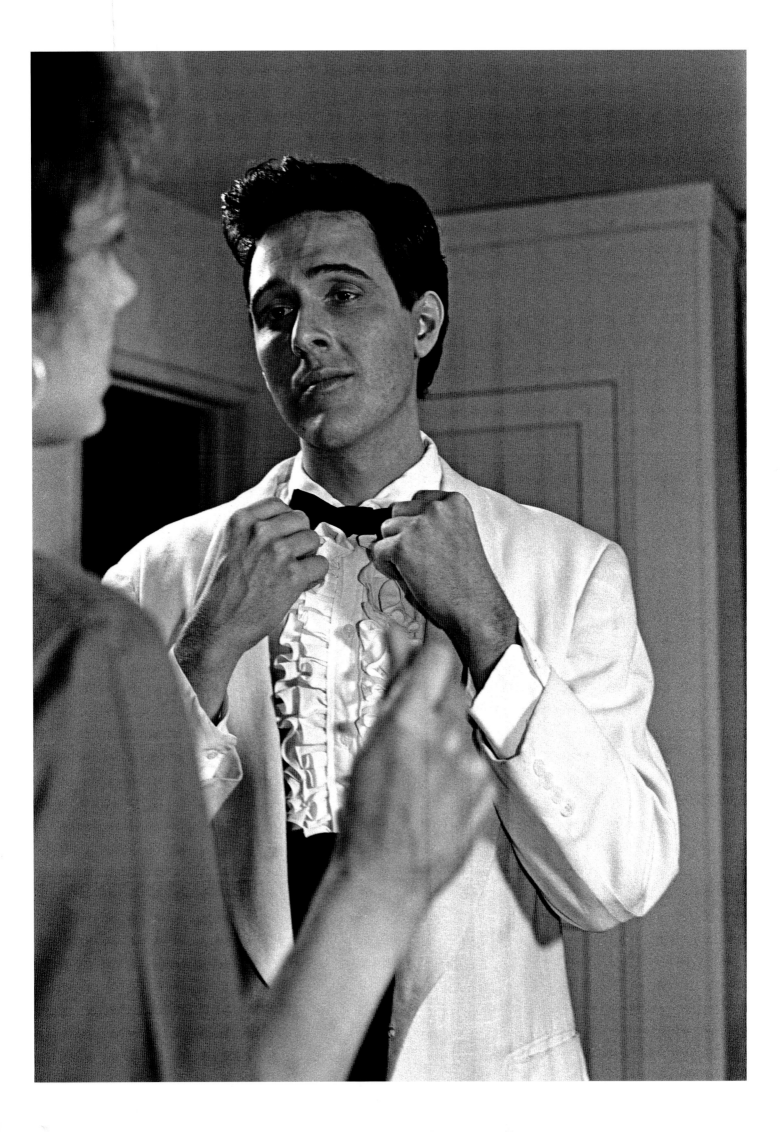

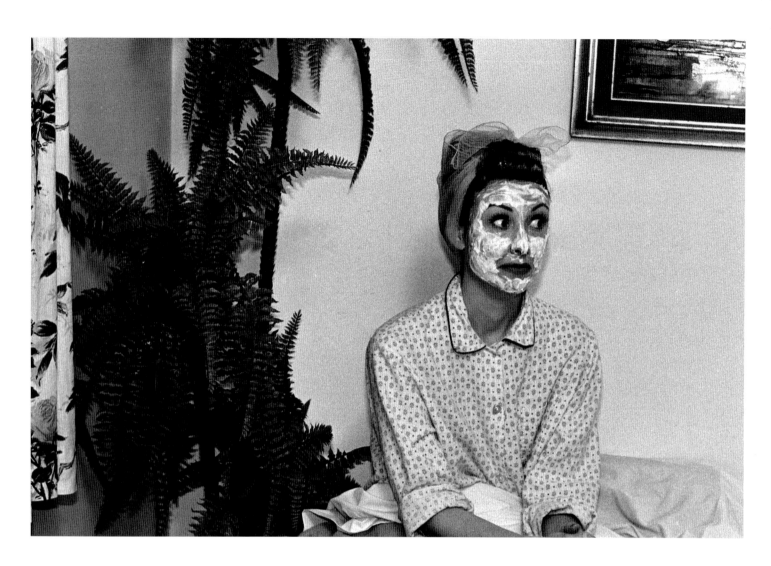
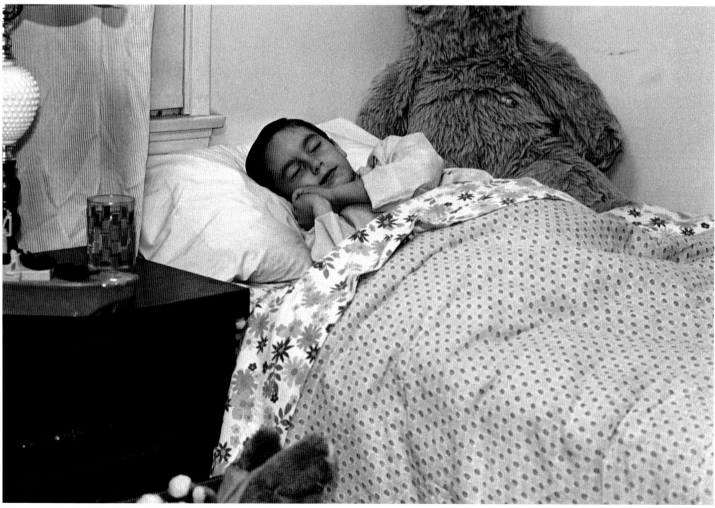

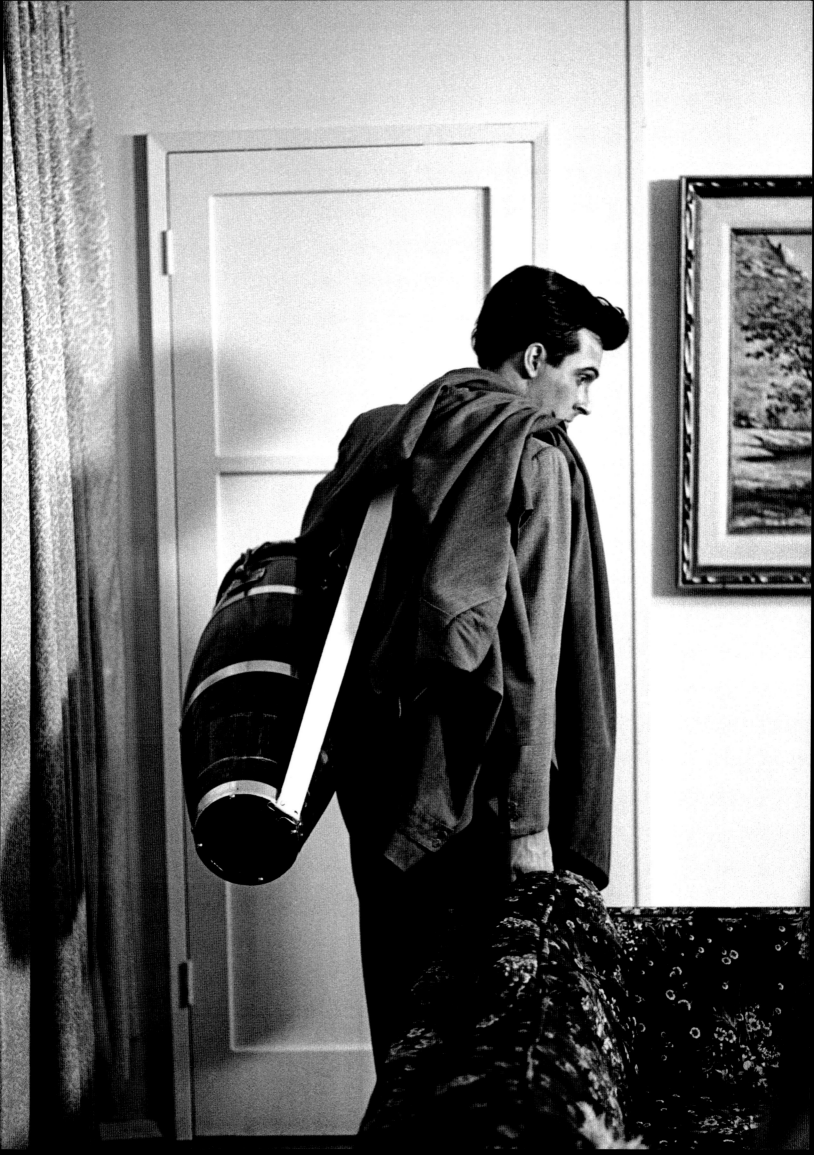

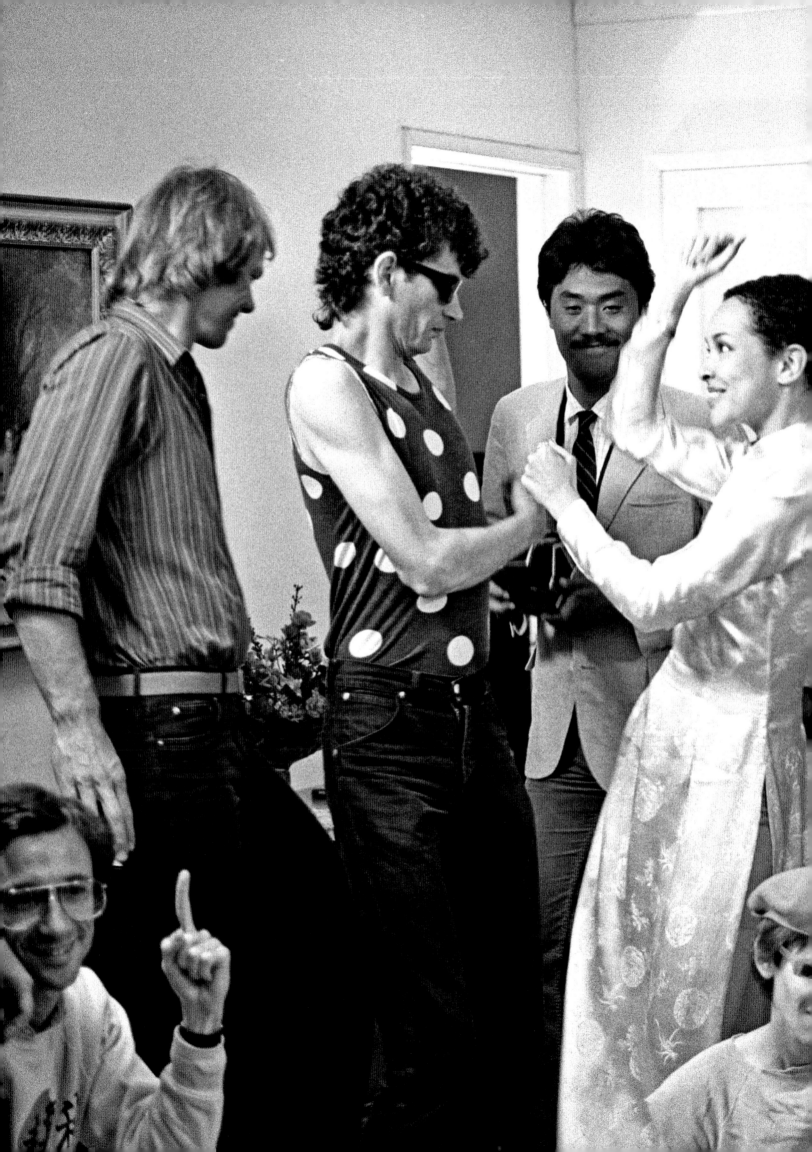

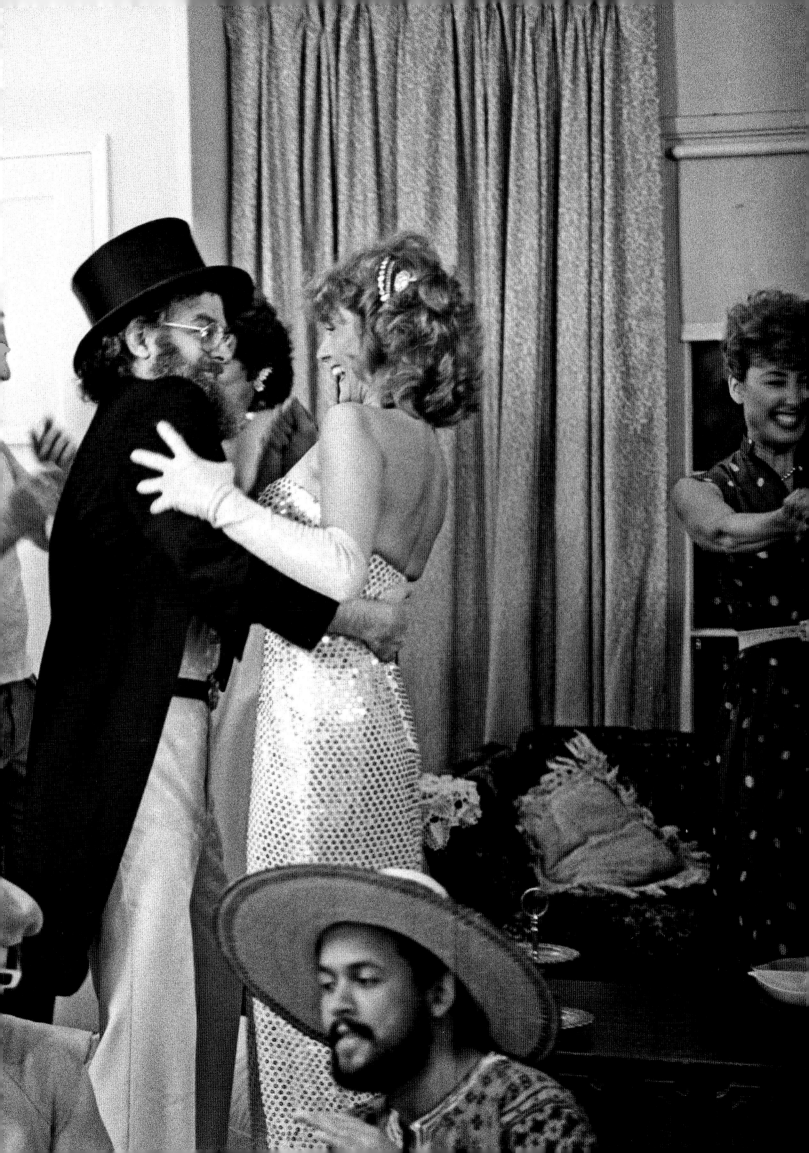

2

I LOVE ROCKY ROAD VIDEO SHOOT

AGUA DULCE AIRPARK AND DINER,
SANTA CLARITA, CA

This video was the first directing job for Dror Soref.
Jim, Steve, and I had some significant screen time,
Dr. Demento grabbed a close-up, and you might also
recognize "Musical Mike" Kieffer playing his hands.
There were cute girls, an accordion stunt double, ice
cream "junkies" and a posse of cone-thrusting extras.
It was a long shoot that went well-past midnight but was
a lot of fun. And an old movie trick was employed: since
real ice cream would have melted under the lights and
over the course of multiple takes, mashed potatoes with
various food coloring was used instead.

You will notice some photos of a bunch of kids with
accordions. Although their scene was shot, it wasn't
used, and nobody seems to recall their role. I hope they
got lunch, or at least some mashed potato ice cream for
their trouble! You will also notice that I appear in some
photos in this chapter, and I hereby thank "Musical Mike"
for taking those with my camera.

Only six images in this chapter have been seen before,
from prints made by Joel Miller. Two of them appeared for
the first time in *The Authorized Al*, a book which is highly
prized by Al collectors.

There are several scenes in the video where ice cream
flavor boards are visible on the wall, but never clear
enough to read the names. For the record, they are:
Straw Fur, Jan's Oatmeal Ice, Carrot Lime, Almond
T-Bone, Chock Pot, Chicken Fat, Duck Tartar, Pea
Frost, Veal Snow, Beef Jam, Vanilla Lox, Spinach
Sherbert, Punk Ice, Beef Juice Creme, Lamb Fudge,
Potato Crunch, Pork Swirl, Flounder Toffee, Corn
Lumps, and of course, Rocky Road! I'm pretty sure
that Al didn't create this list, because he would have
spelled sherbet correctly.

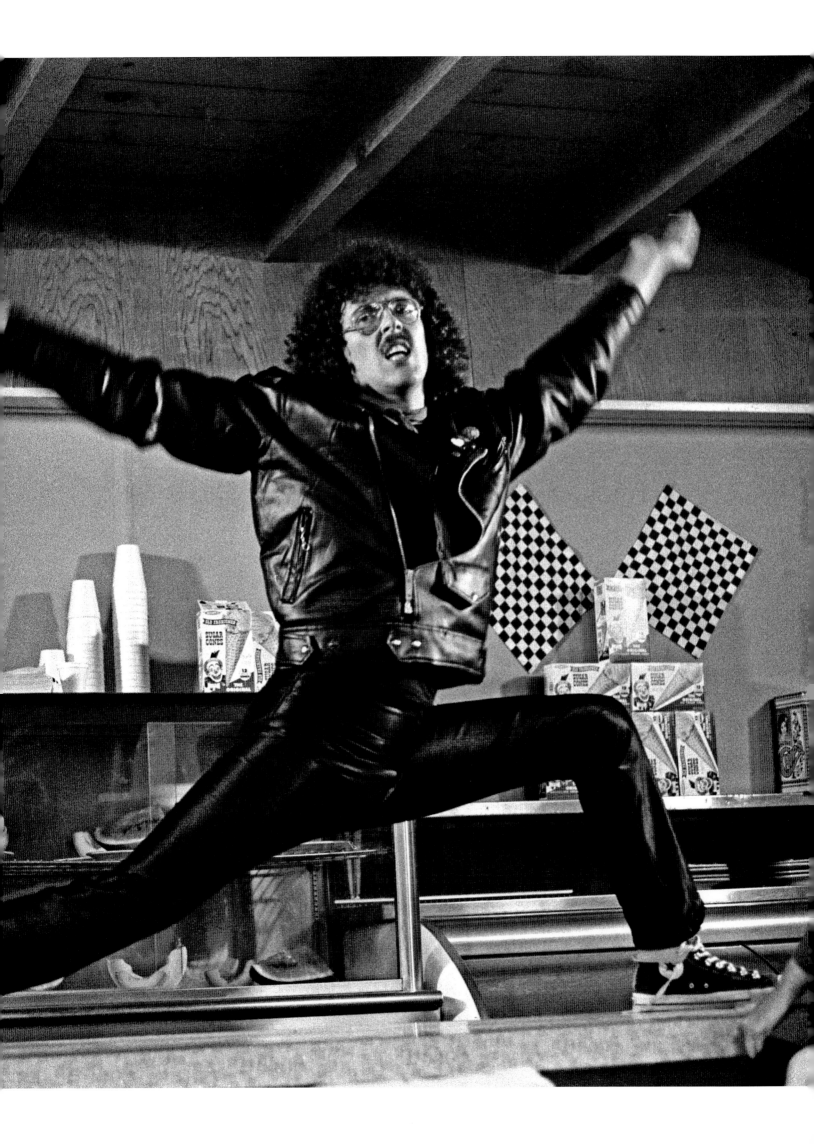

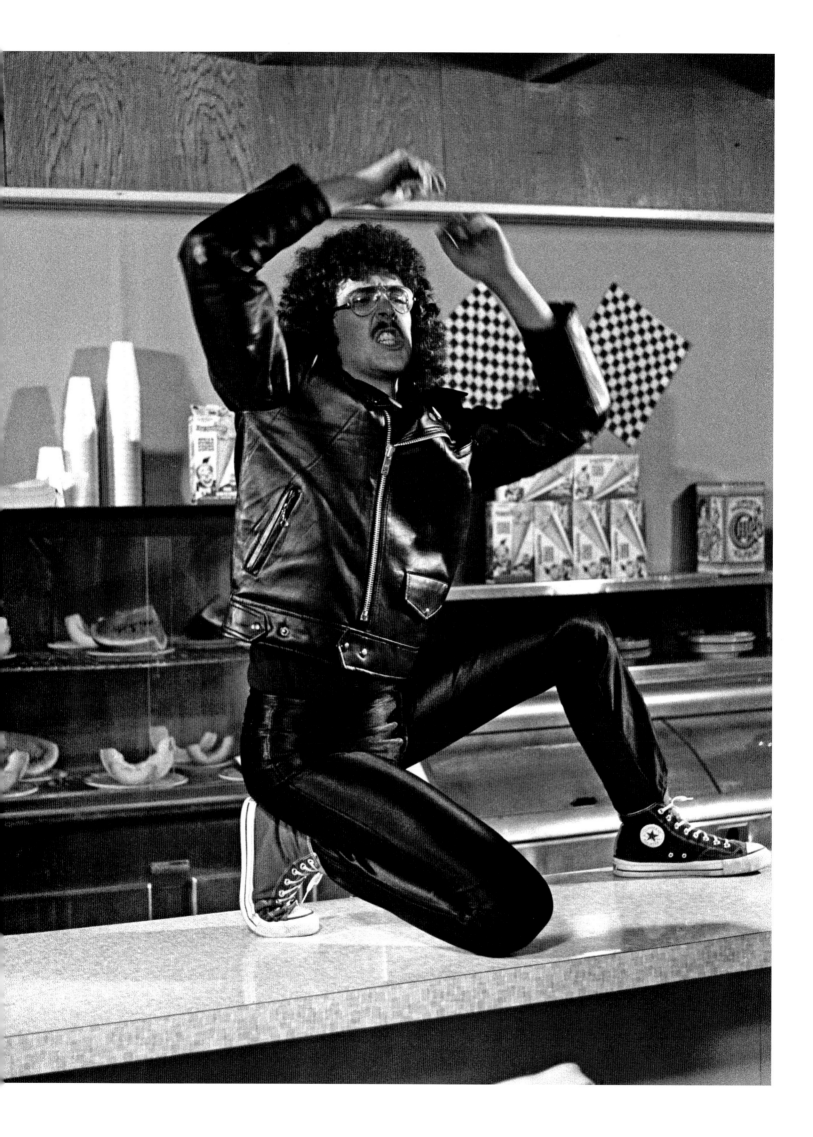

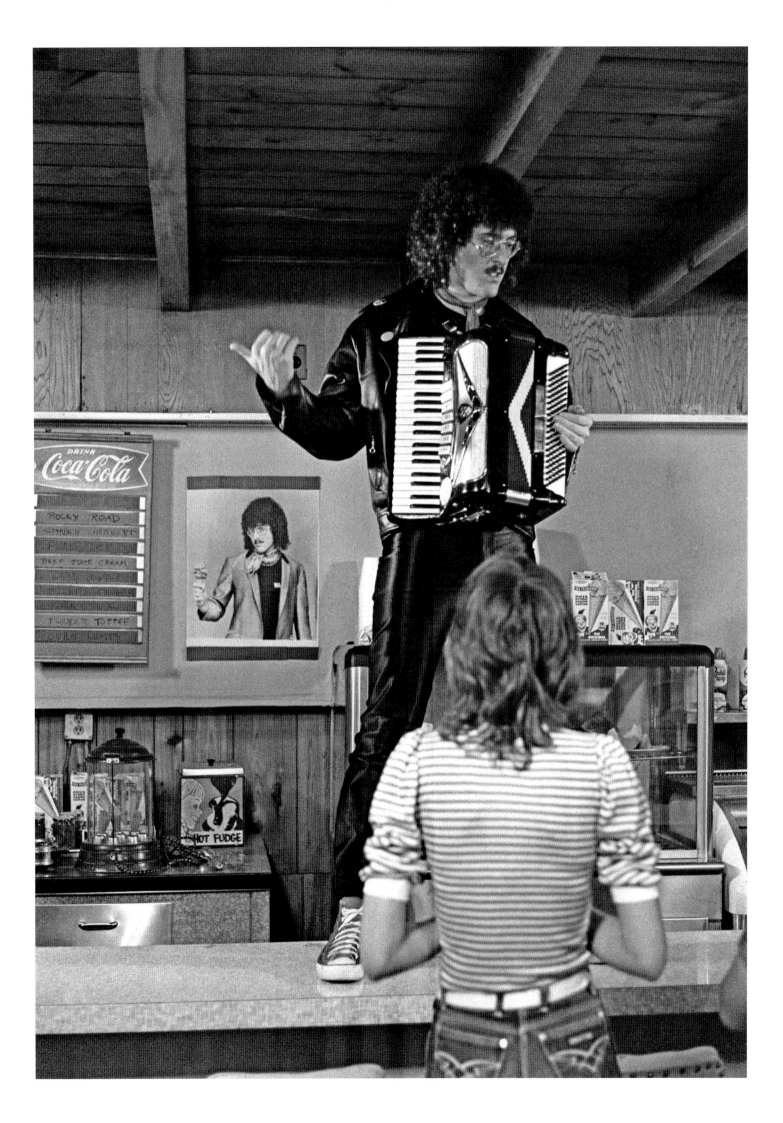

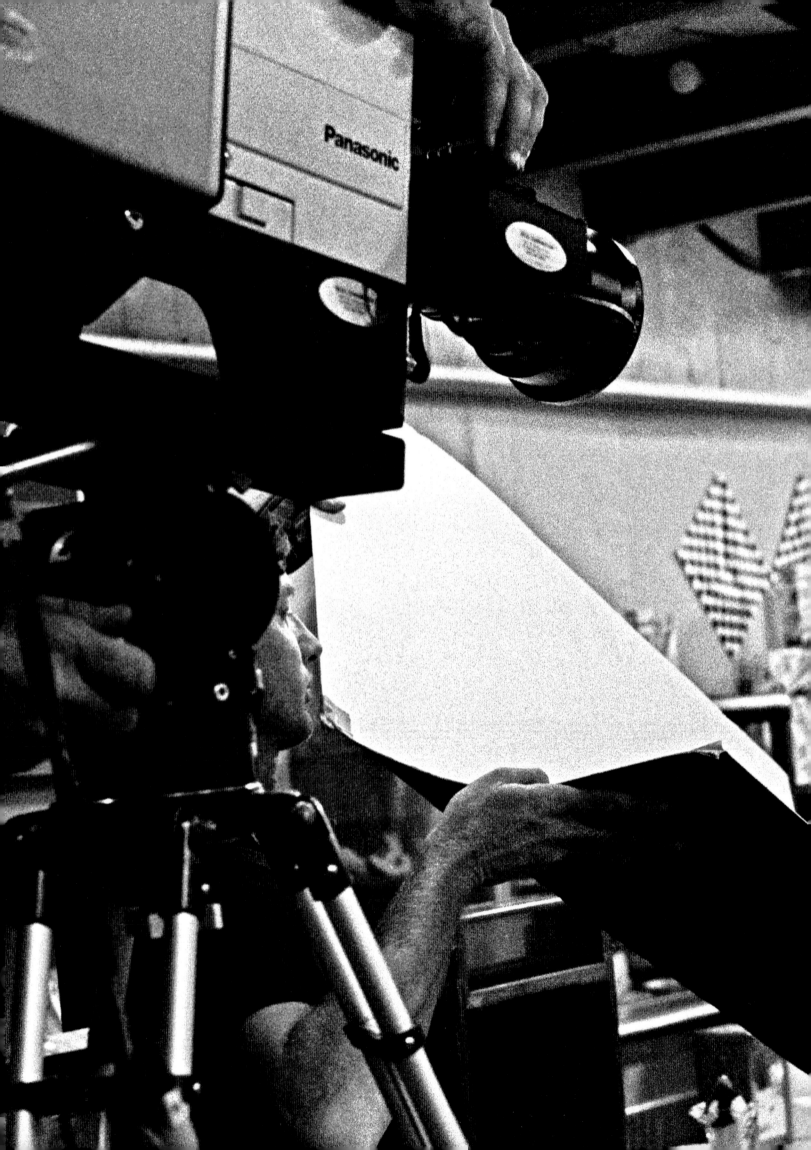

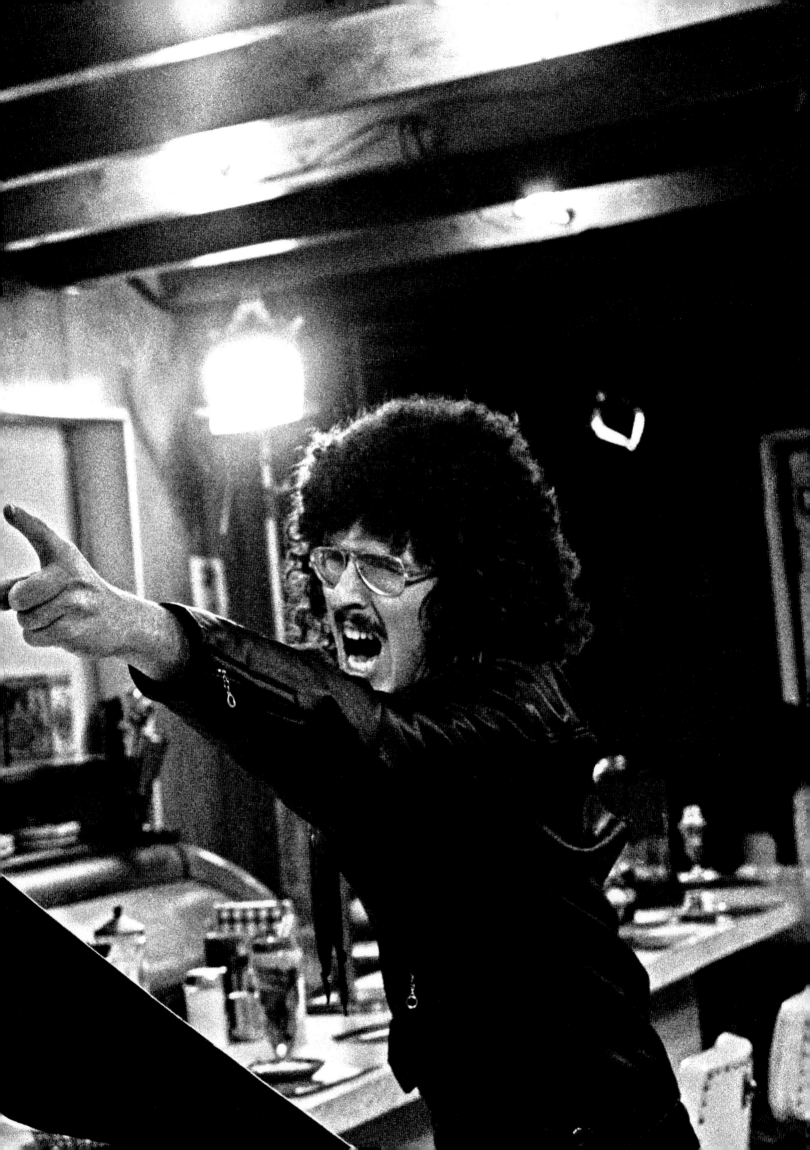

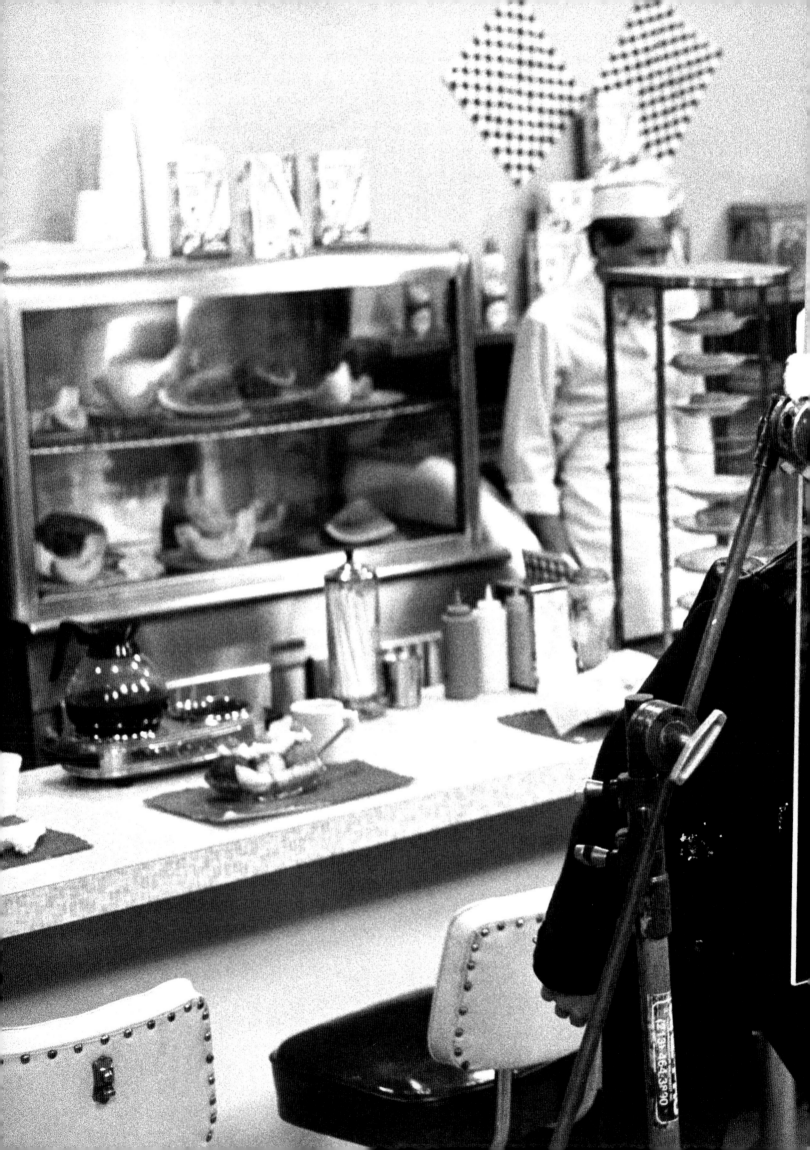

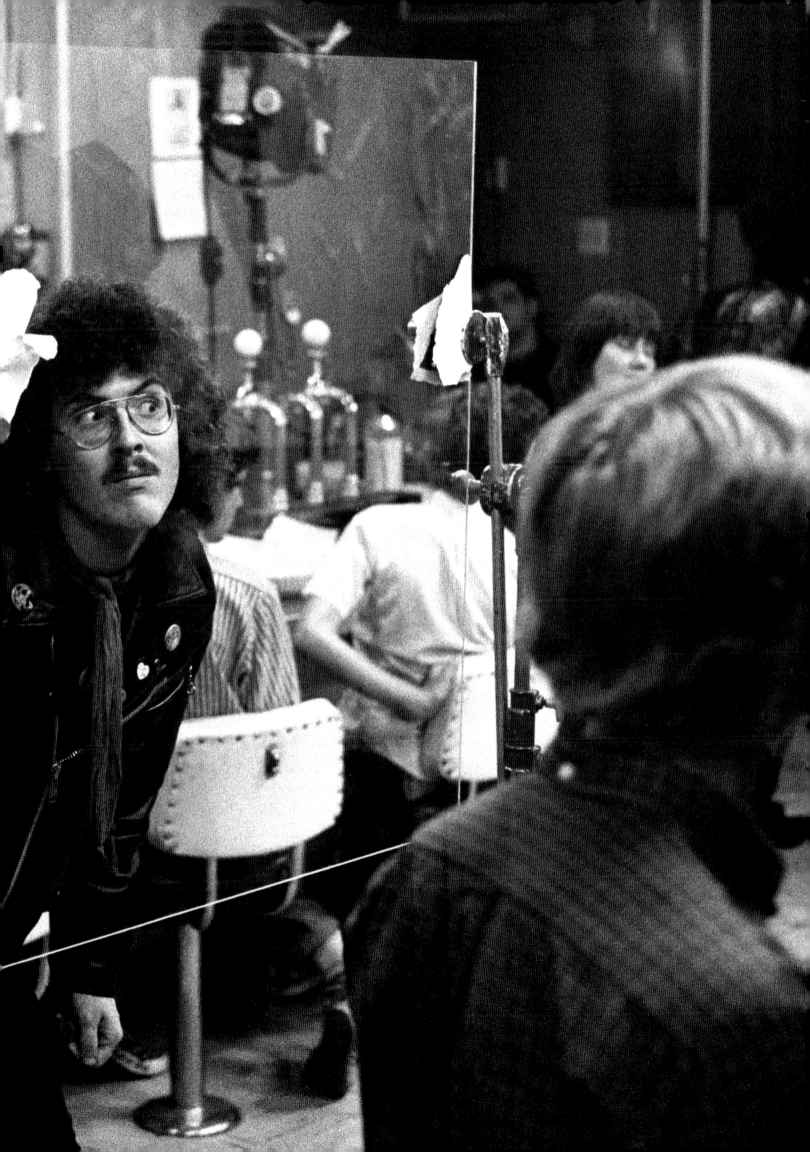

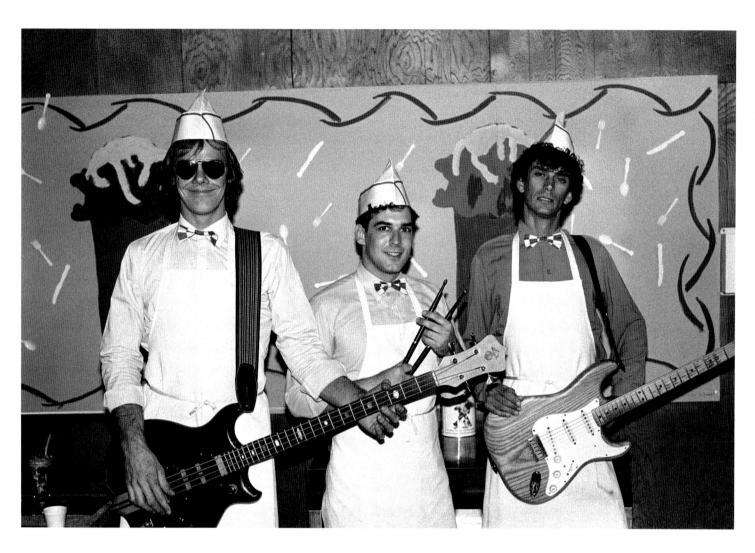

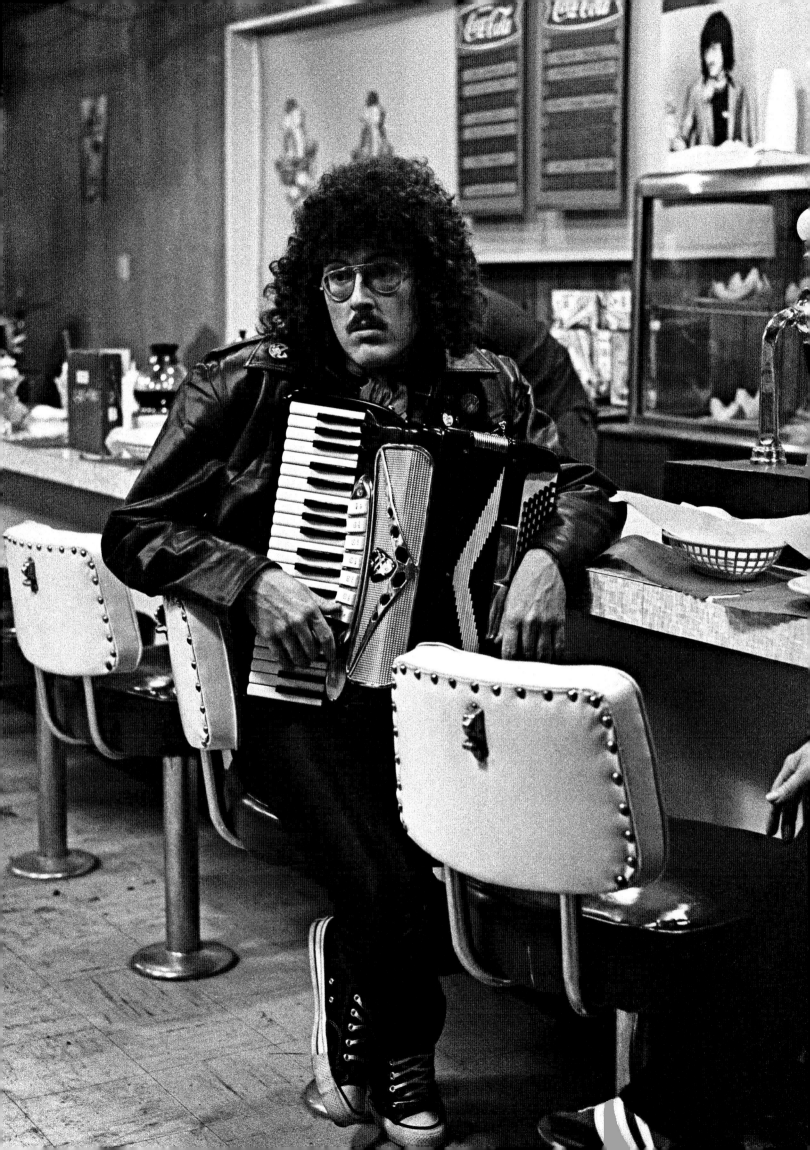

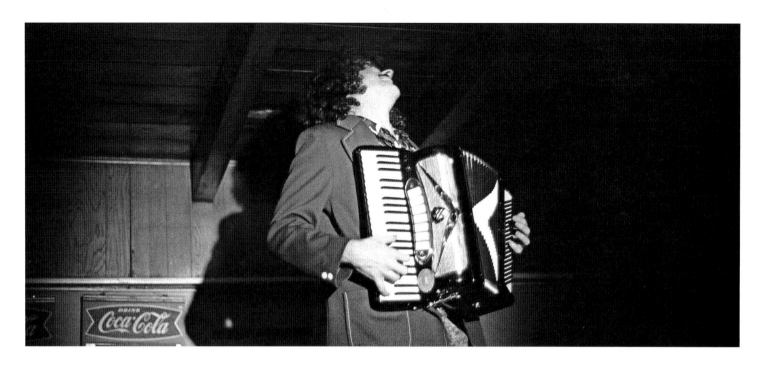

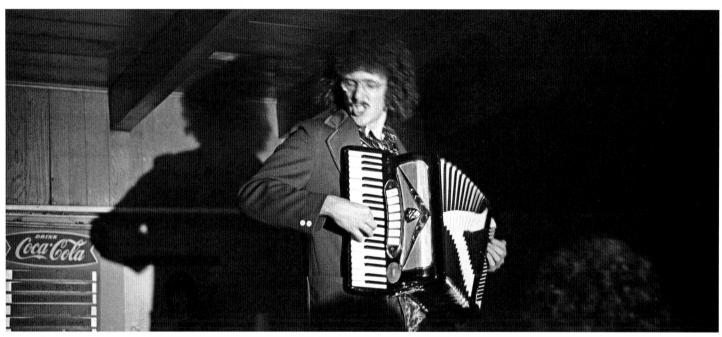

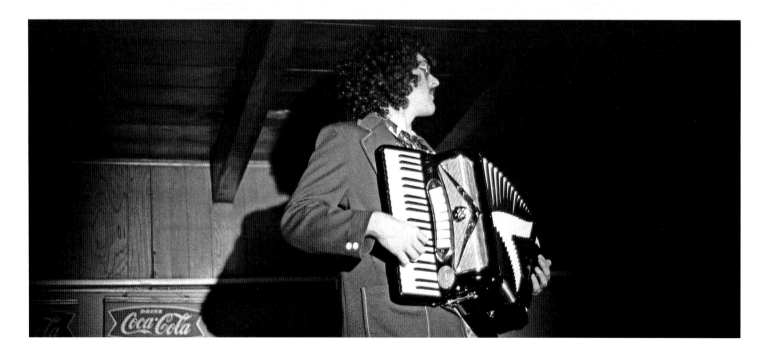

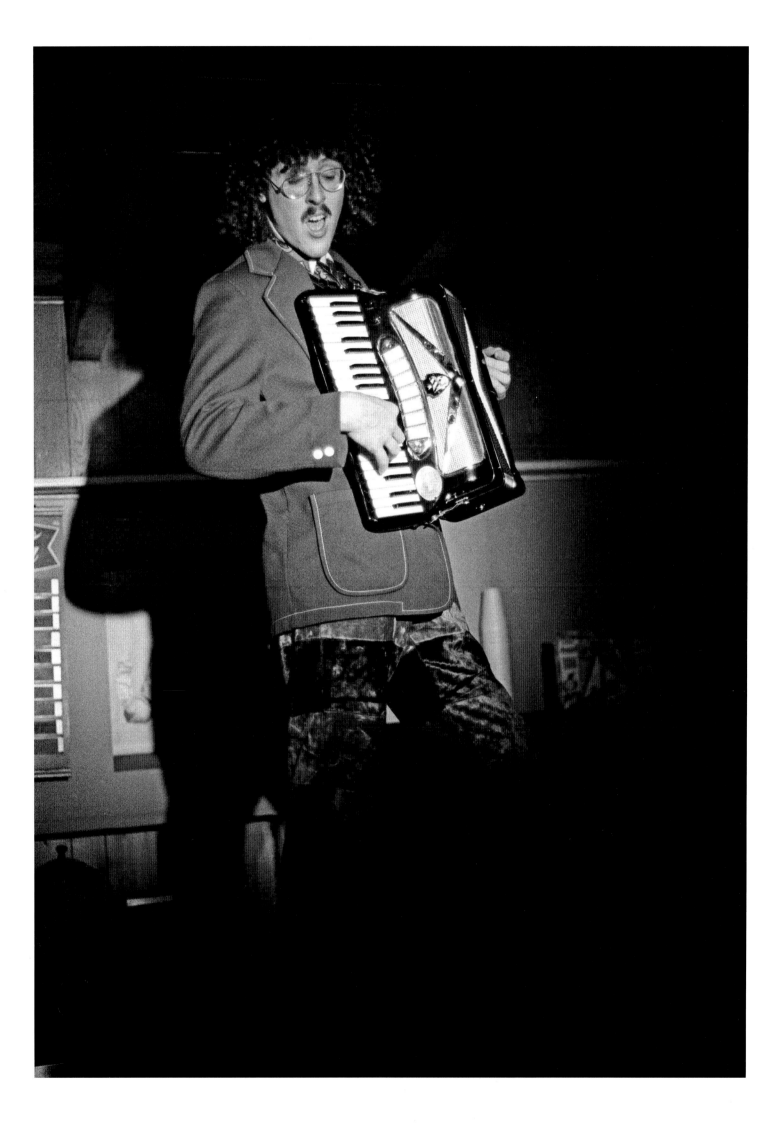

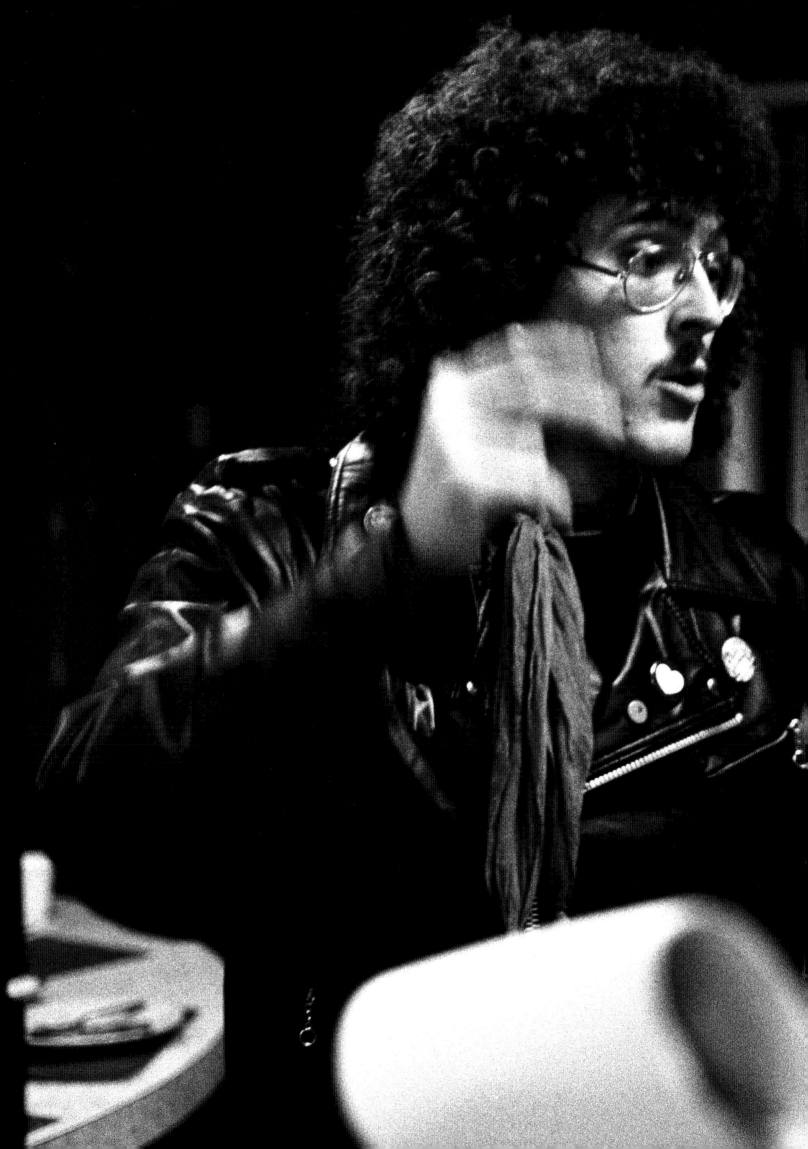

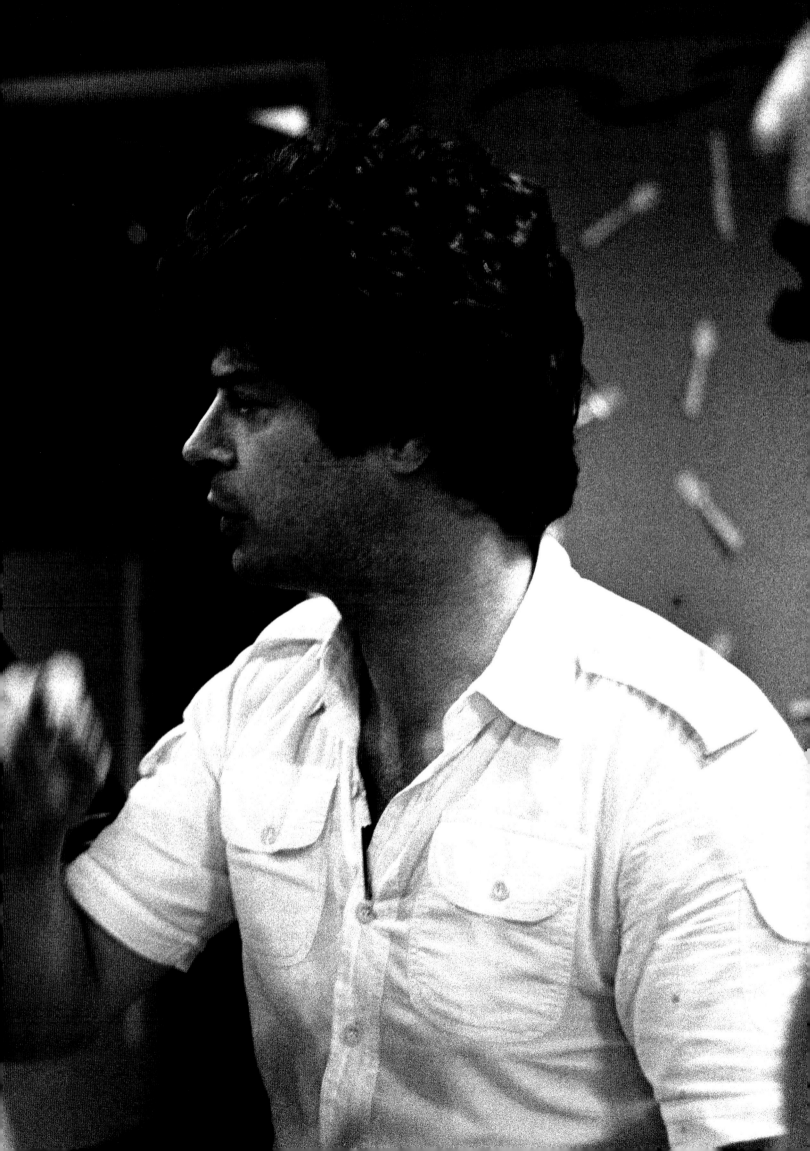

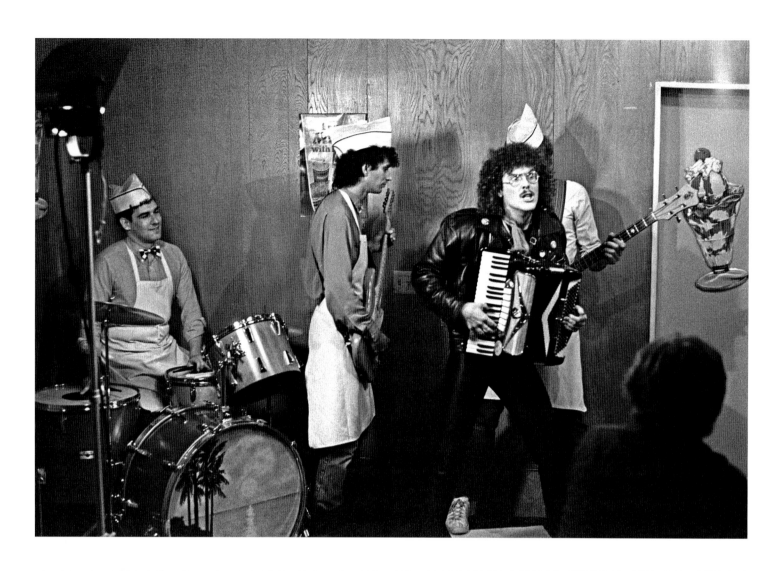

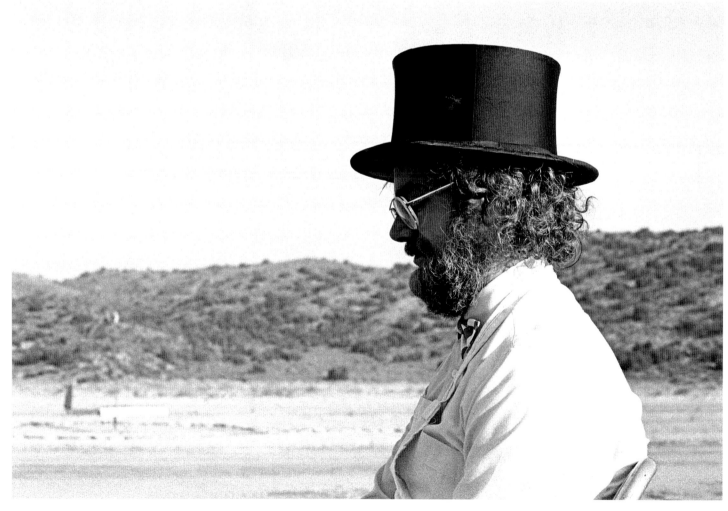

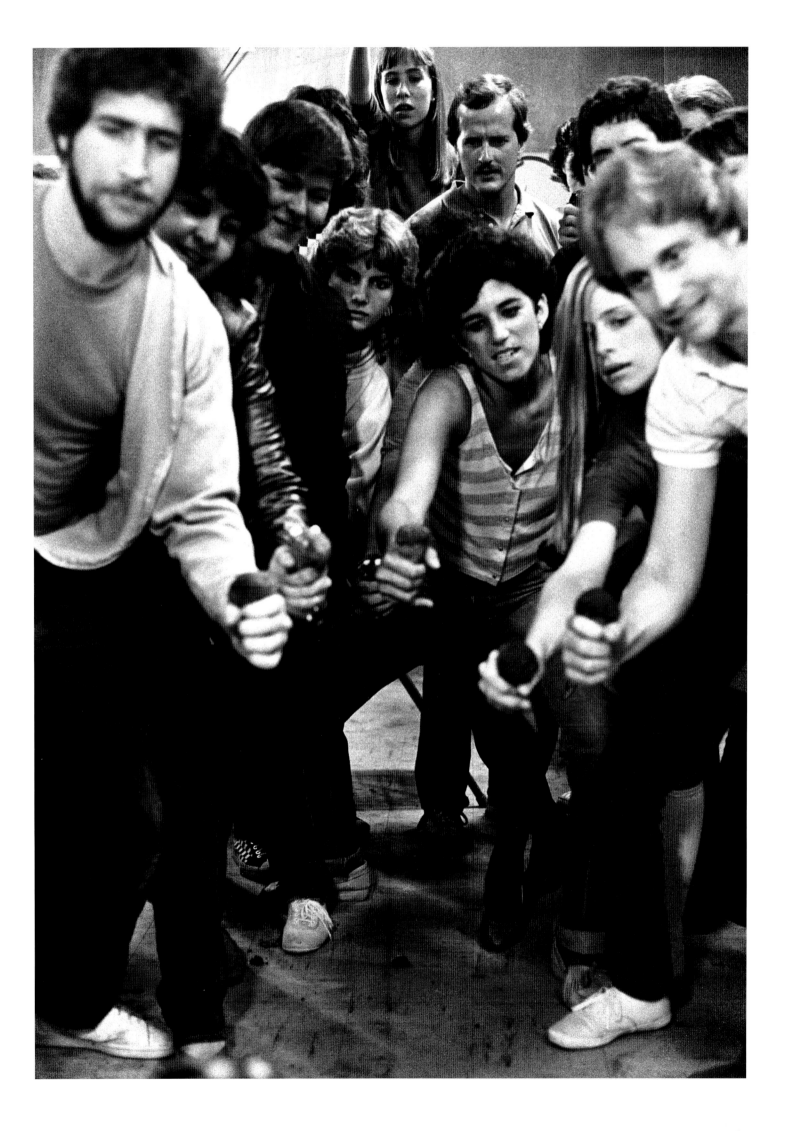

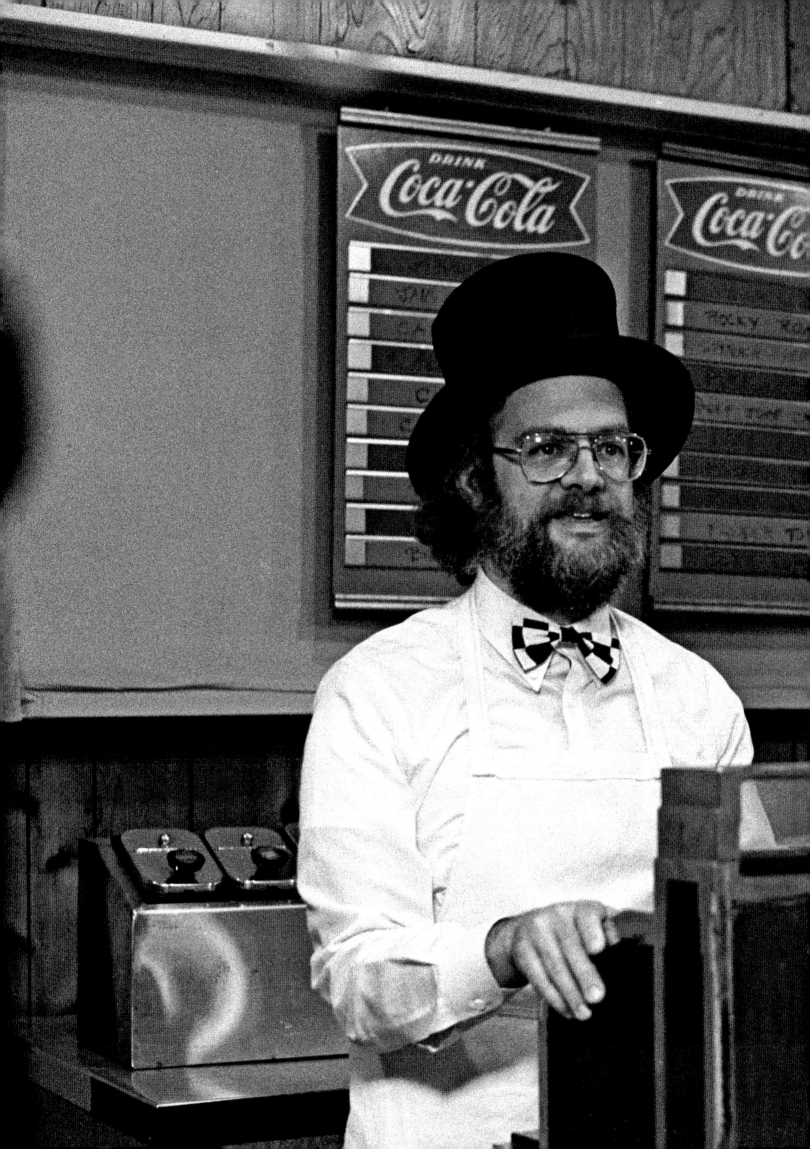

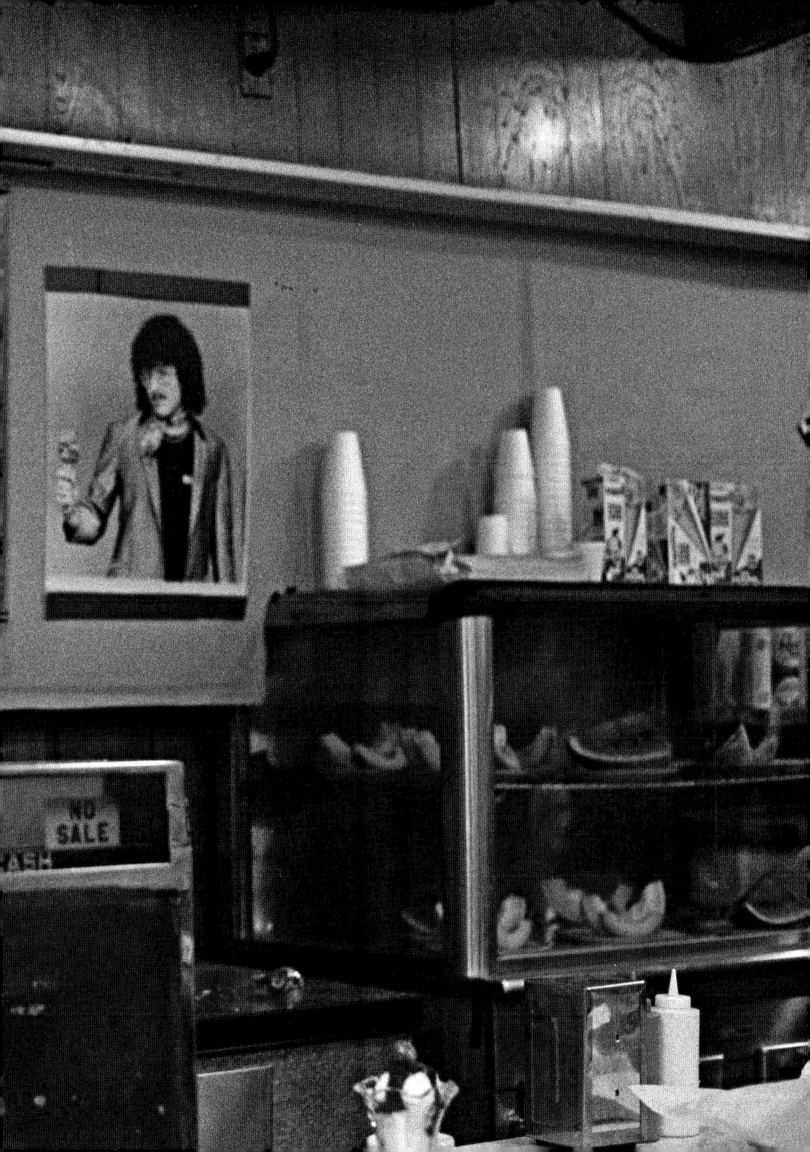

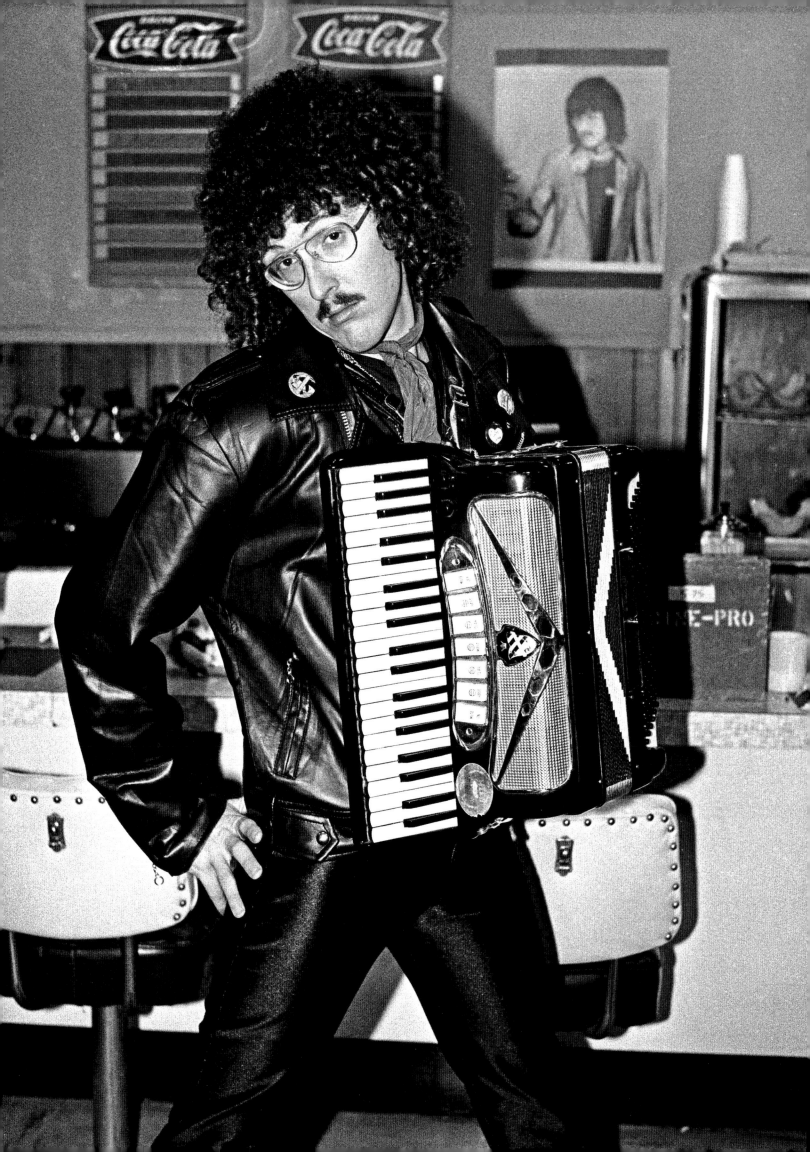

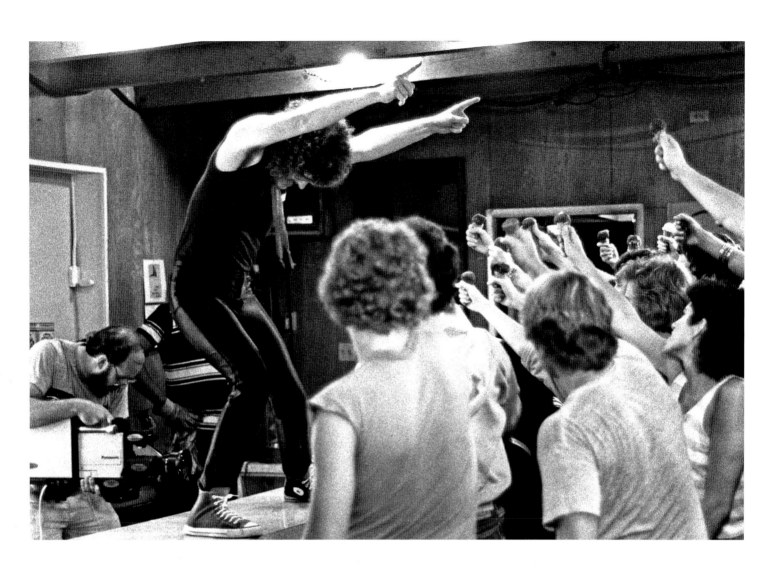

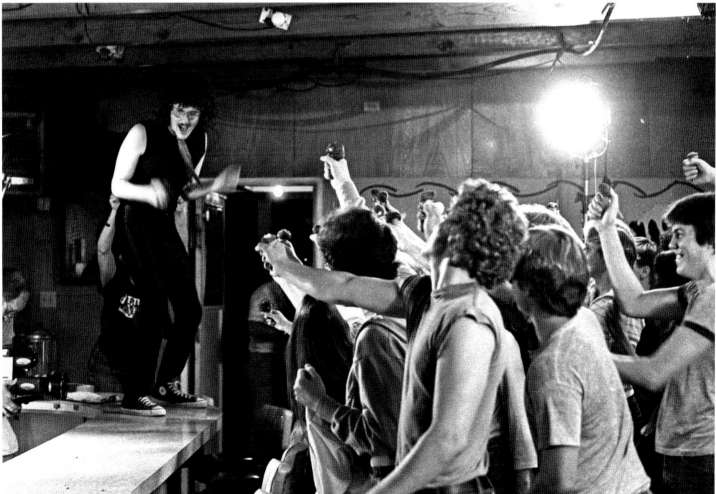

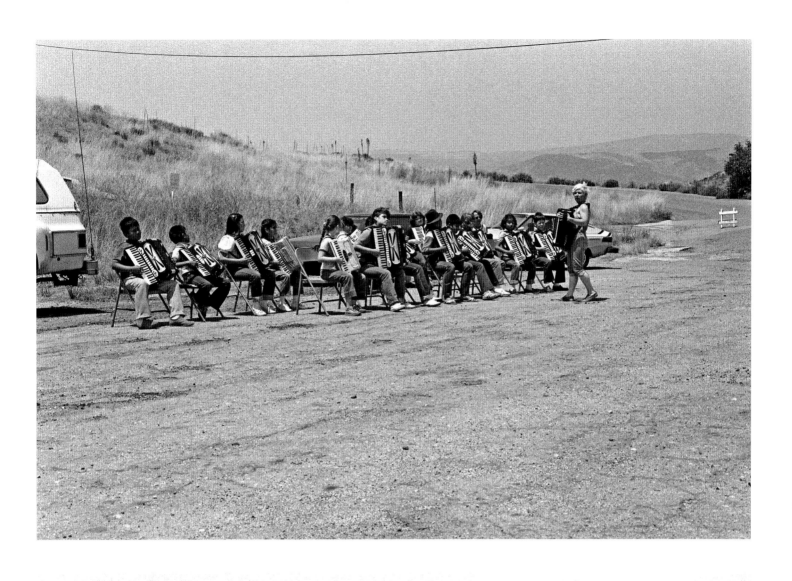

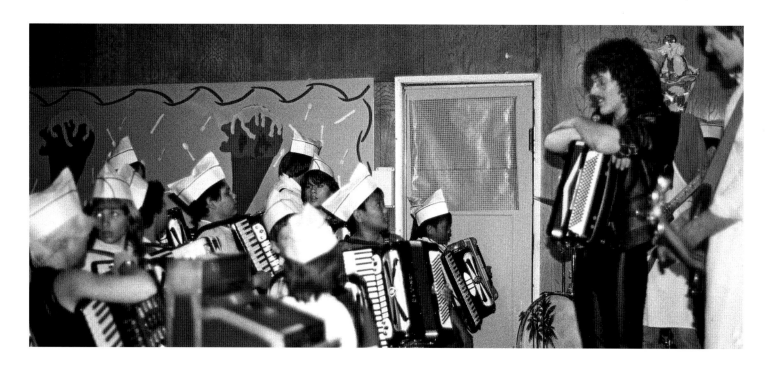

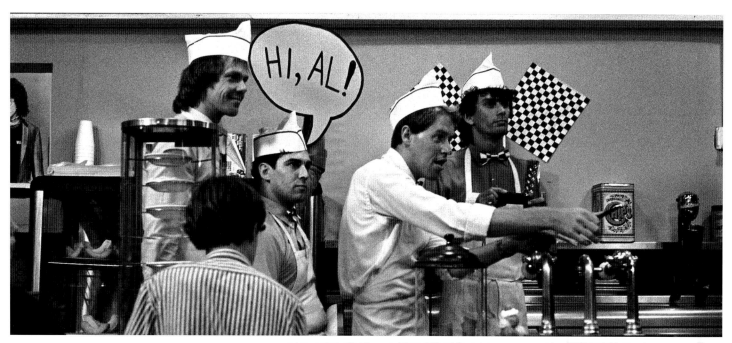

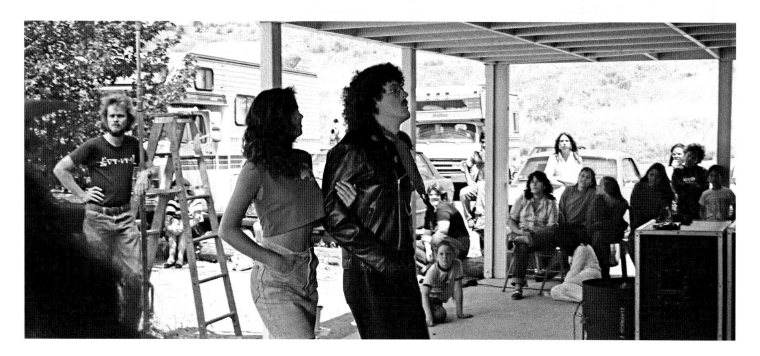

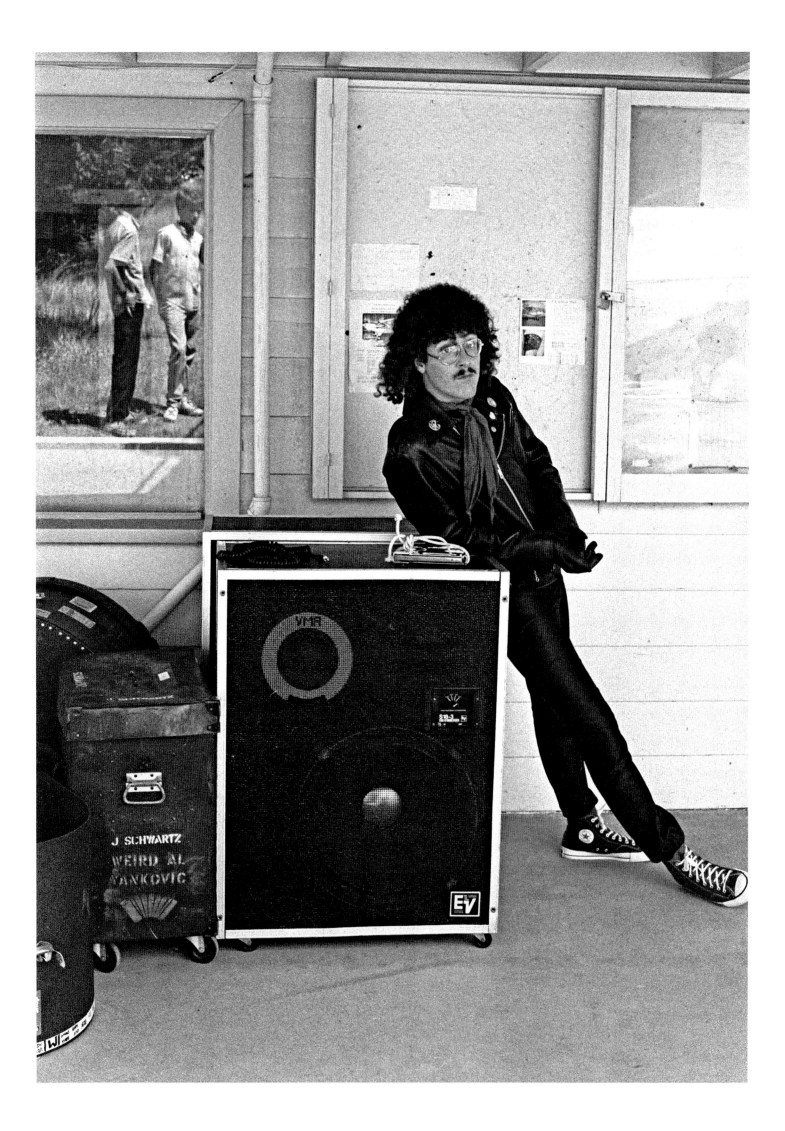

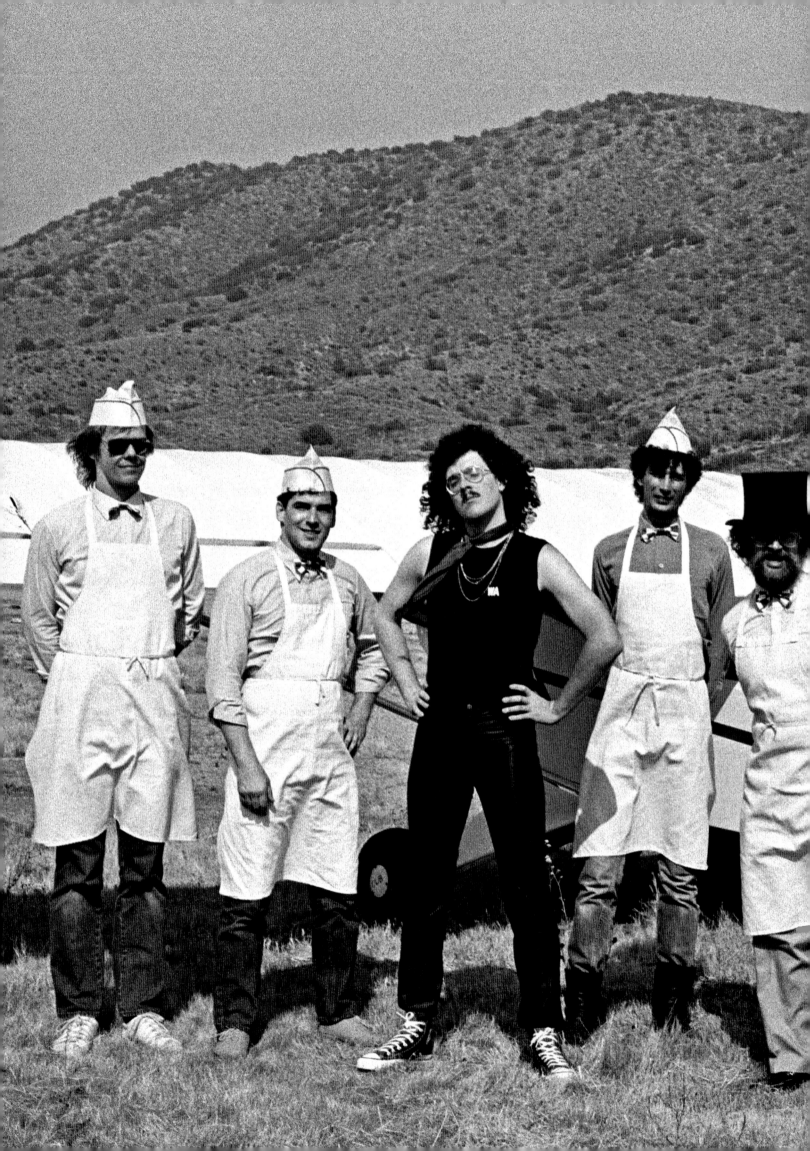

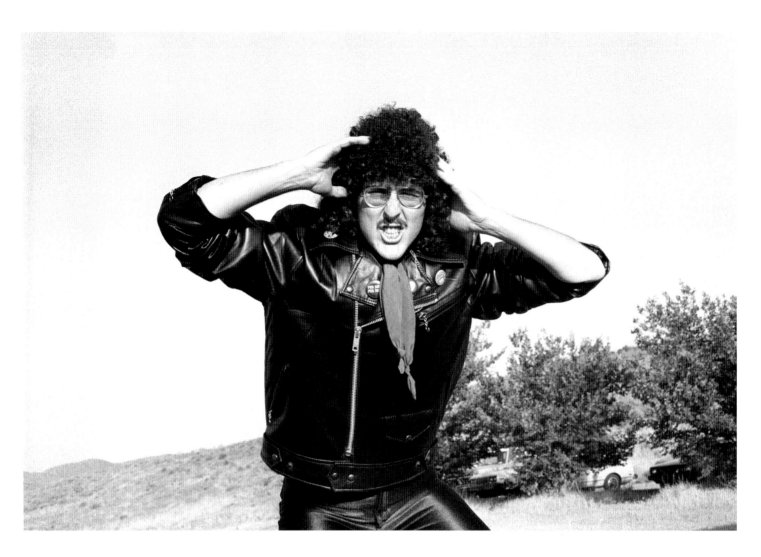

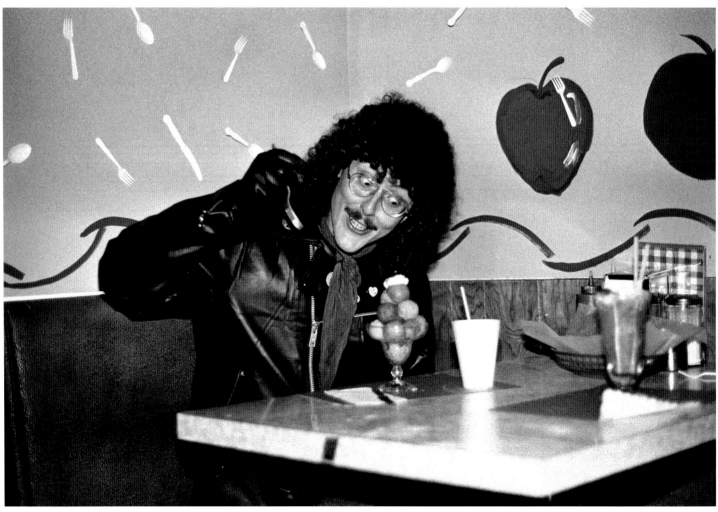

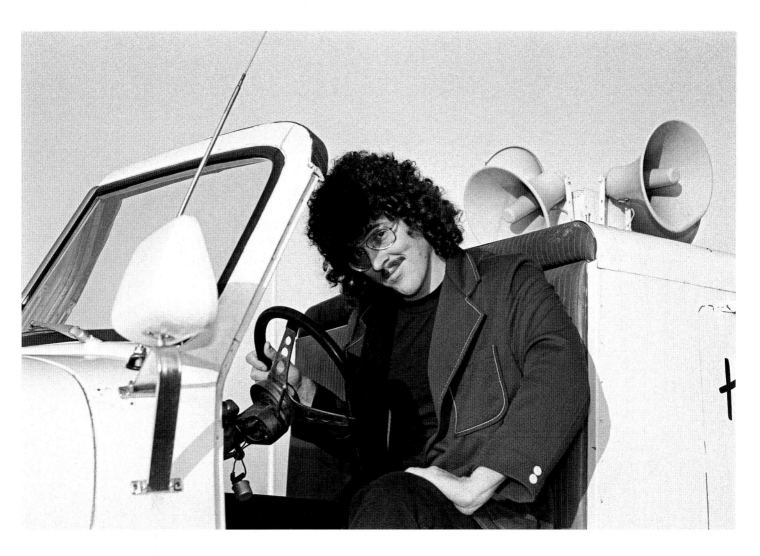

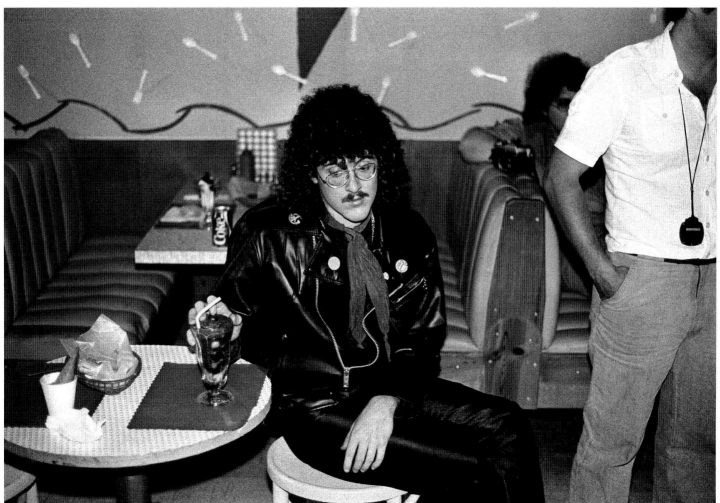

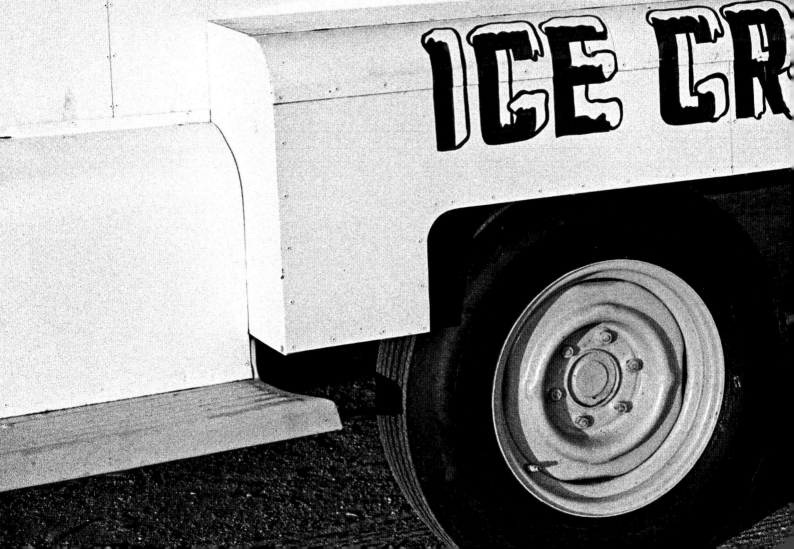

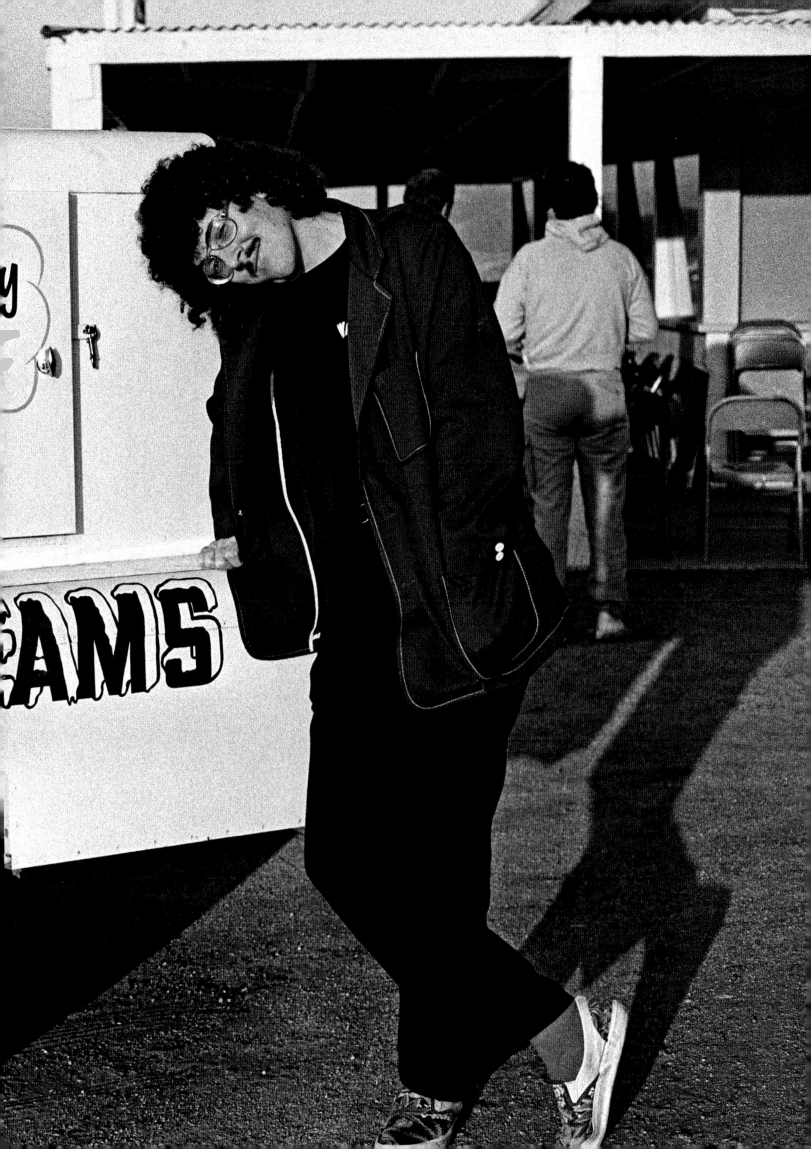

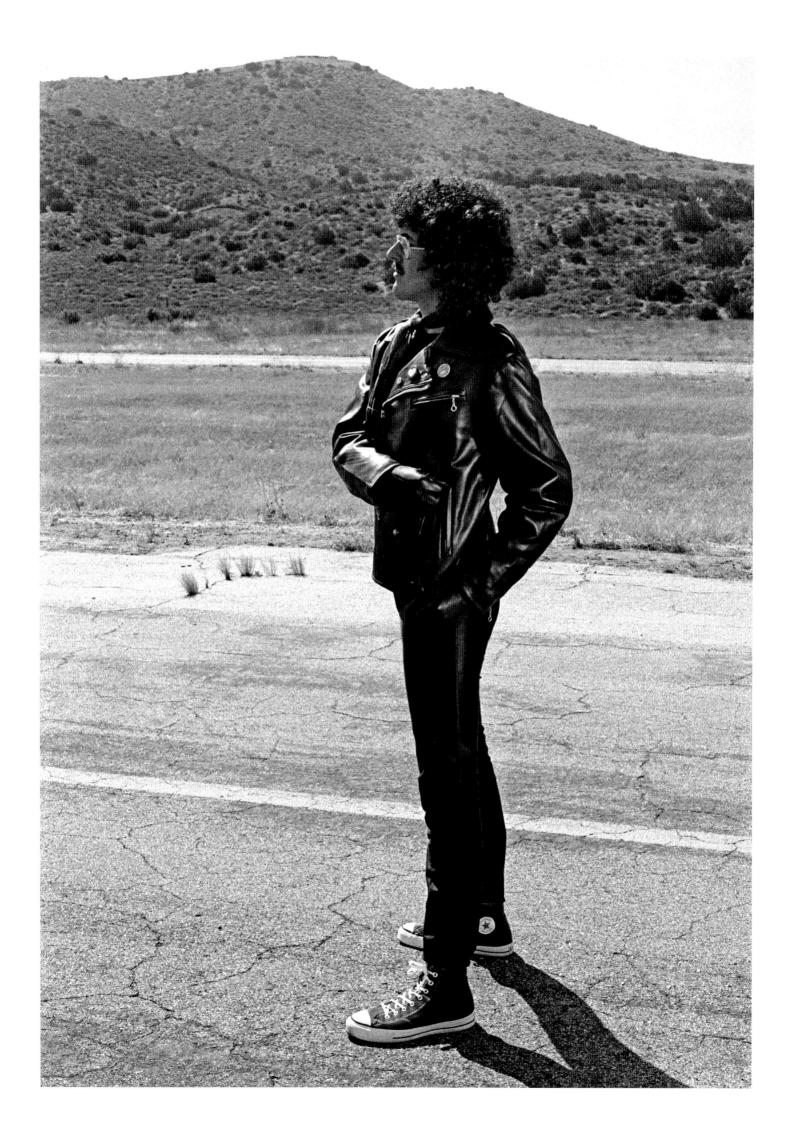

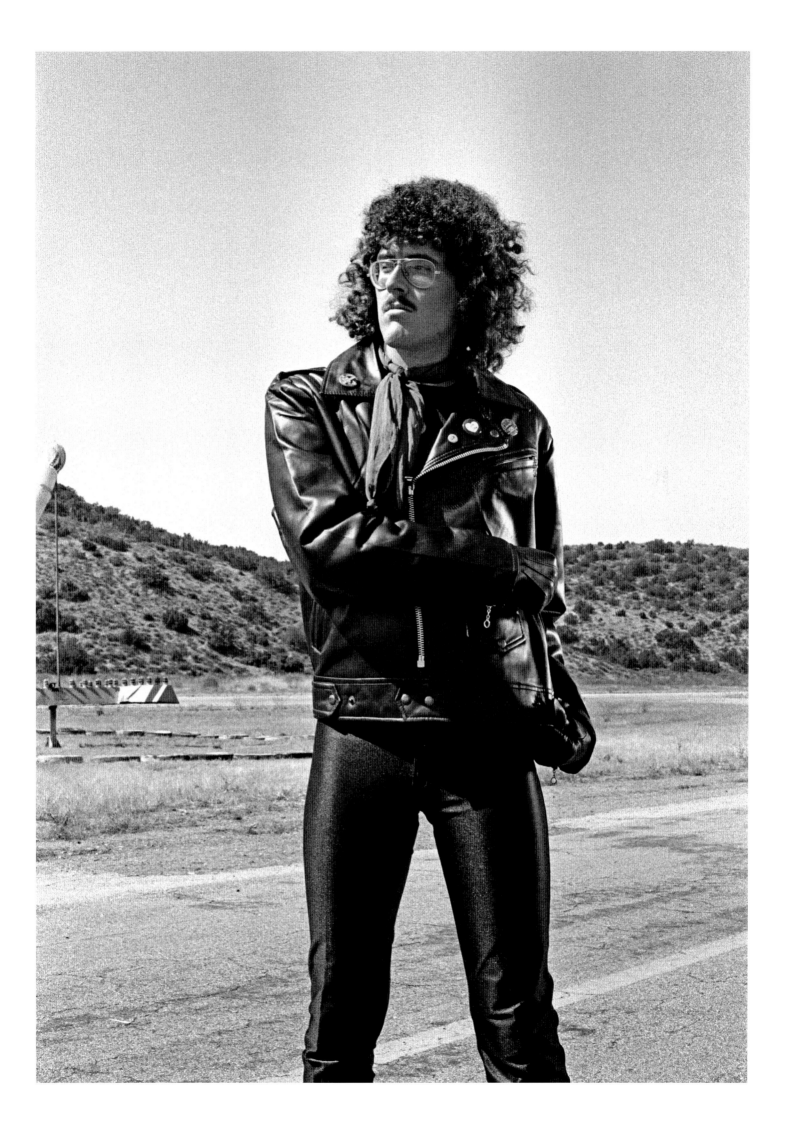

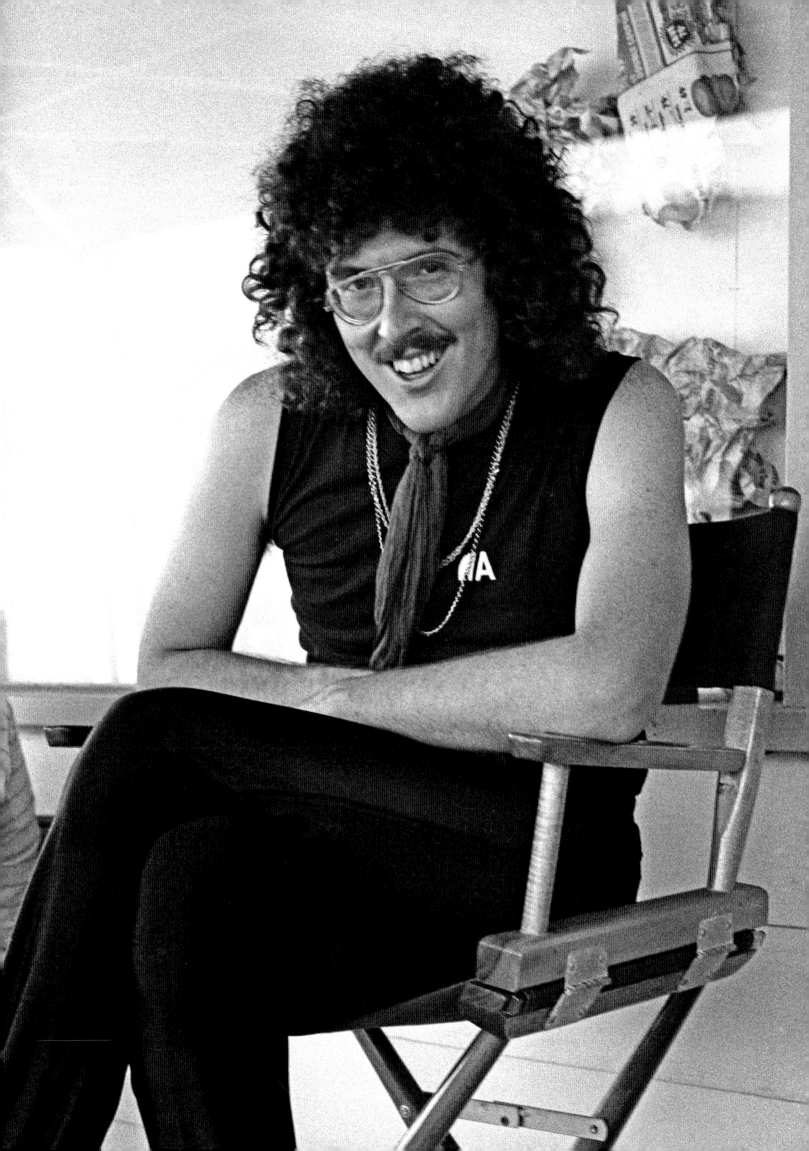

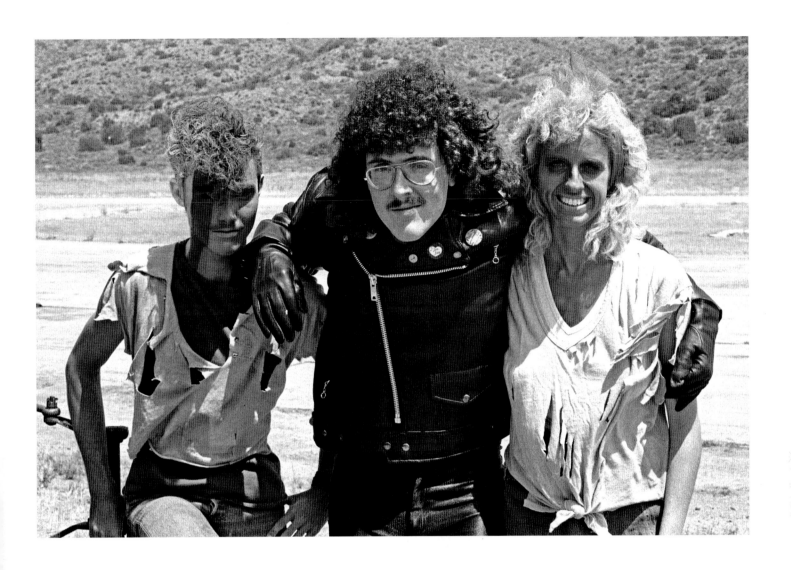

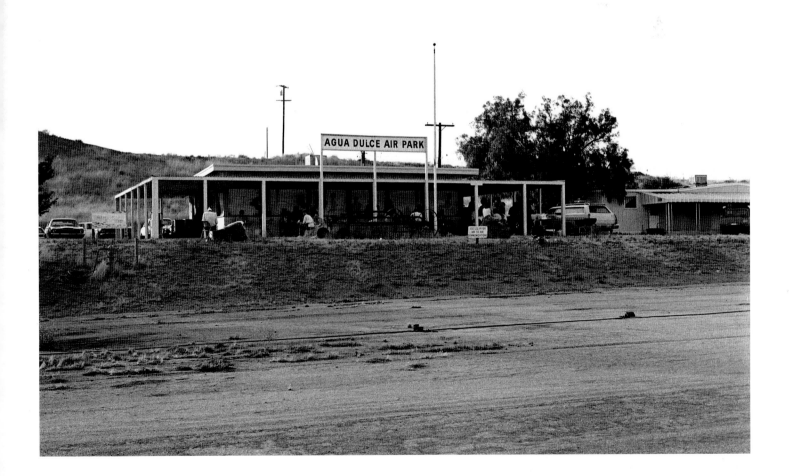

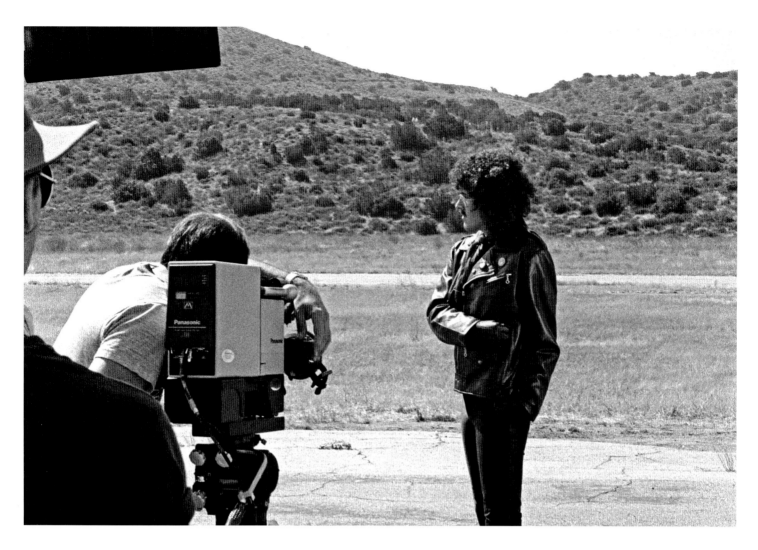

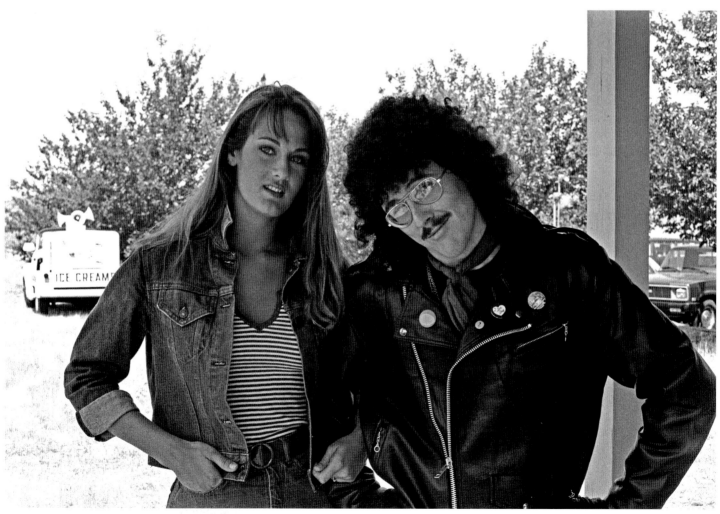

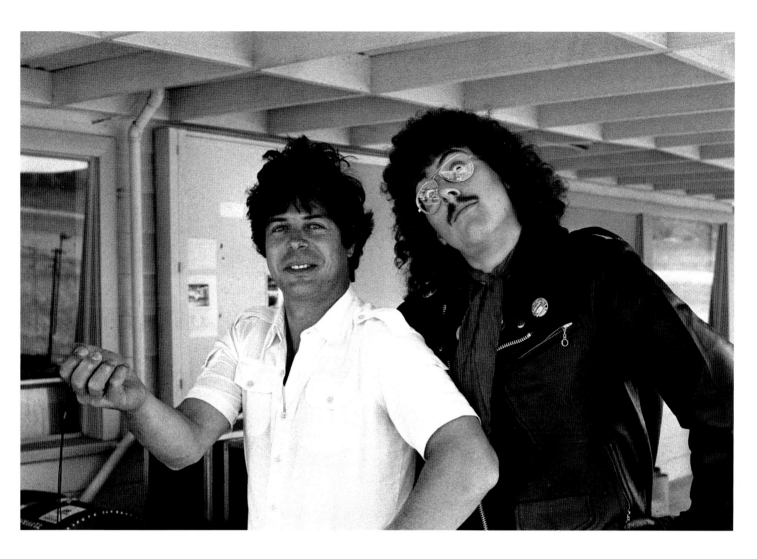

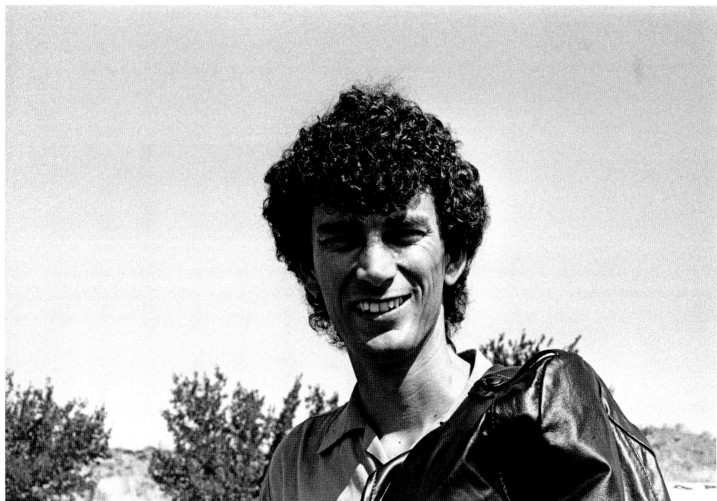

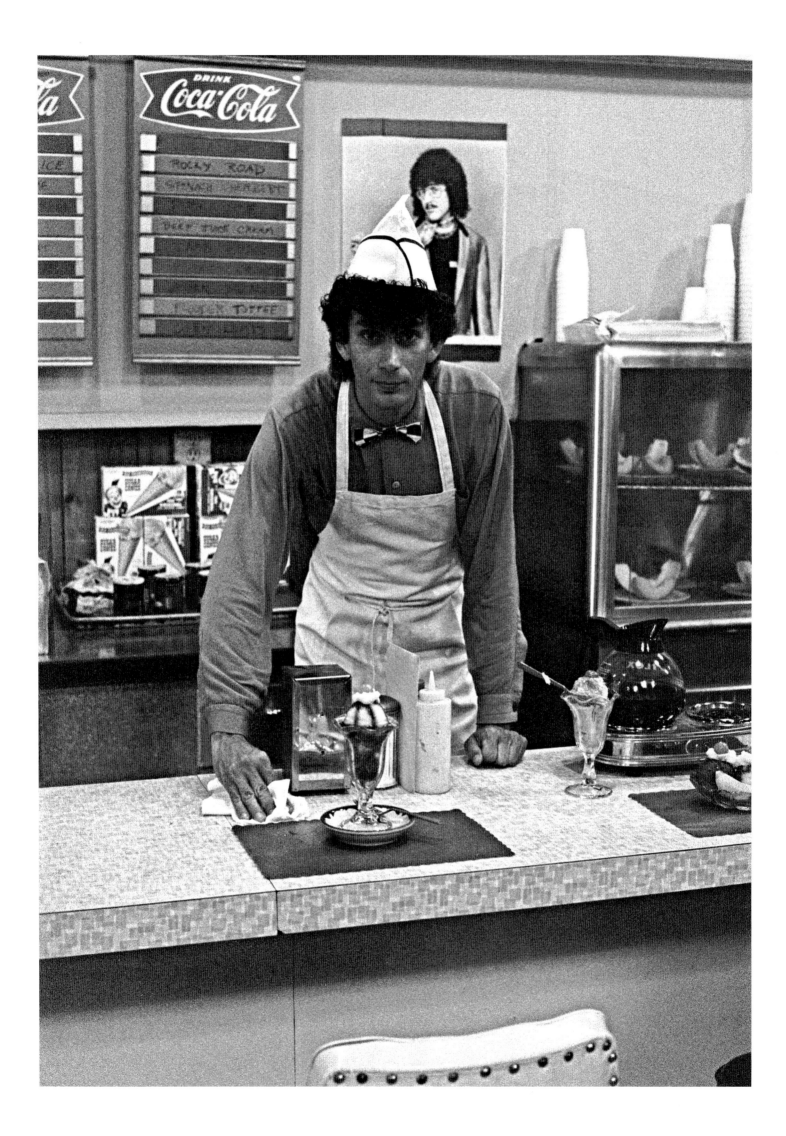

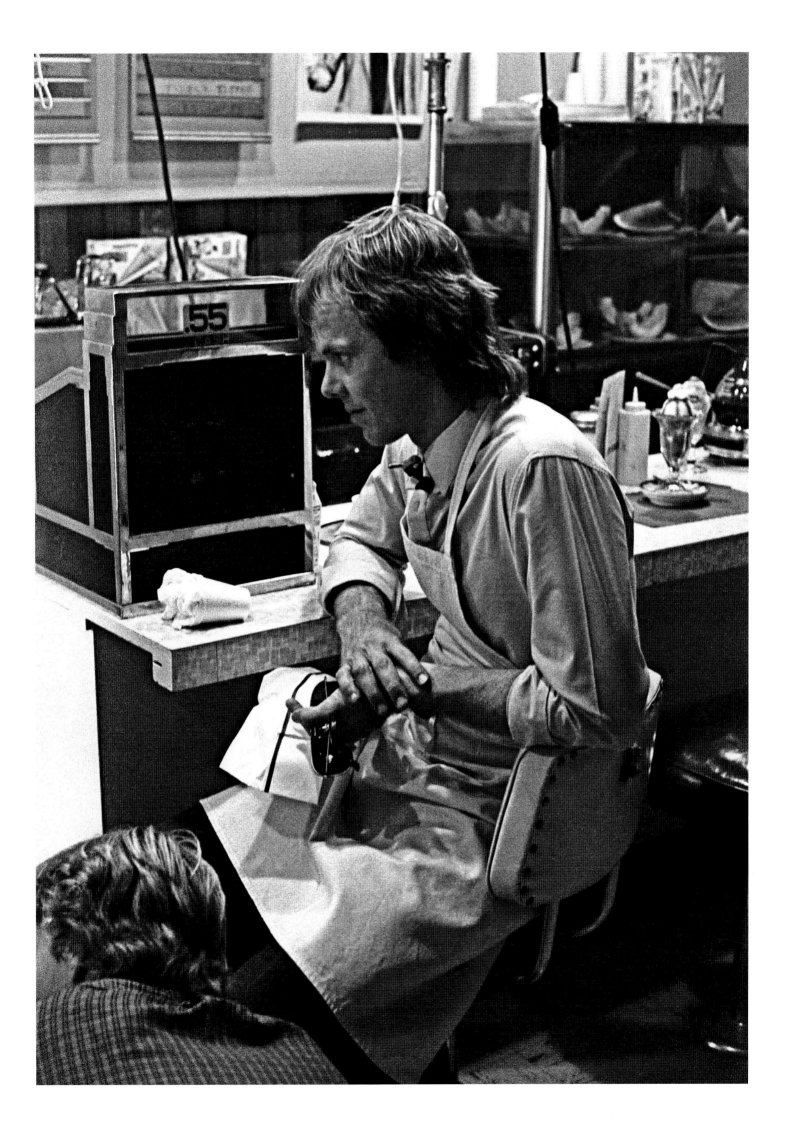

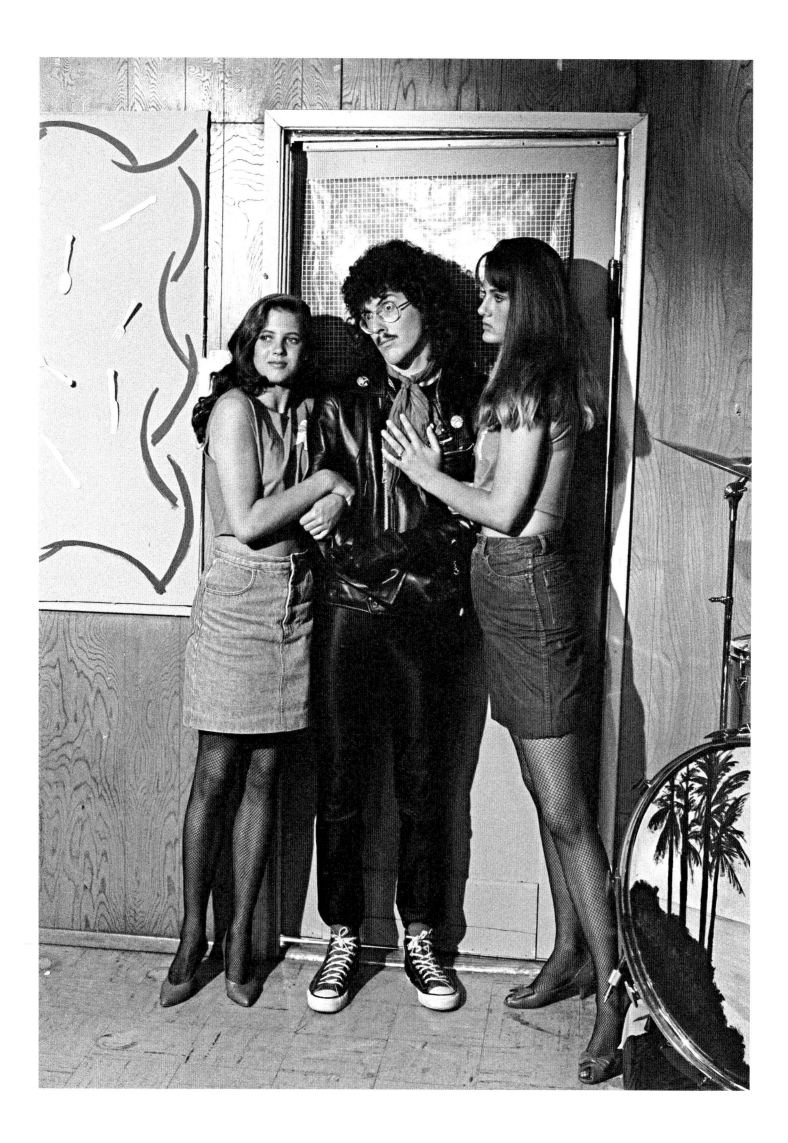

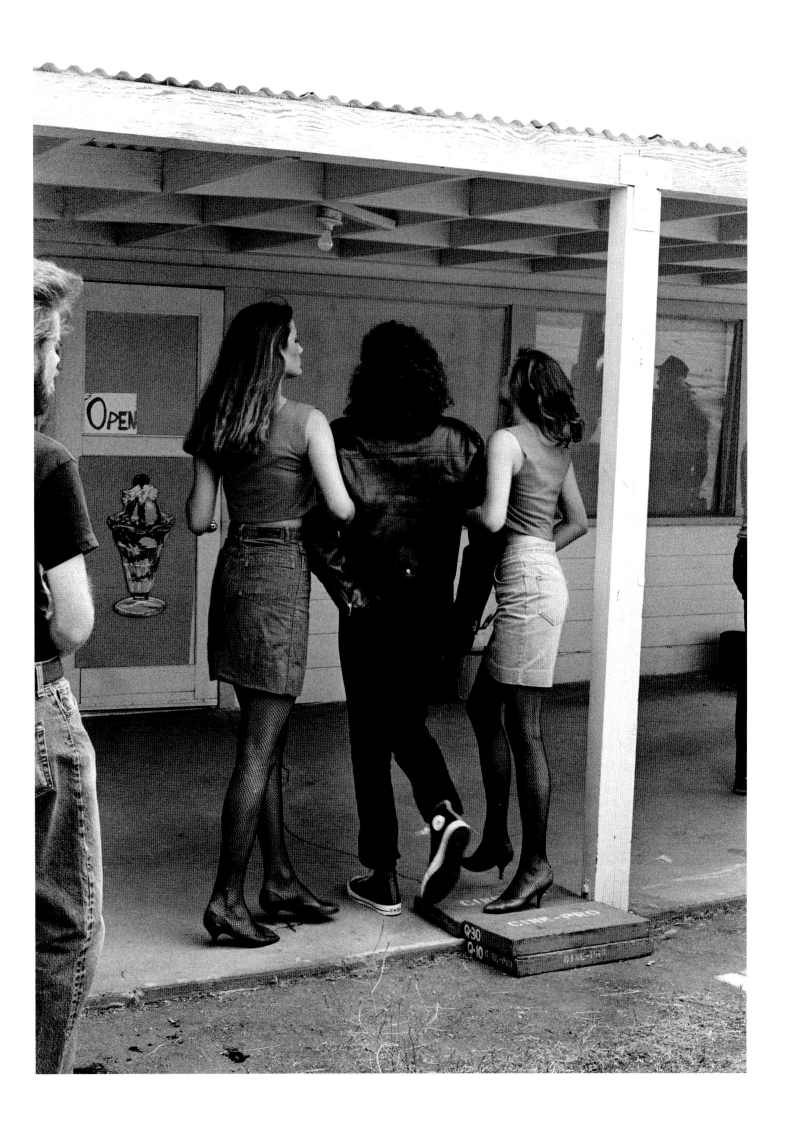

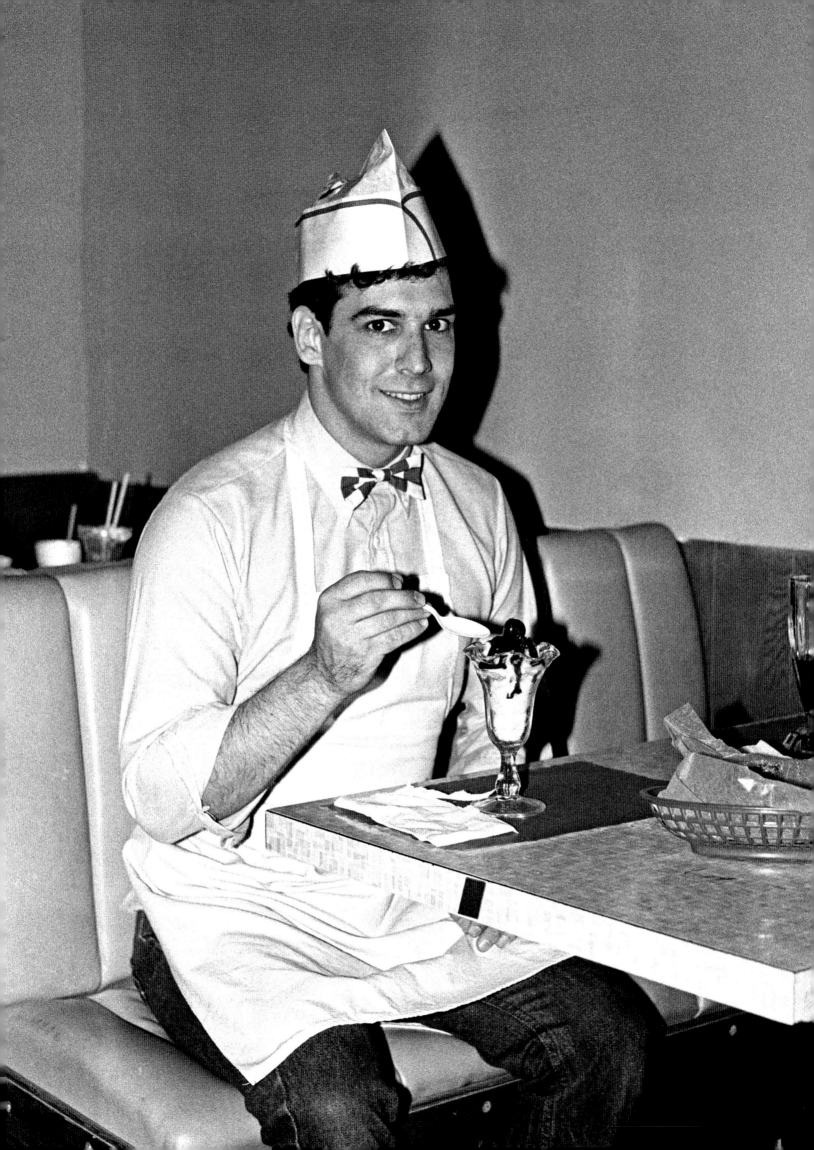

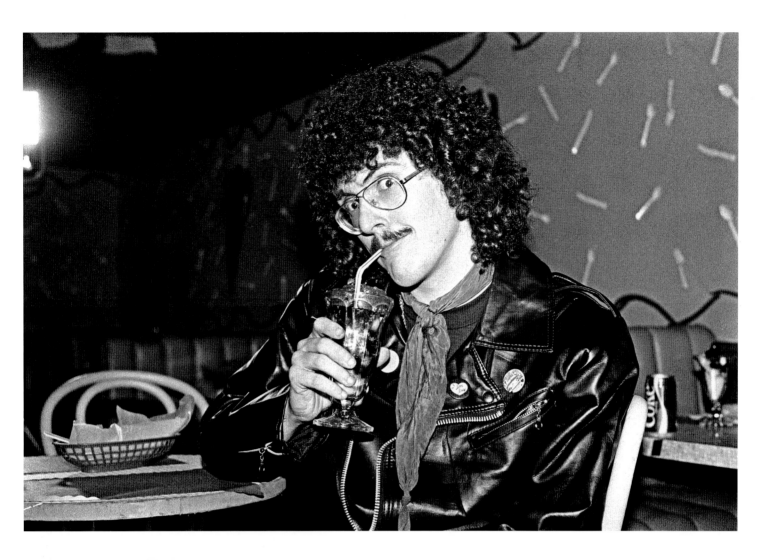

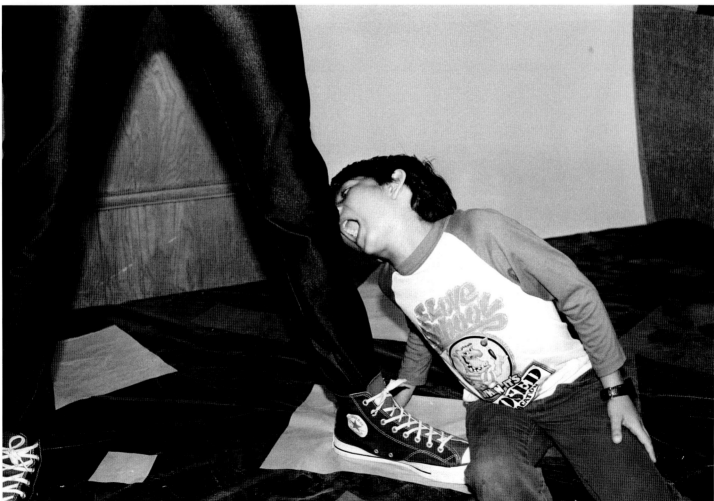

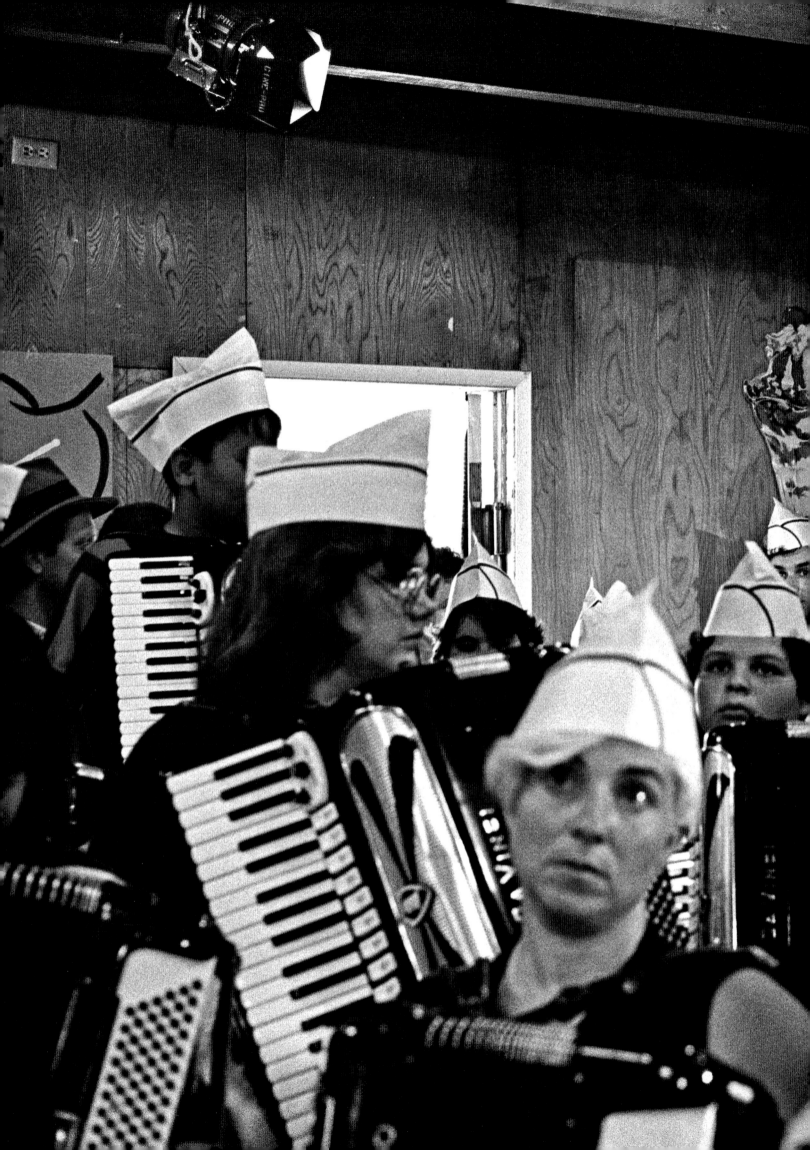

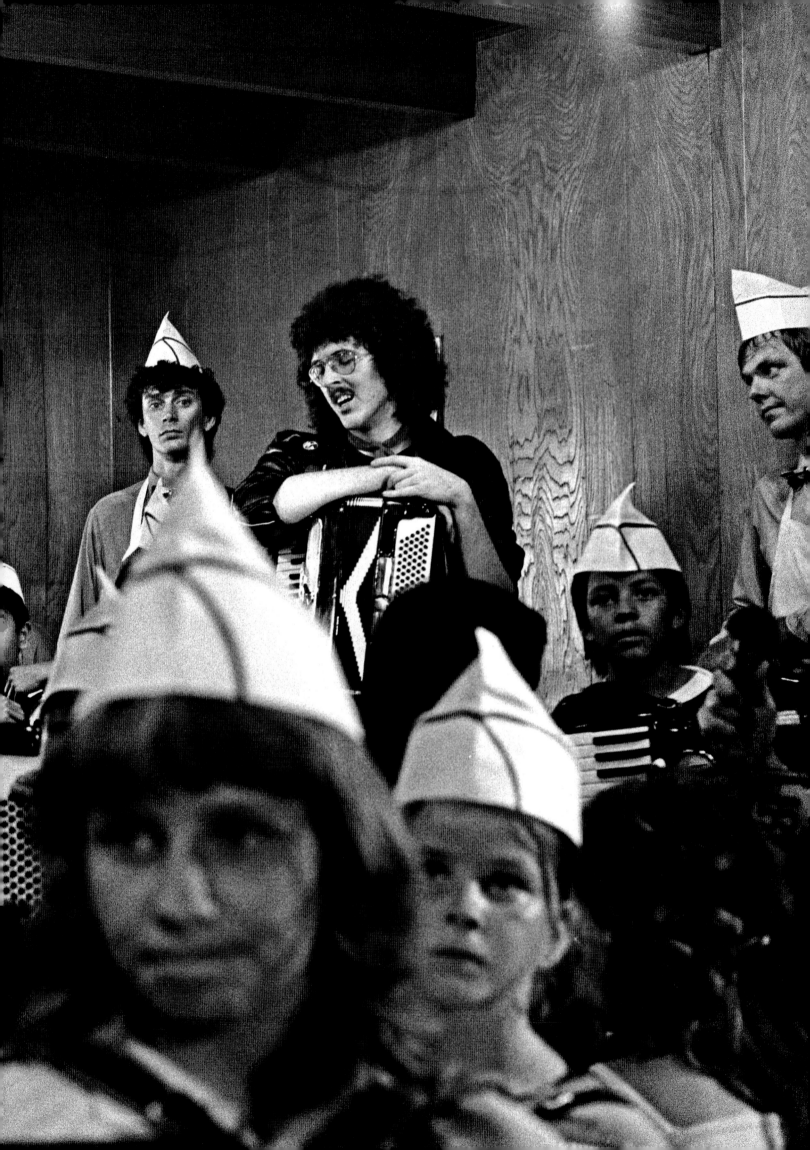

3

A GLIMPSE INTO THE RECORDING PROCESS: OVERDUBS

SANTA MONICA SOUND RECORDERS, SANTA MONICA, CA

This was the Scotti Brothers Records' in-house studio, where we recorded most of our tracks from 1983-1998. We recorded the basic tracks (drums, bass, guitar and probably a rough lead vocal) for "Buy Me a Condo," "Midnight Star," "Mr. Popeil," "Nature Trail to Hell" and "That Boy Could Dance" on October 1st. Over the following few days, additional parts and vocals were added by Pat Regan on keys, Jimmy "Z" Zavala on sax, and singers Lisa Popeil, Petsye Powell, Andrea Robinson and Pattie Brooks. Jim West came back to add some guitars to "Nature Trail" and by the last day, Al had finished his vocals.

Our producer Rick Derringer is seen being pensive and animated, though rarely at the same time. And longtime recording engineer Tony Papa seldom gets seen, so I hereby right that wrong with a shot of him. (Hint: he's the guy sitting at that big console with all the knobs and buttons and stuff.)

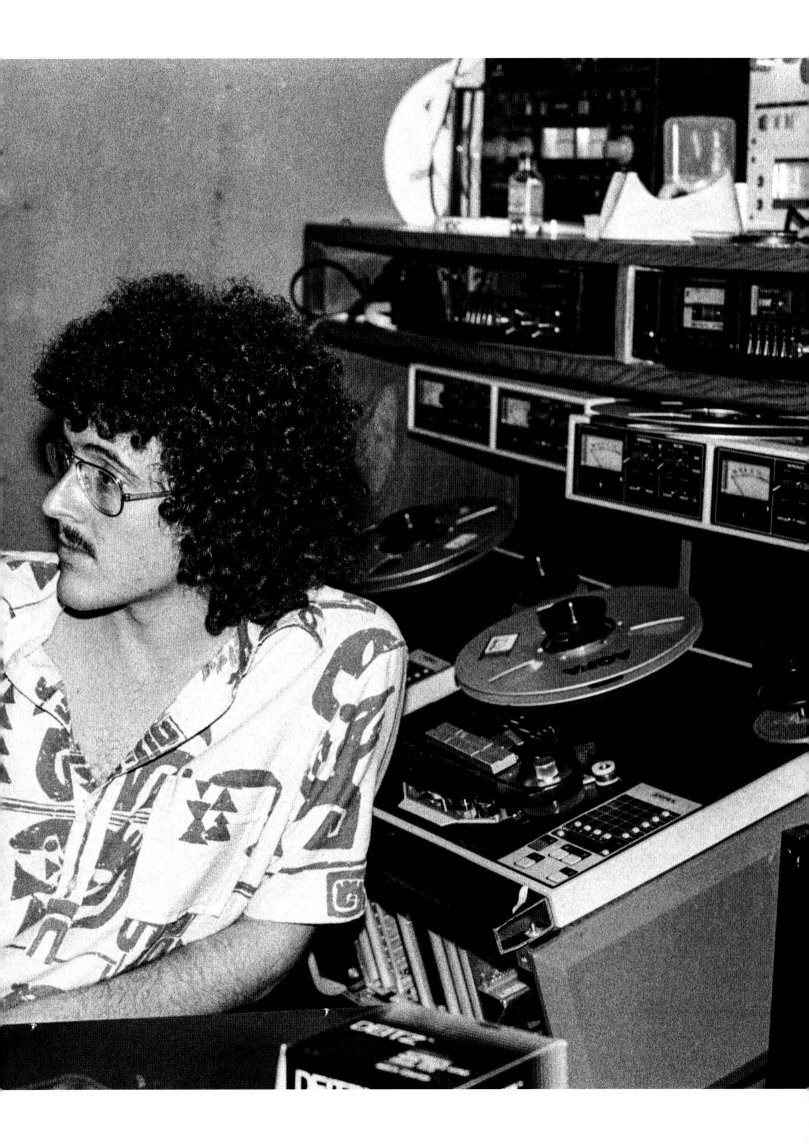

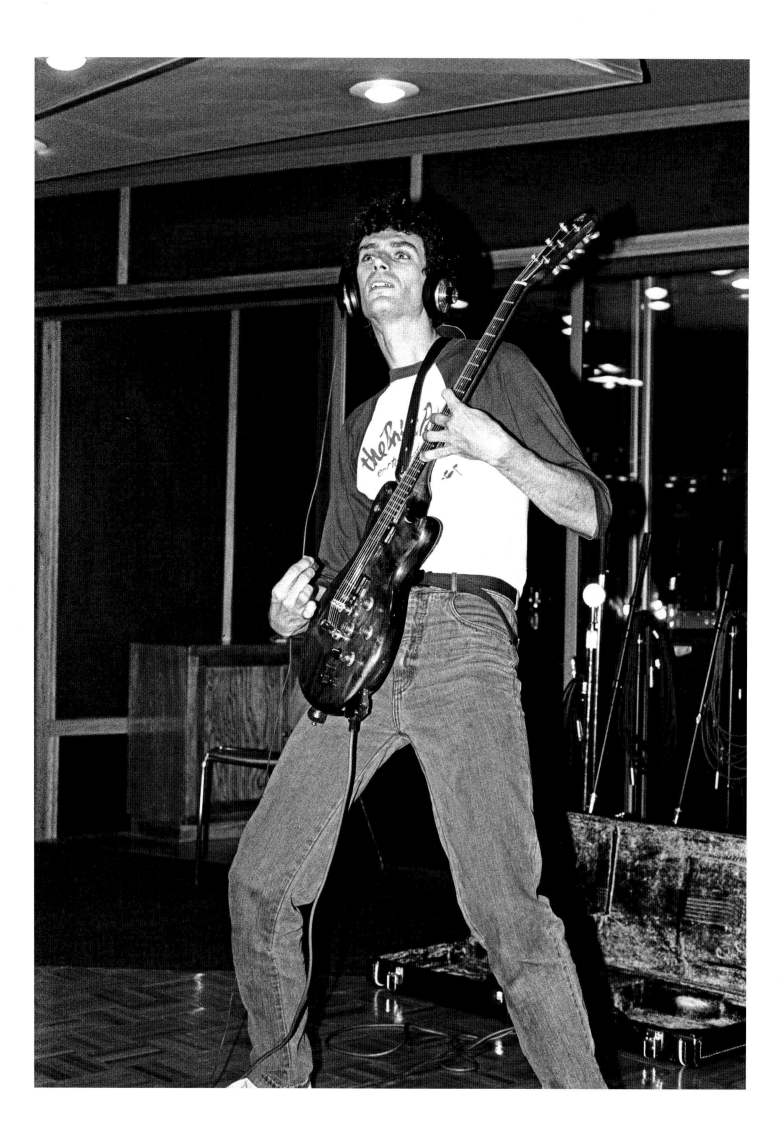

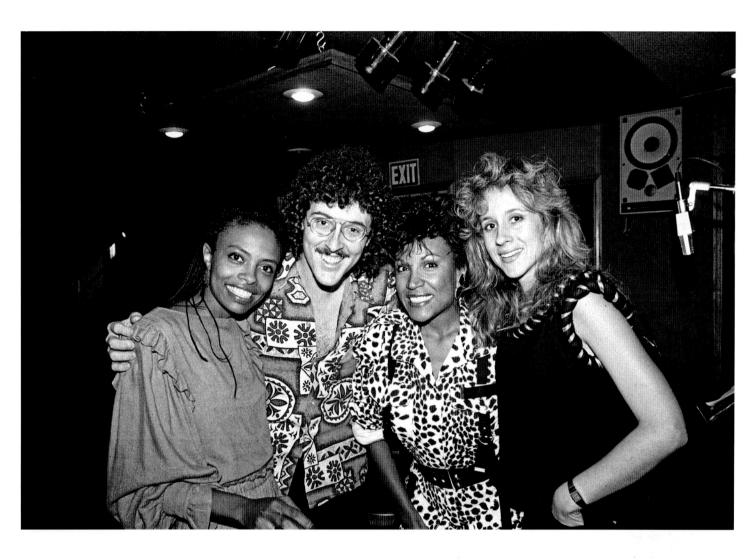

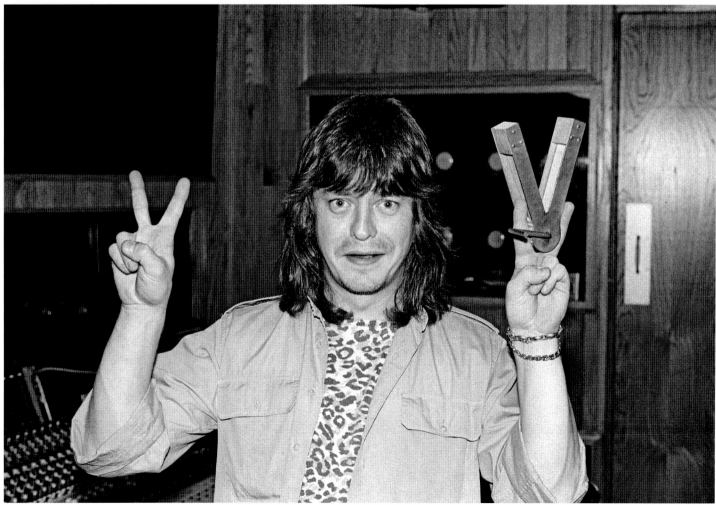

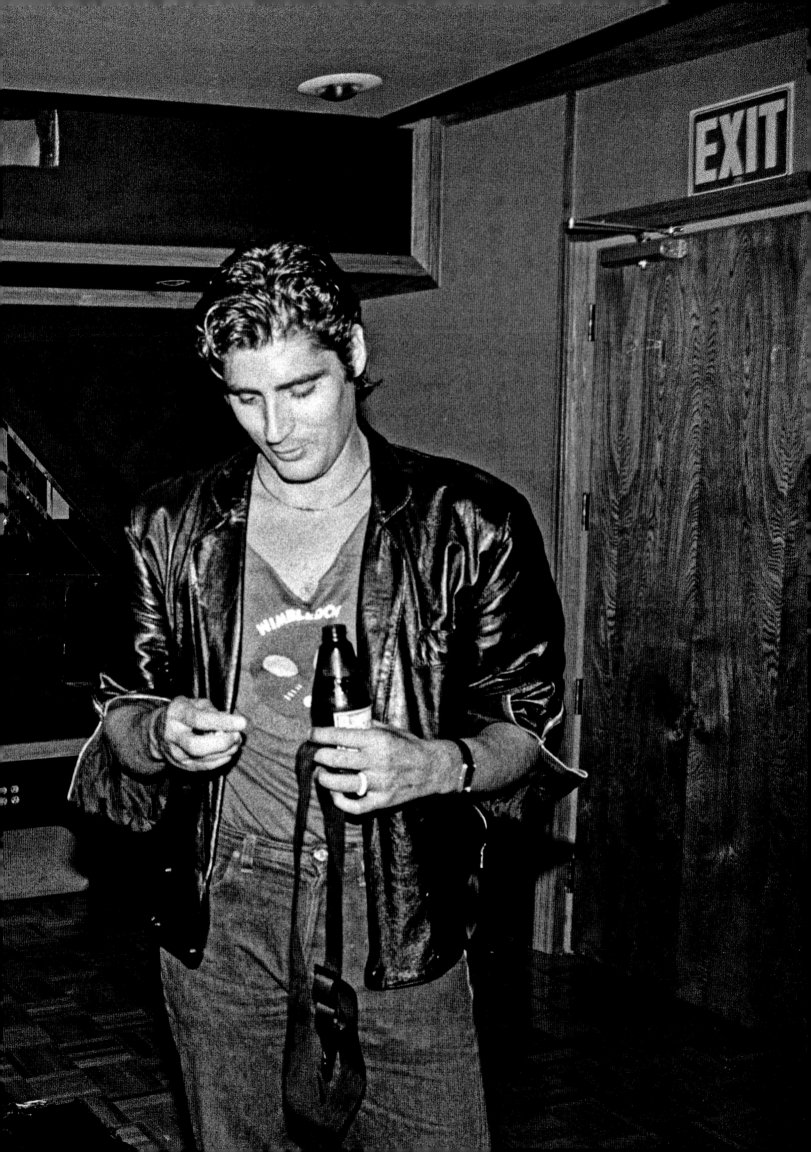

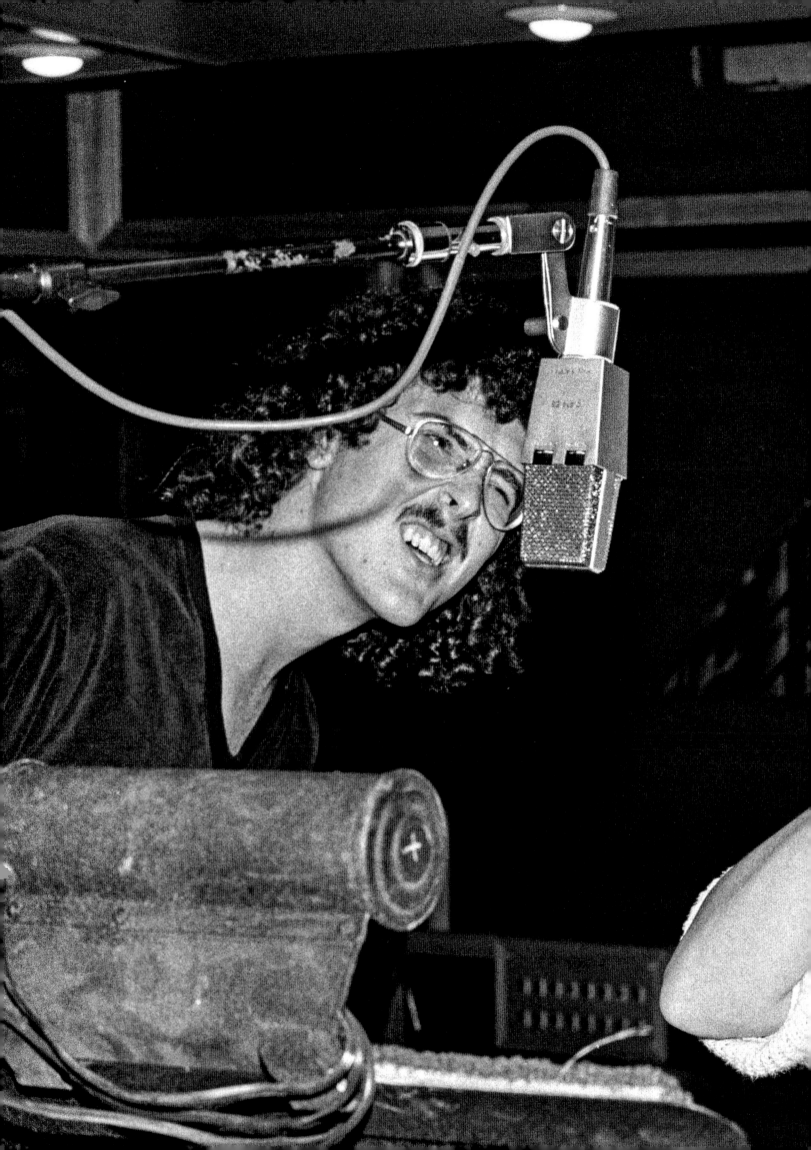

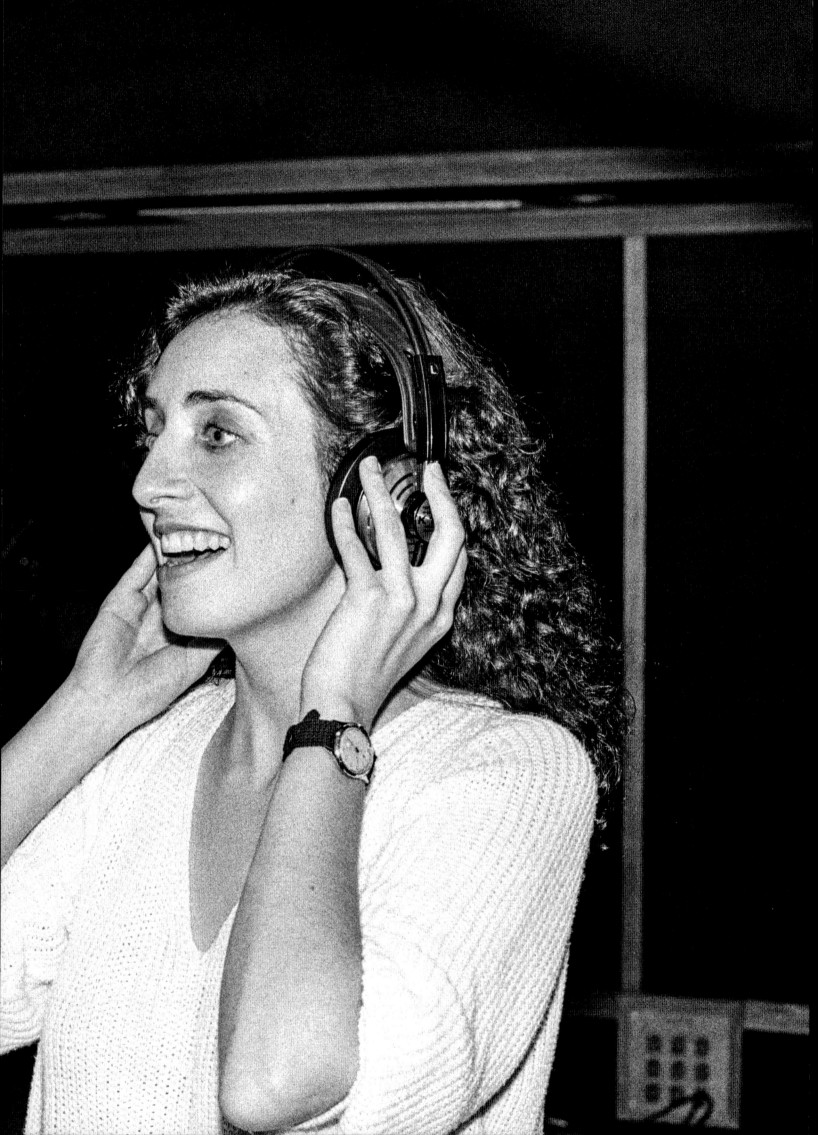

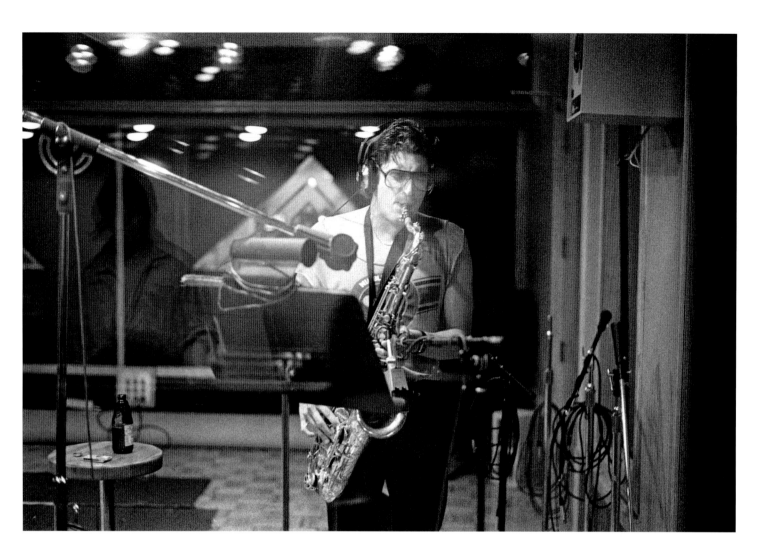

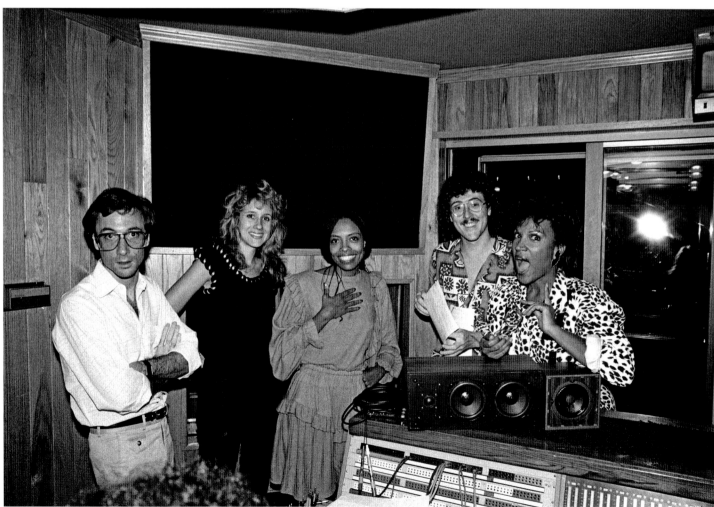

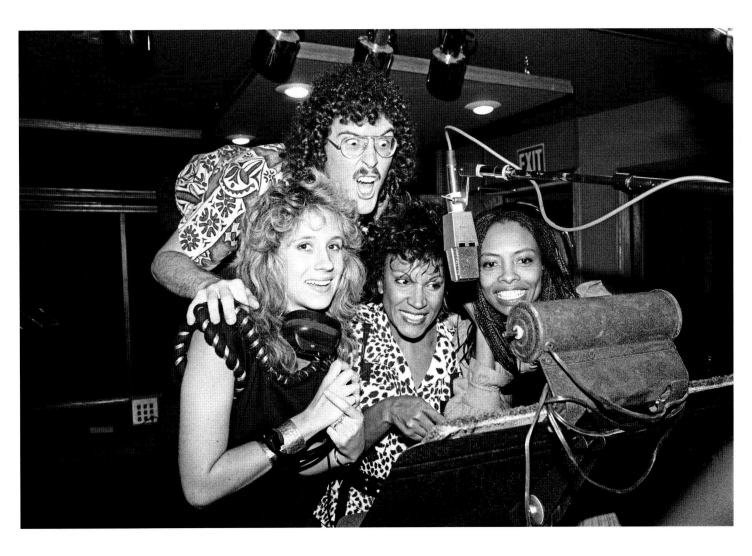

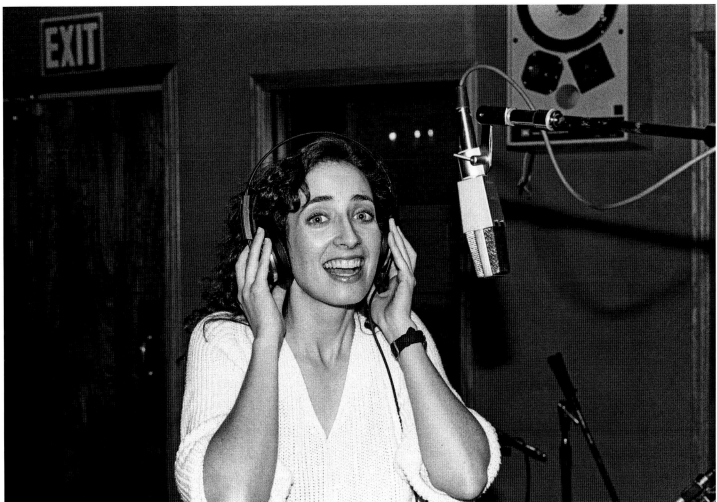

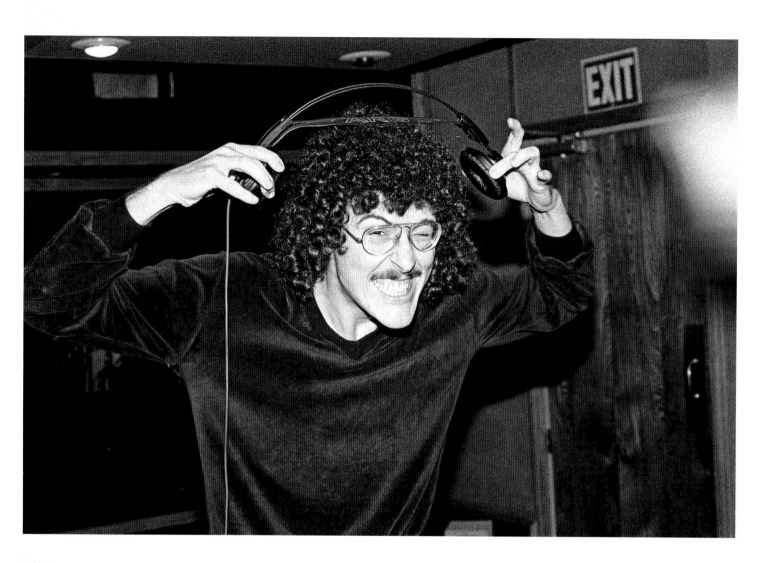

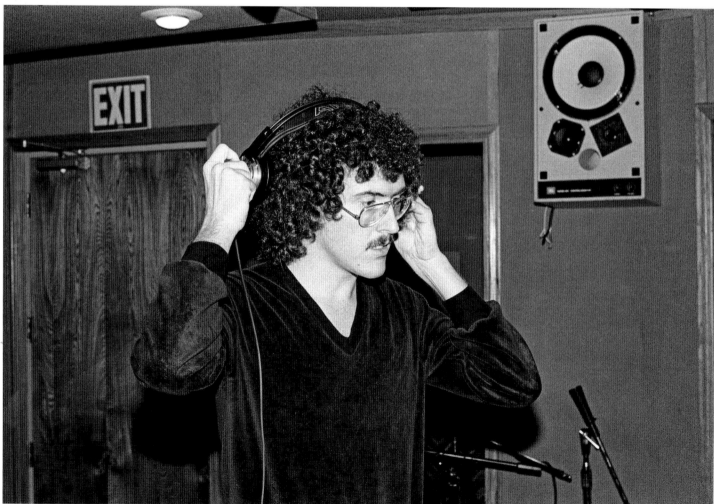

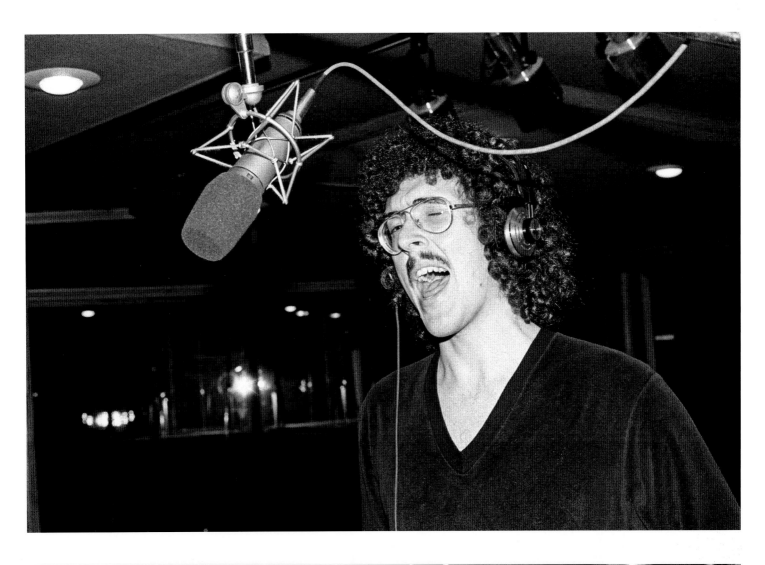
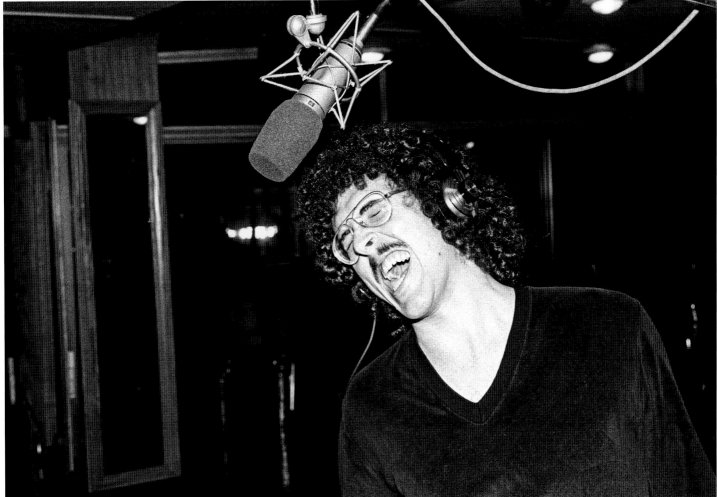

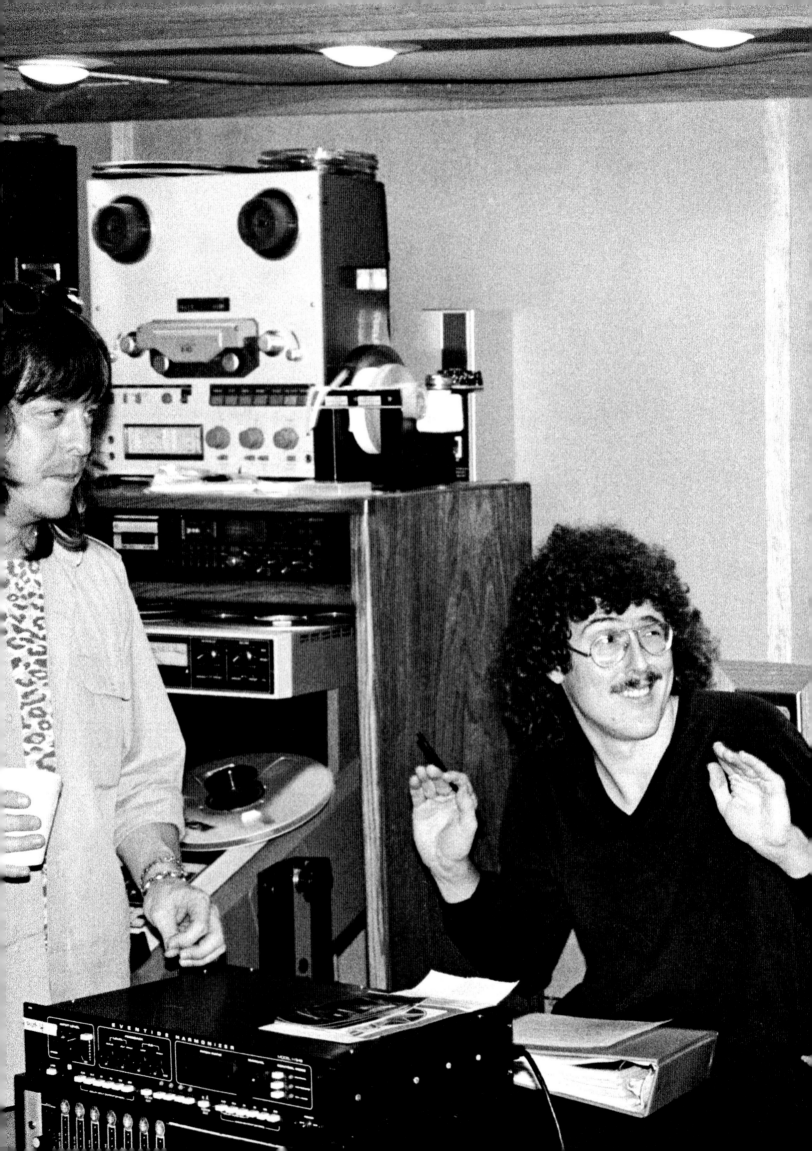

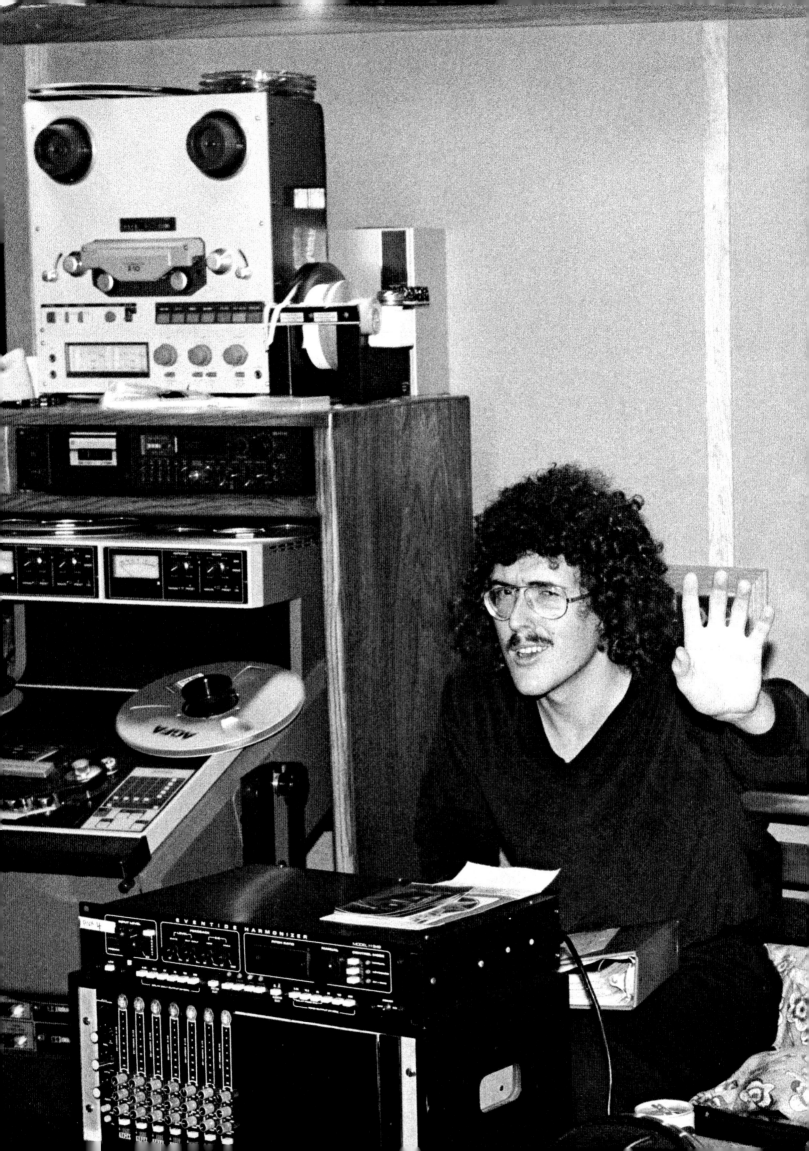

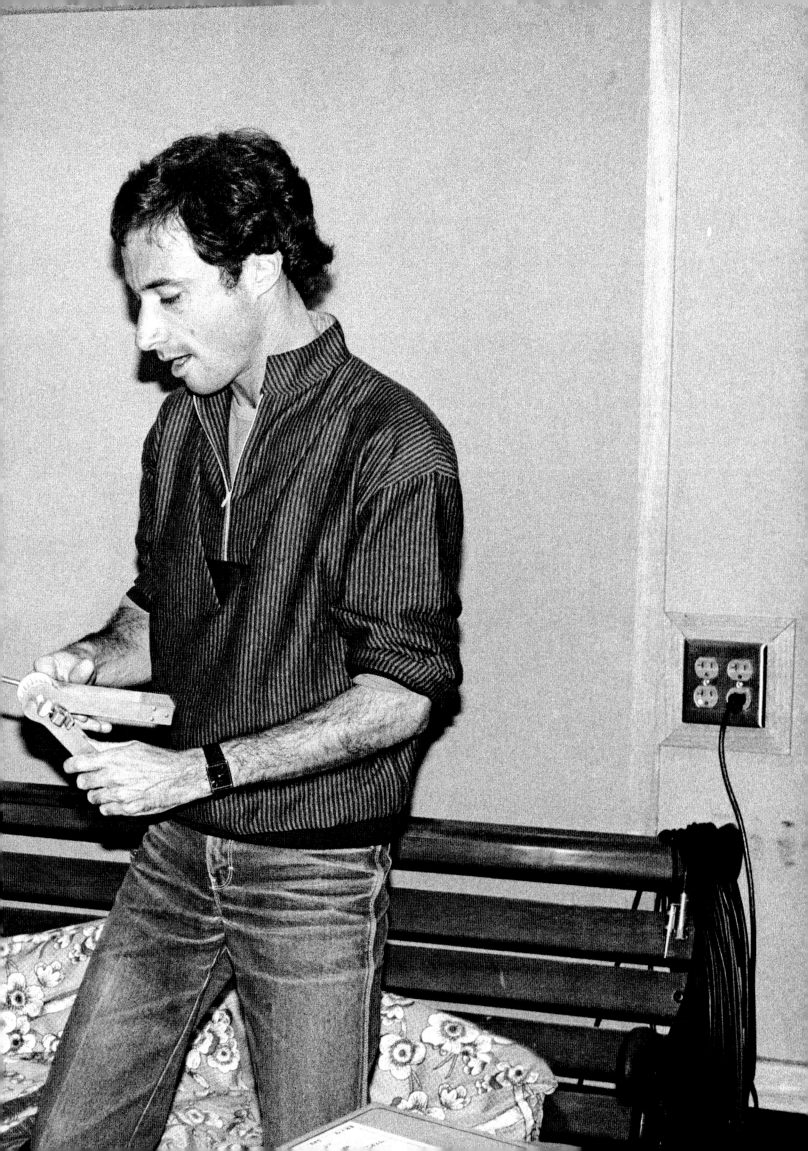

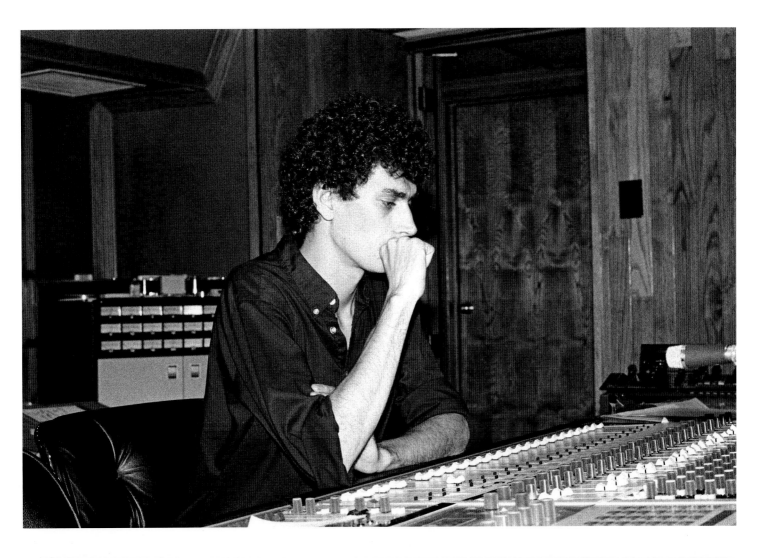

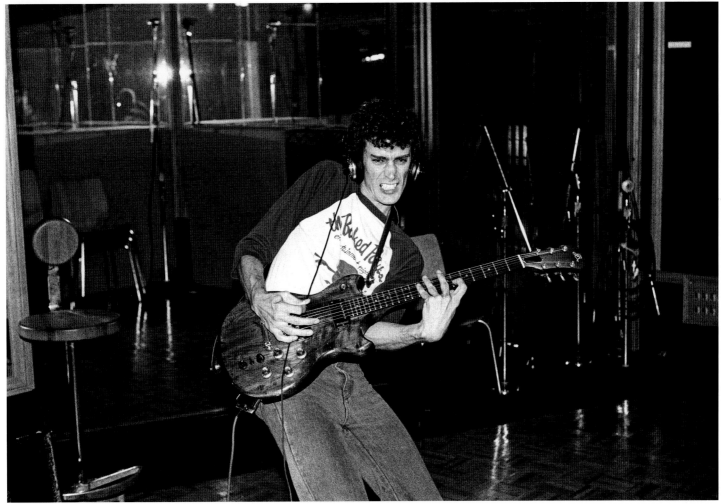

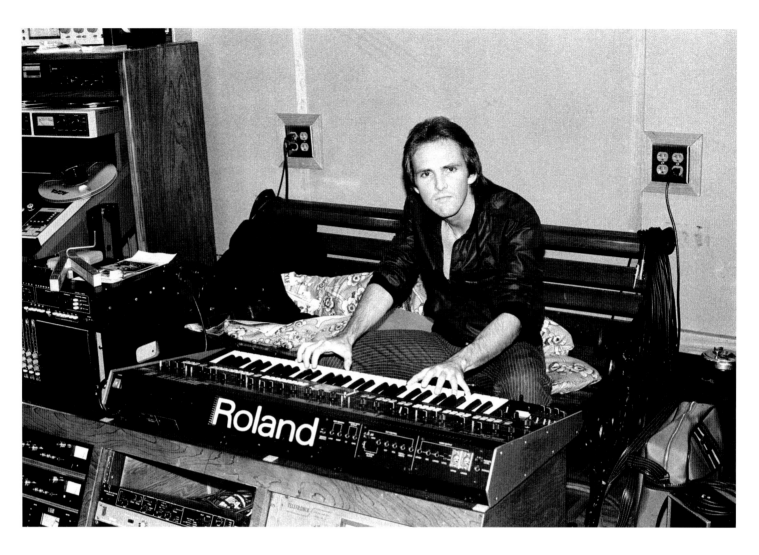

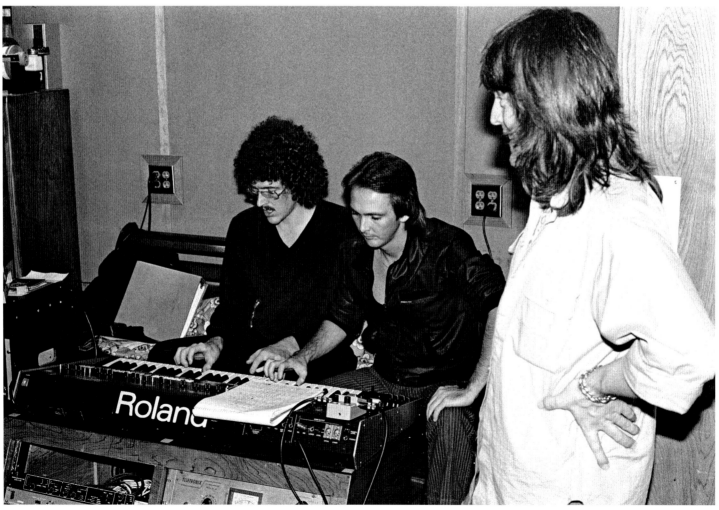

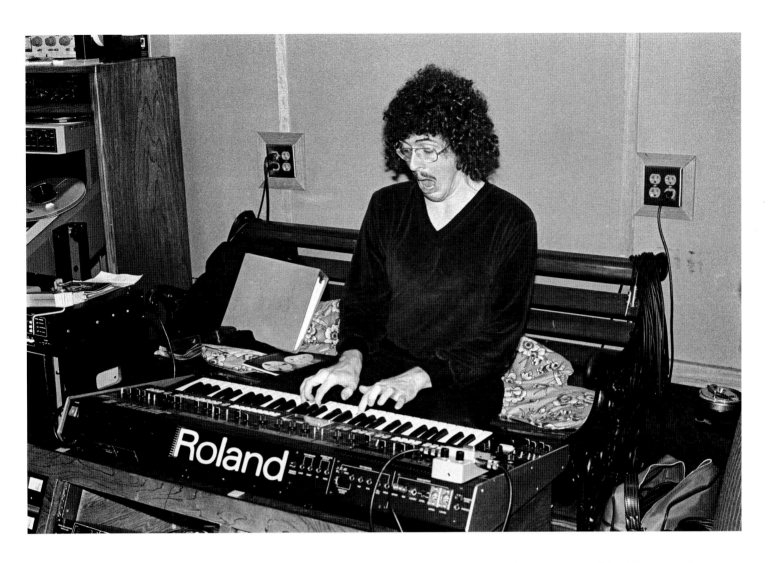

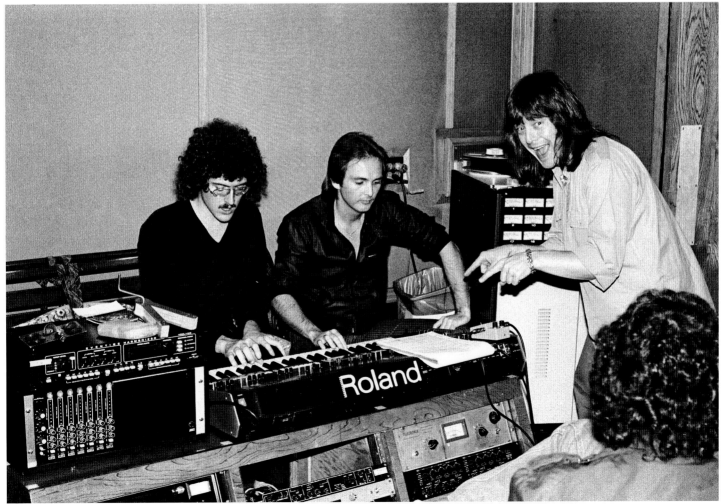

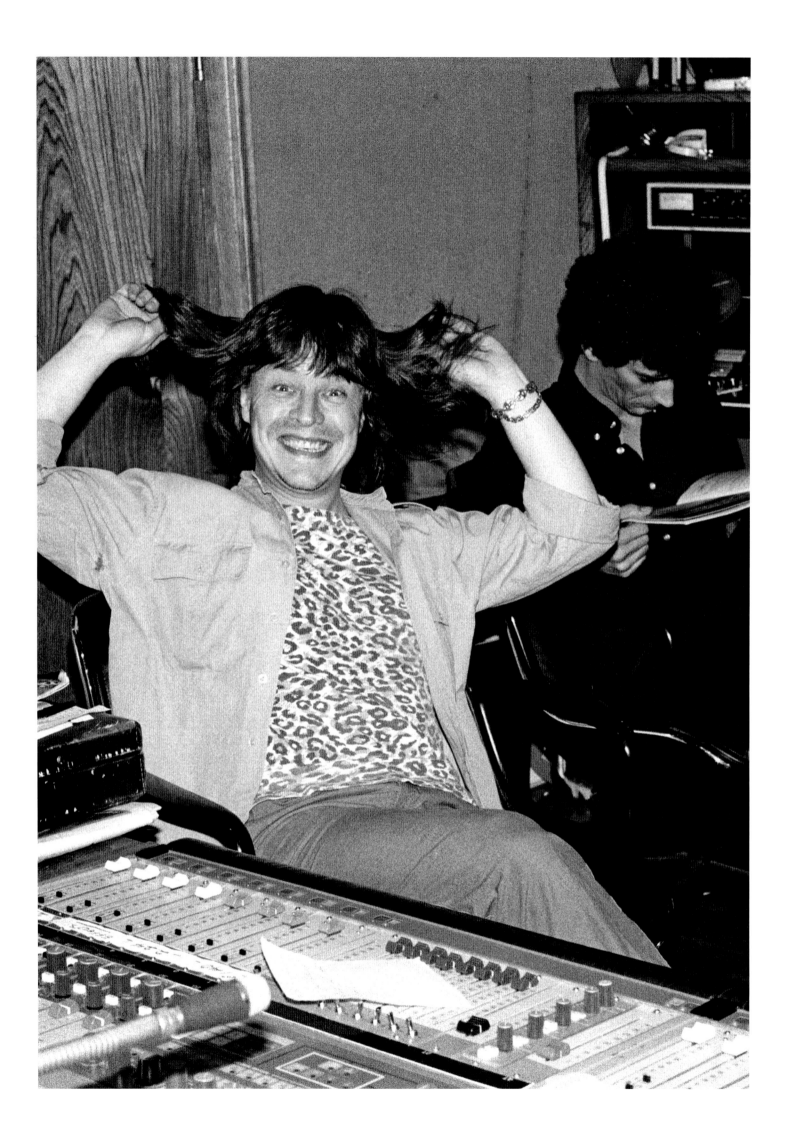

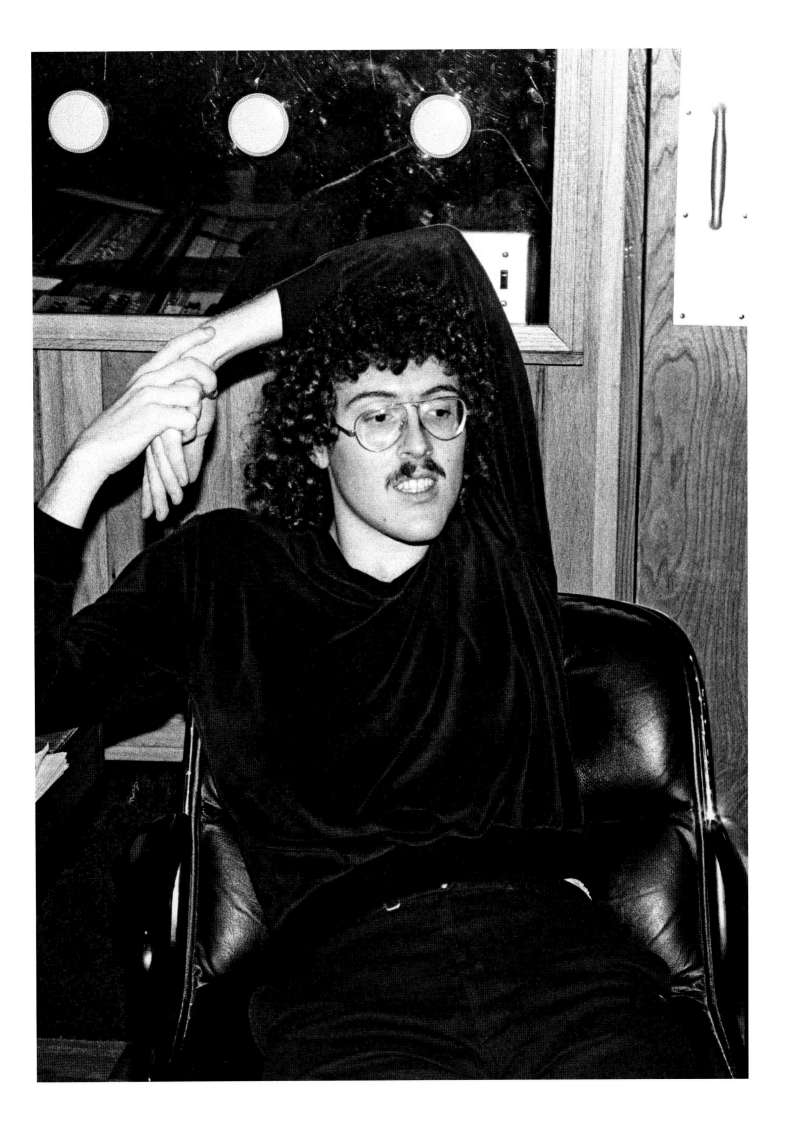

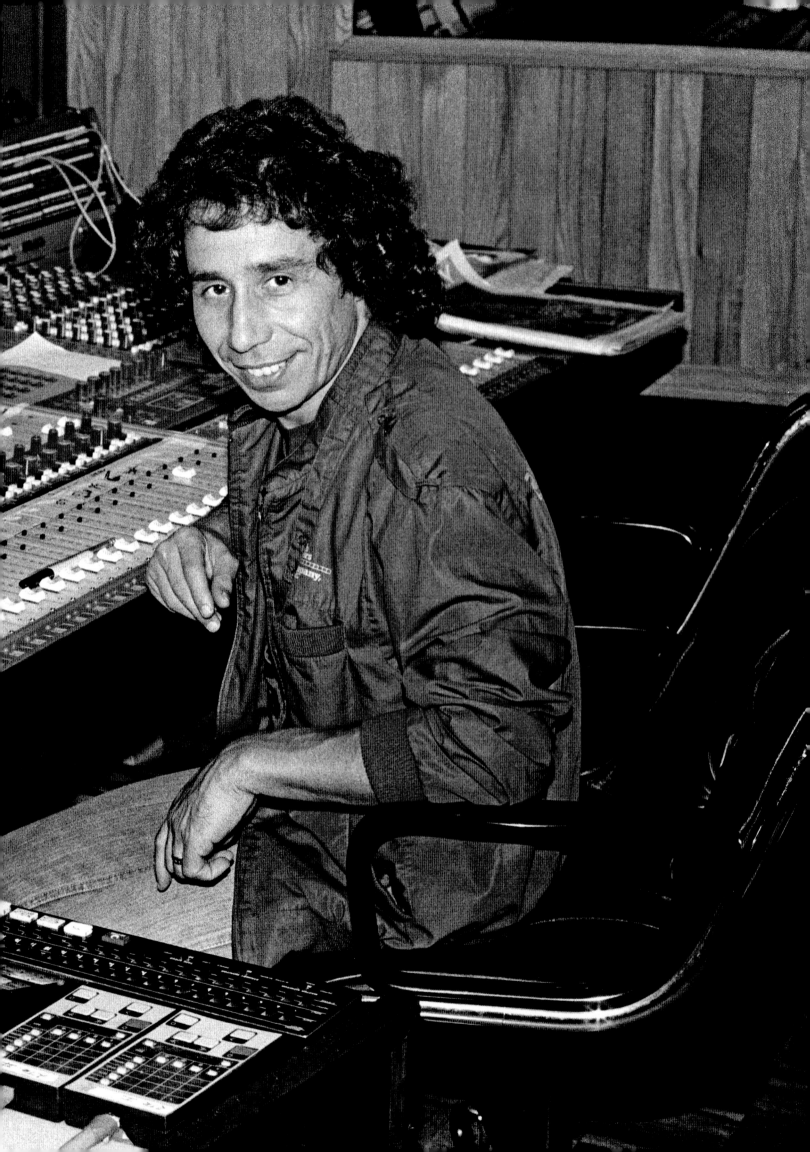

4

EAT IT
VIDEO
SHOOT

S&A STUDIOS. STAGE 2,
LOS ANGELES. CA

Al's manager Jay Levey made his directing debut with "Eat It" and would go on to direct Al's videos through "You Don't Love Me Anymore" as well as directing and co-writing *UHF* and the mockumentary *The Compleat Al*. This was also Al's first video shot on film as opposed to videotape.

Steve, Jim and I were included among the extras – thankfully not as dancers! It was cool to have Michael Jackson video alumnus Vincent Paterson reprise his role as a gang leader from the "Beat It" video, with a dancer named Juba (apologies for not recalling his last name, either) as the rival gang leader. The dancing was taken mostly from the Michael Peters choreography in the MJ video, adapted and staged by Eddie Baytos who says Al's video "was one of my all-time favorite jobs."

Sometimes we get to keep props or even some wardrobe from the videos. In the case of a key prop from "Eat It," Paterson admits "I still have the rubber chicken."

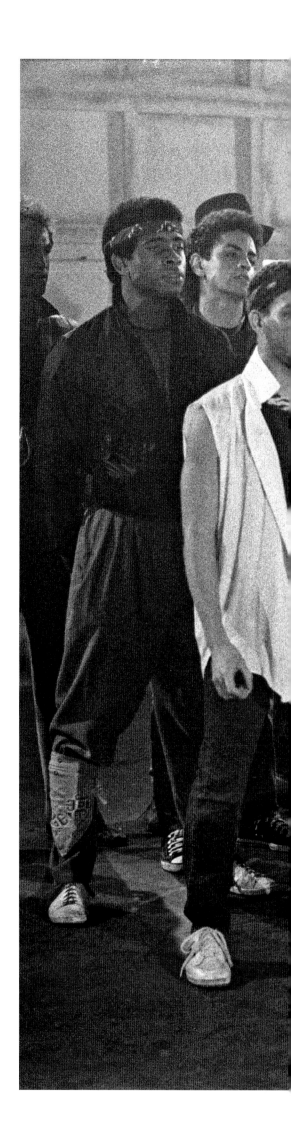

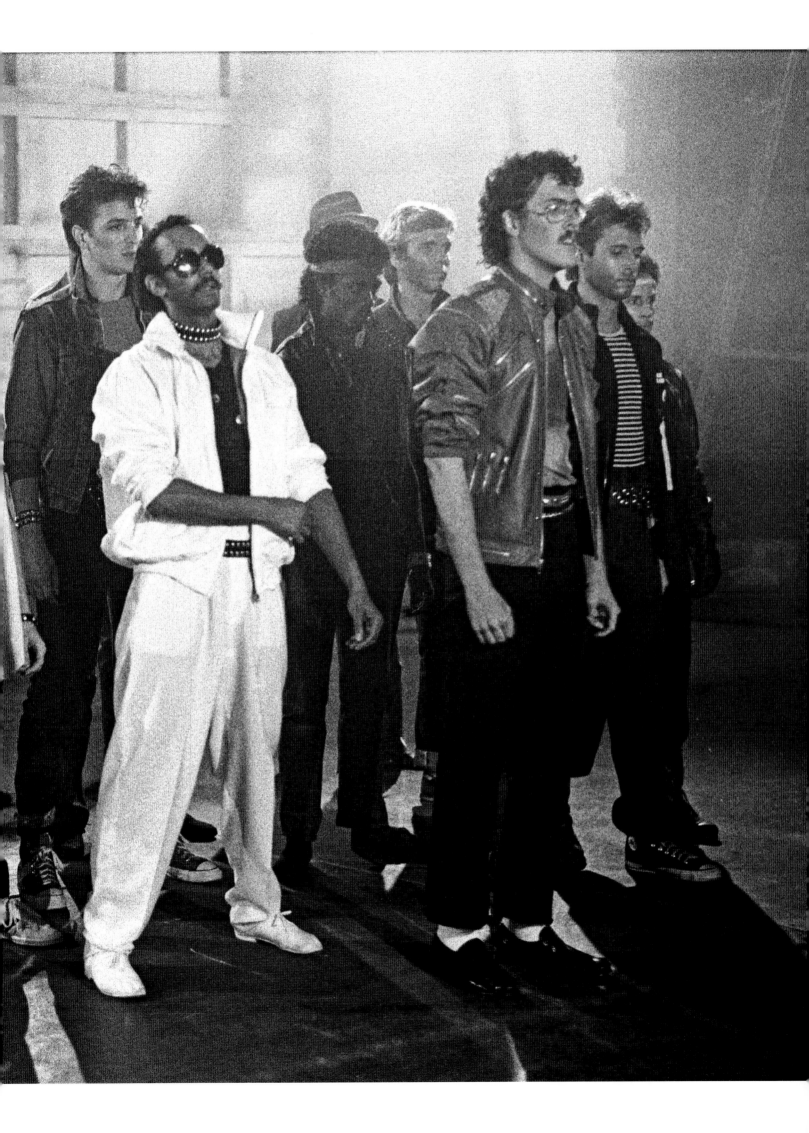

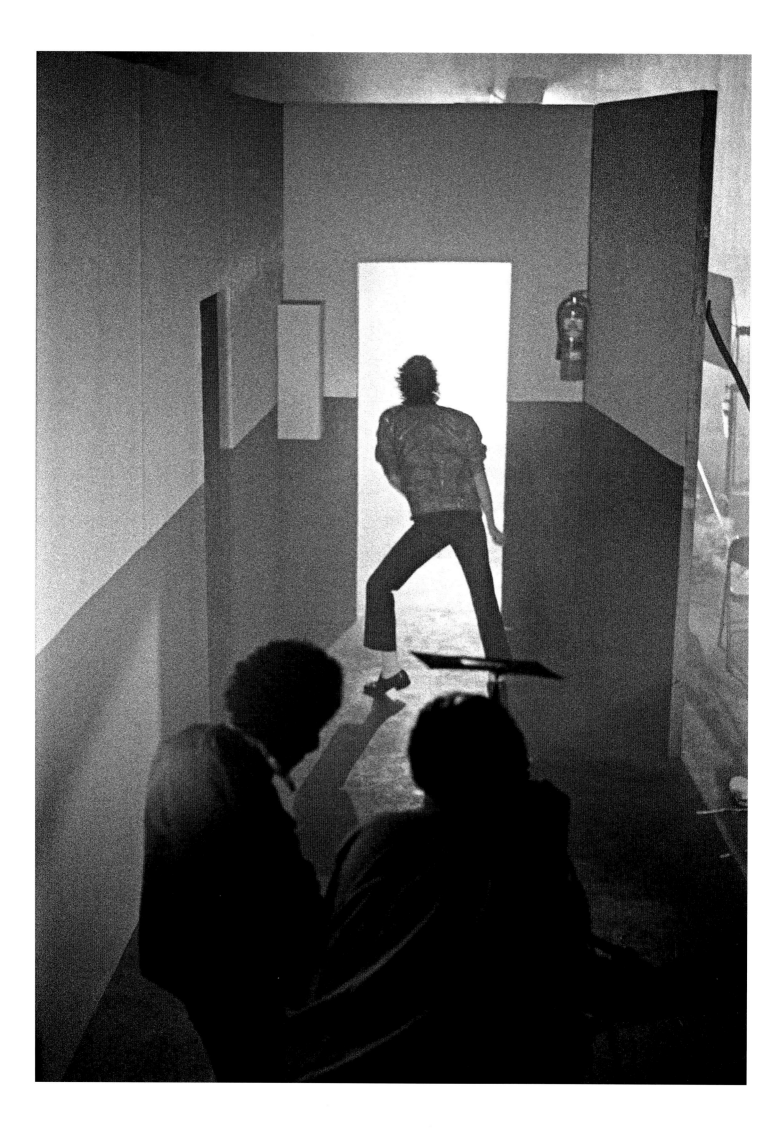

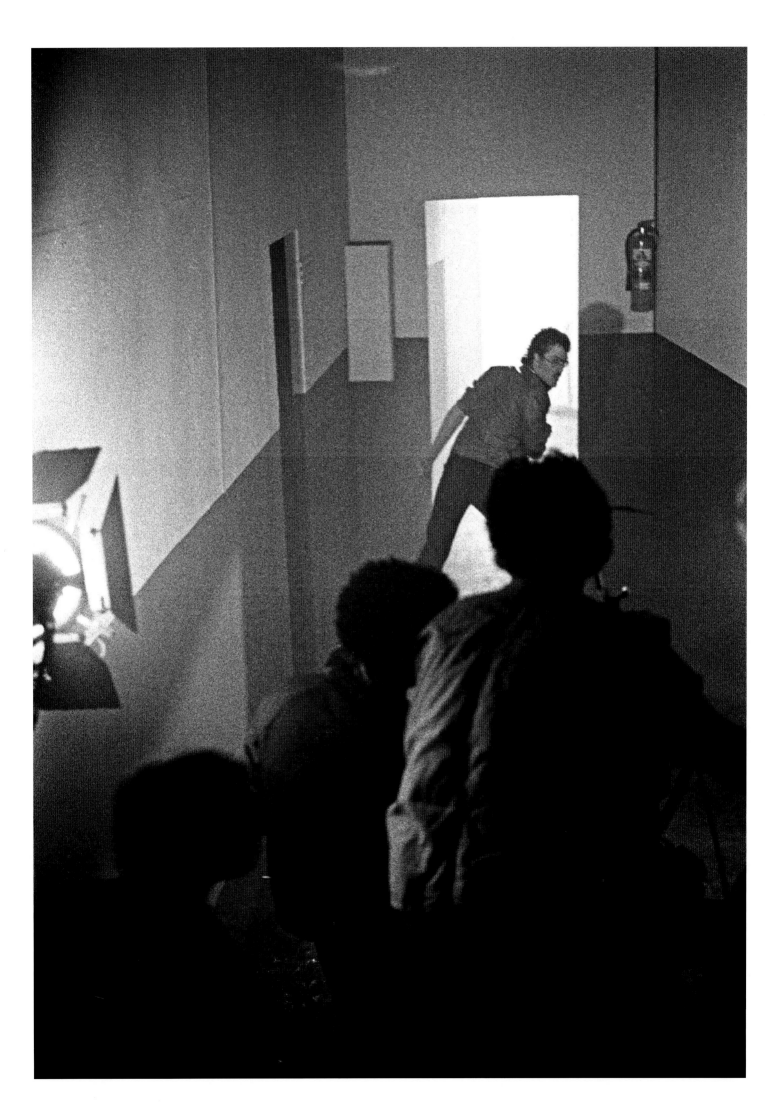

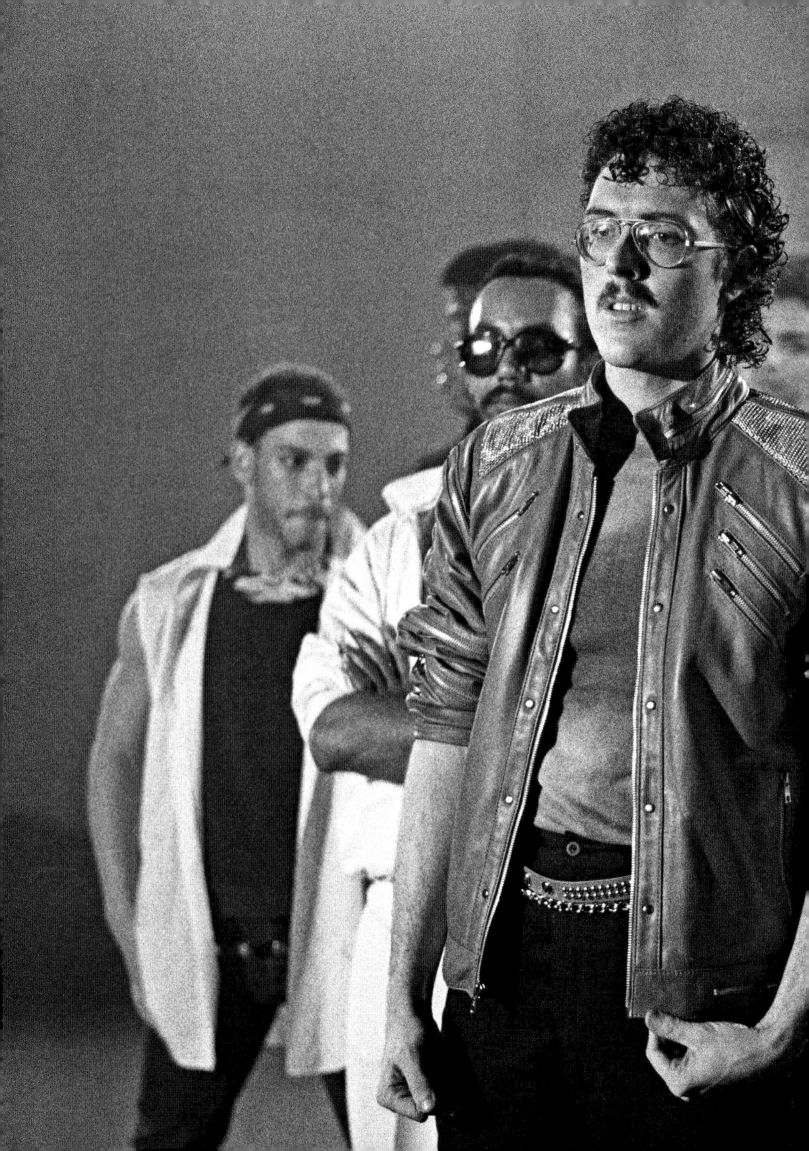

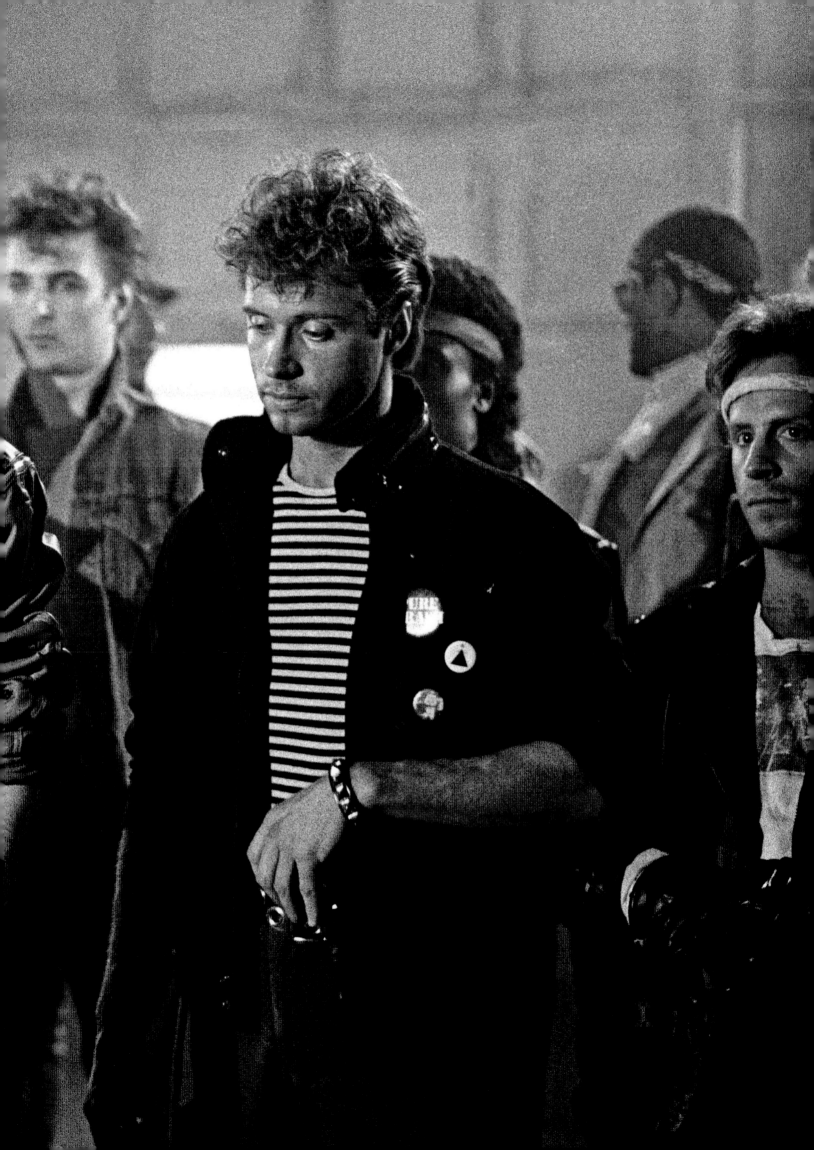

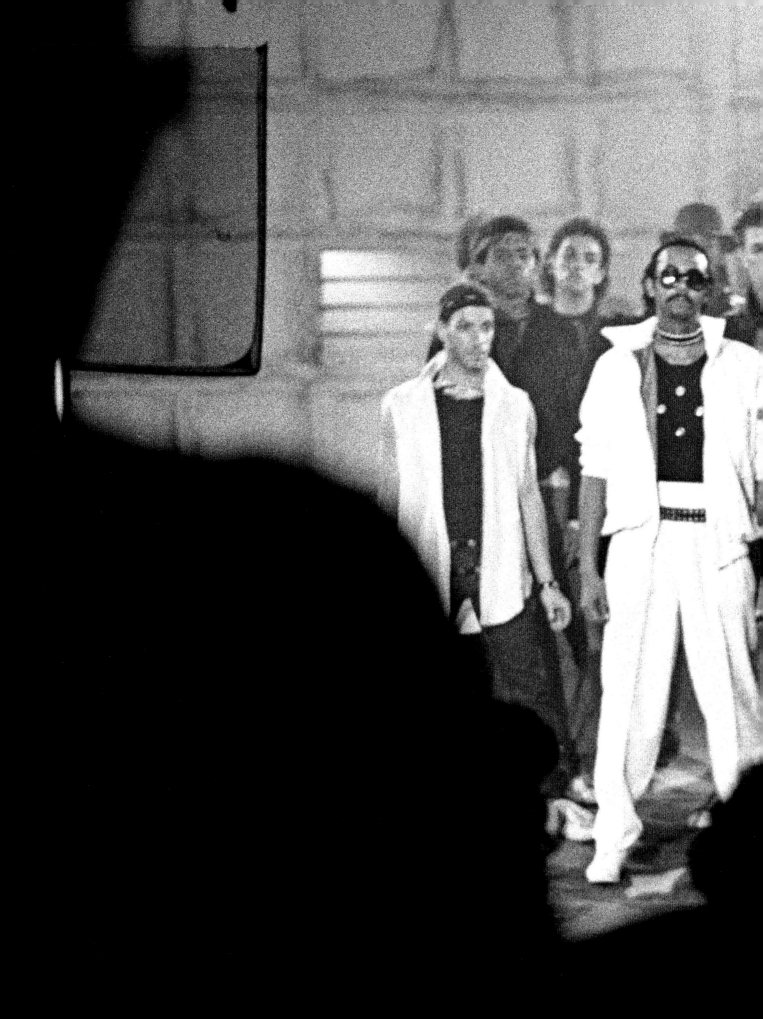

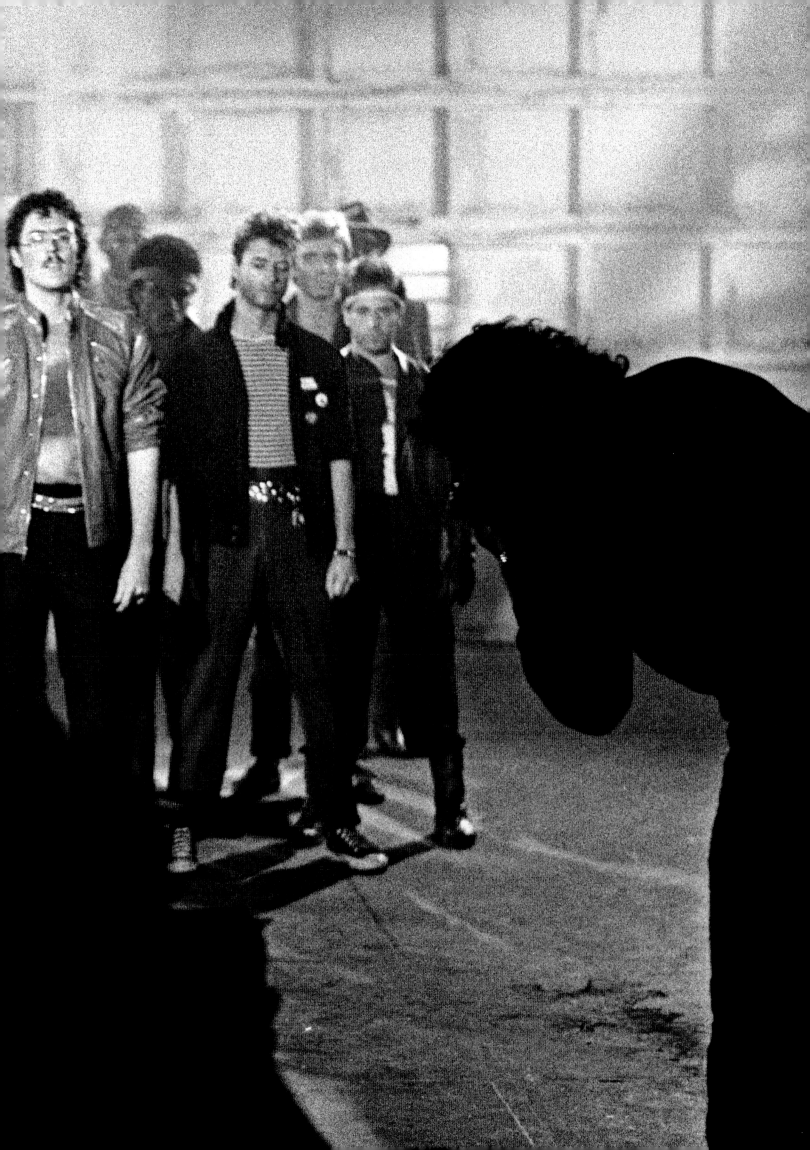

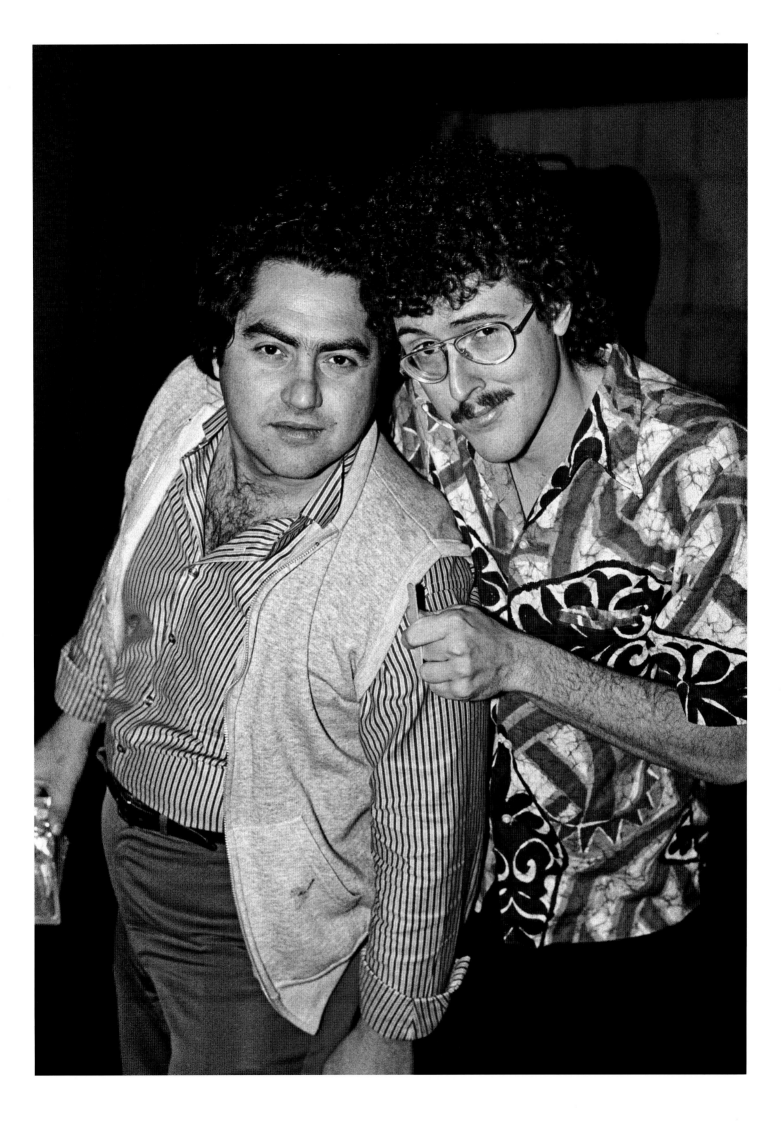

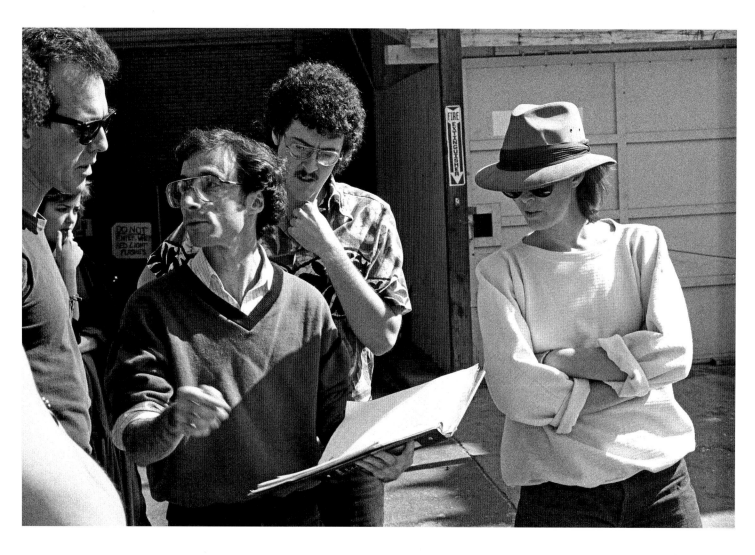

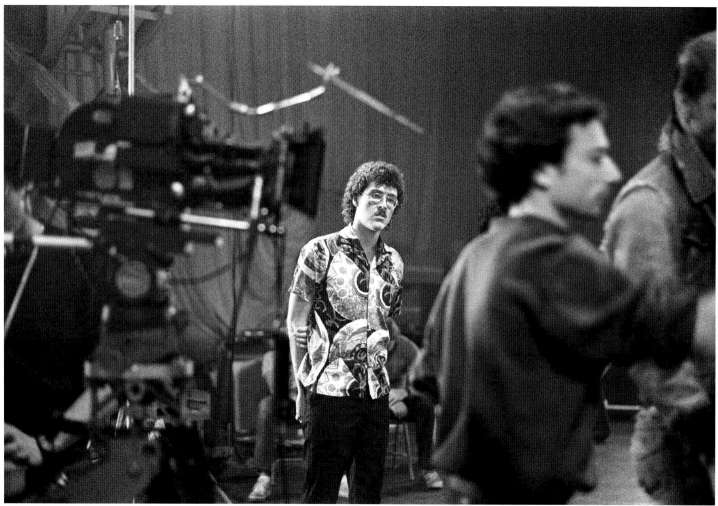

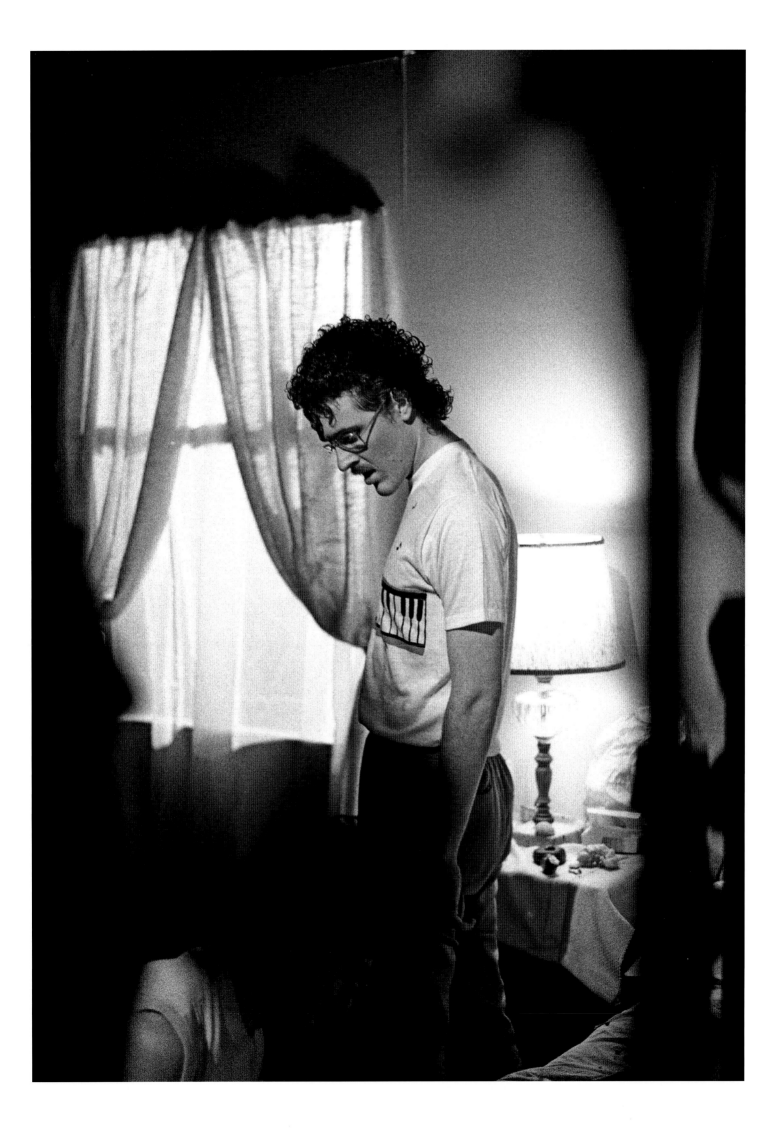

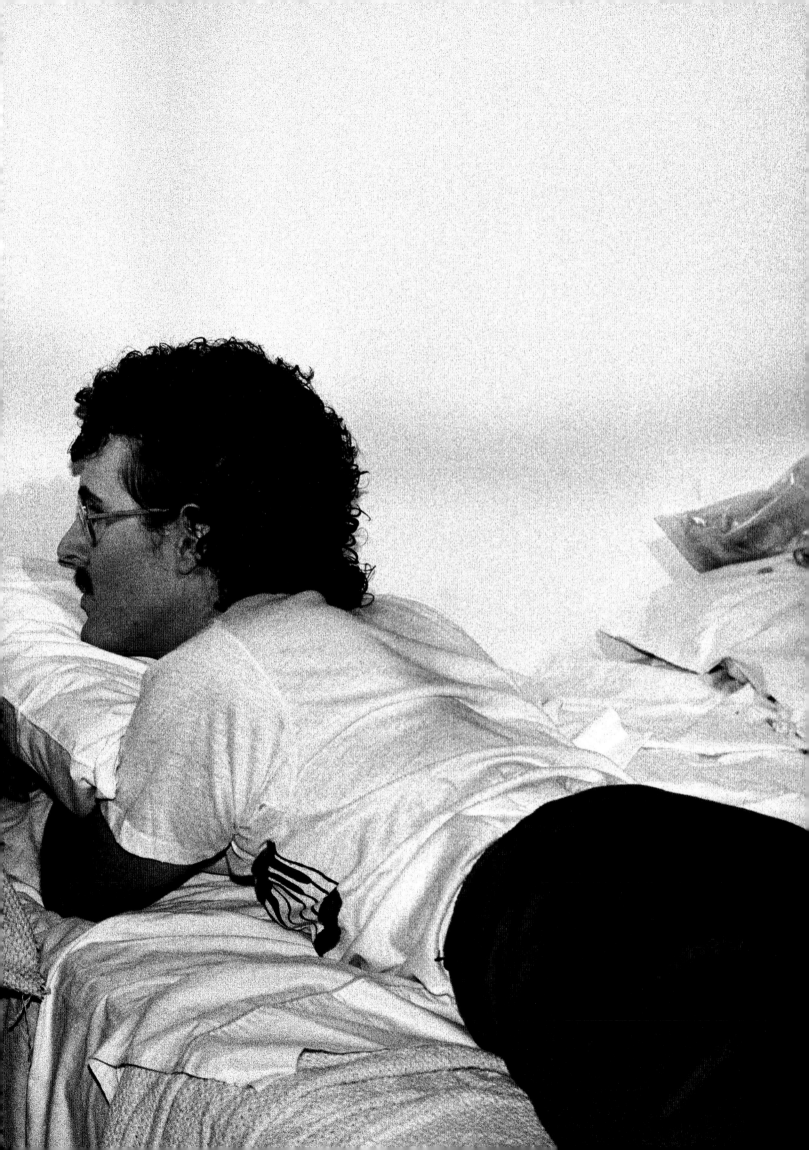

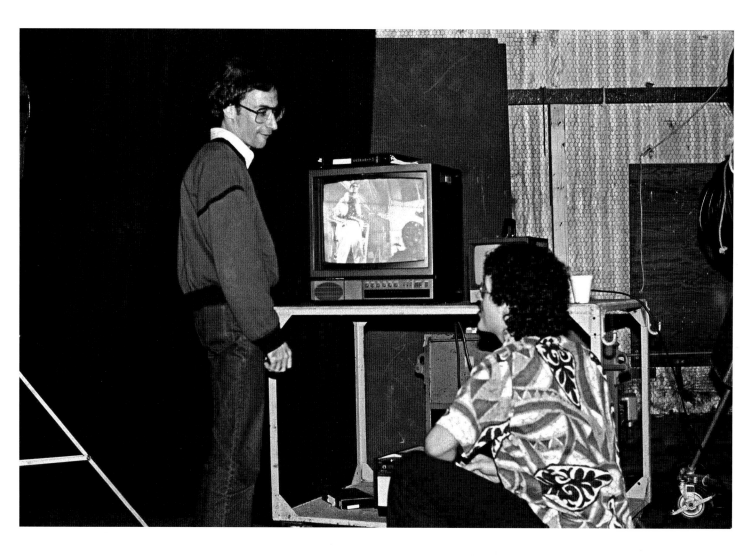

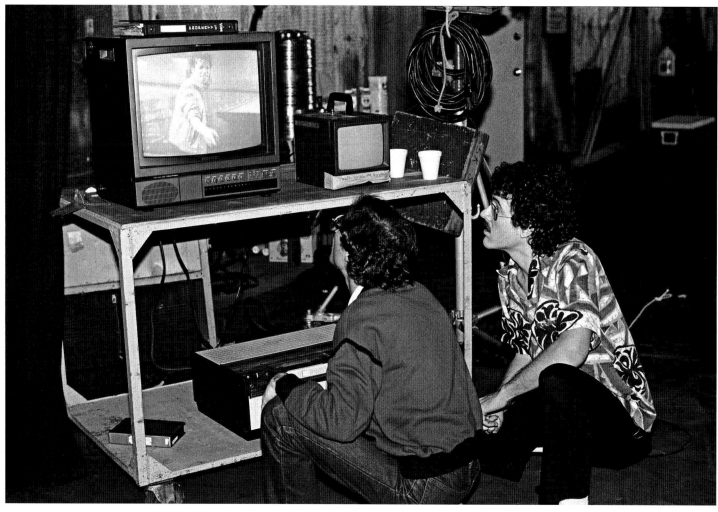

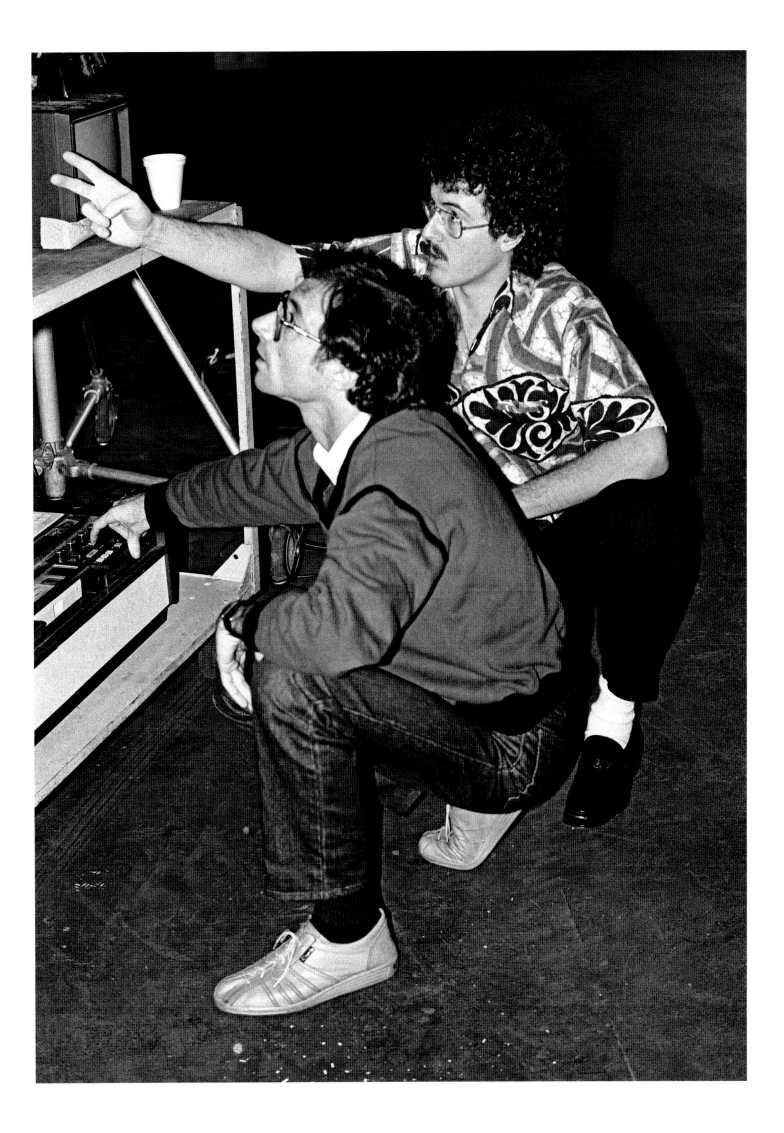

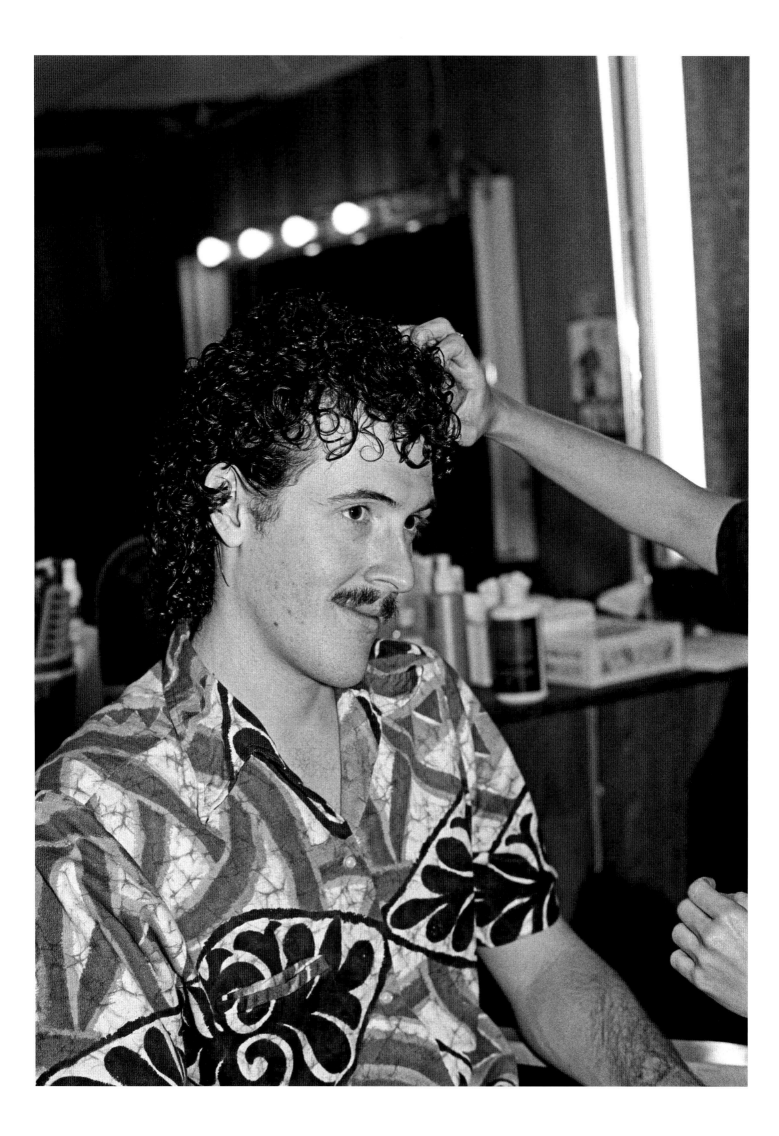

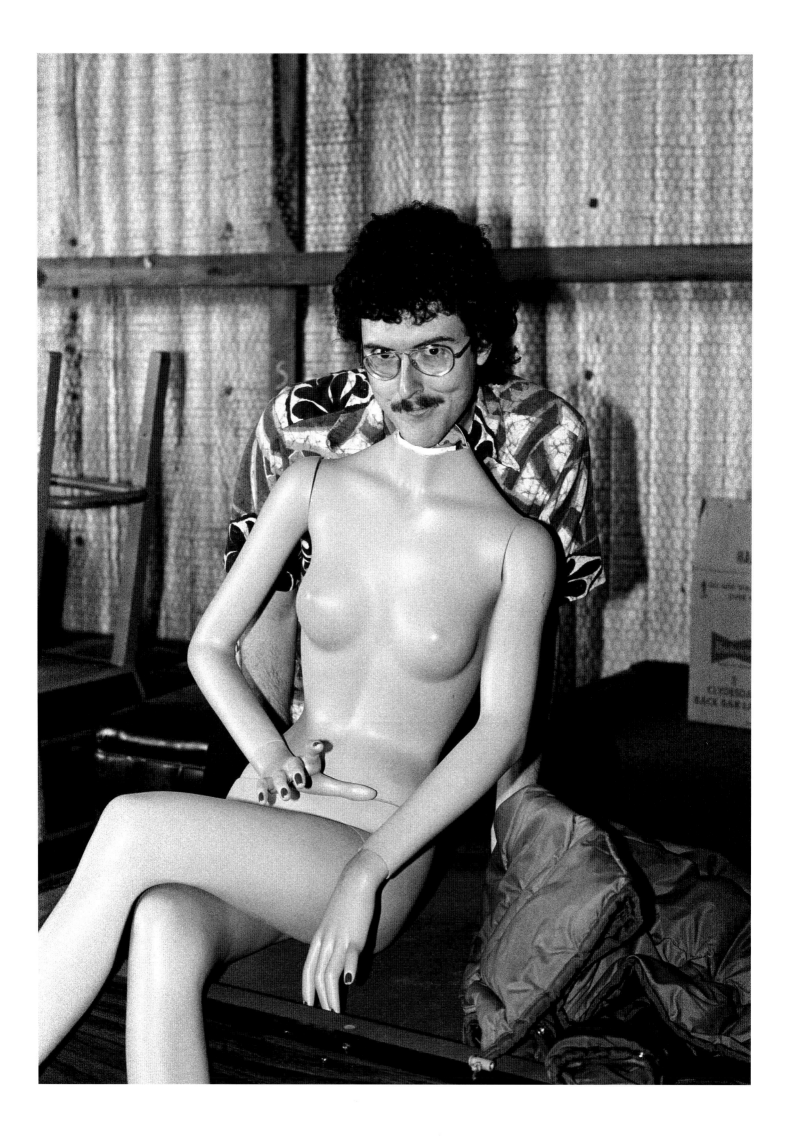

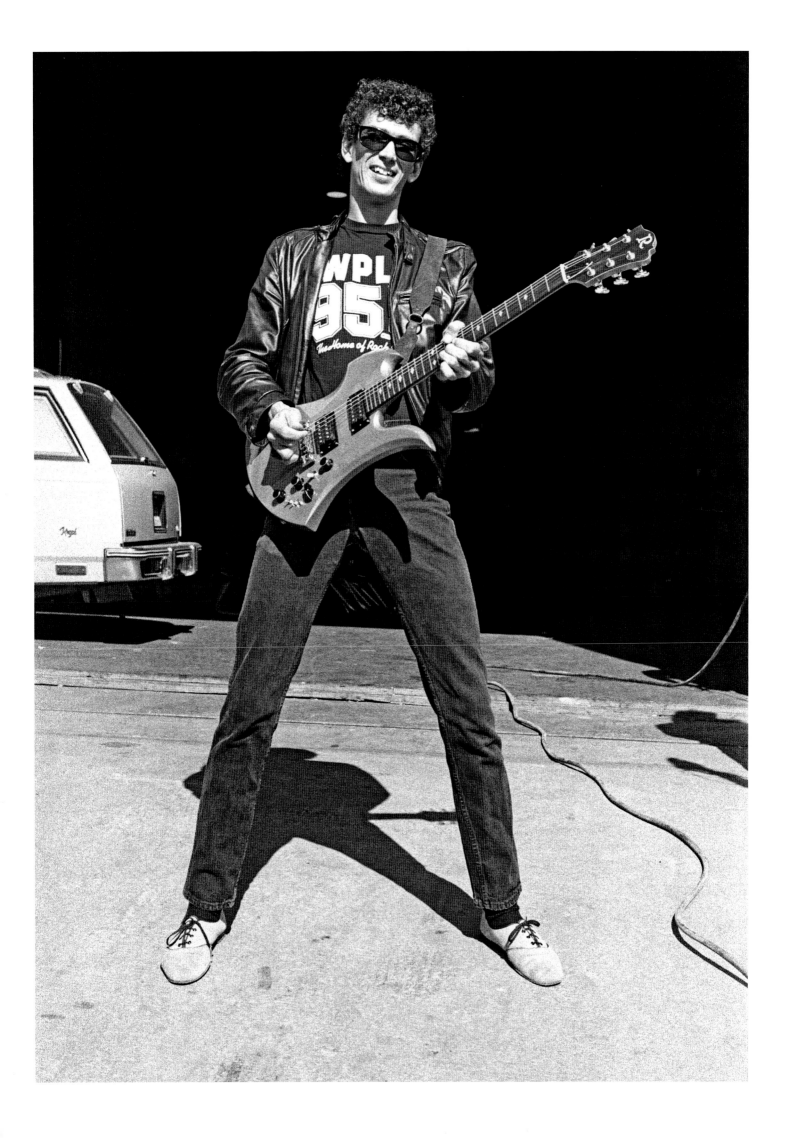

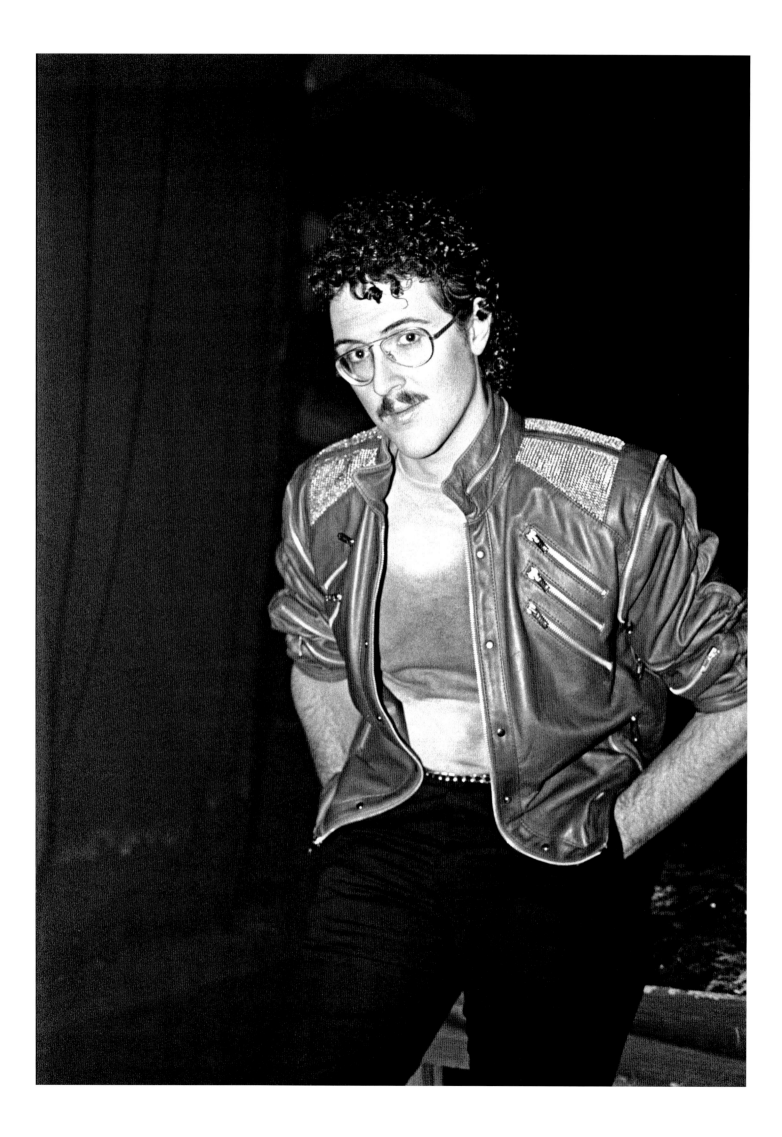

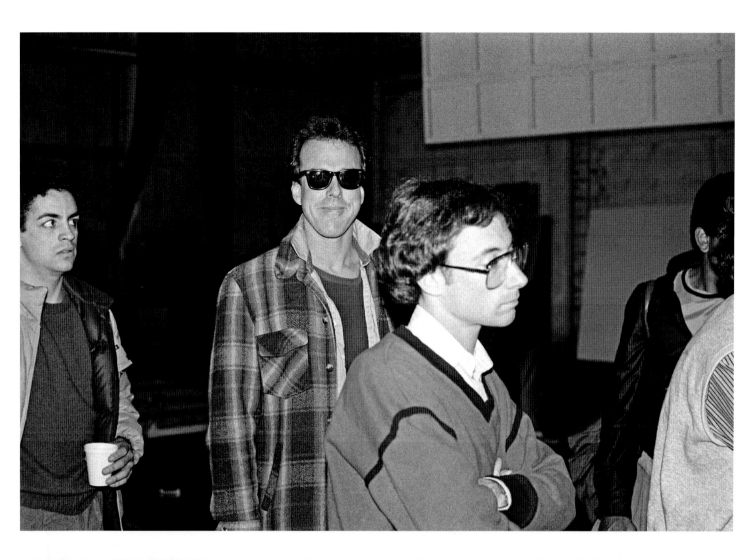

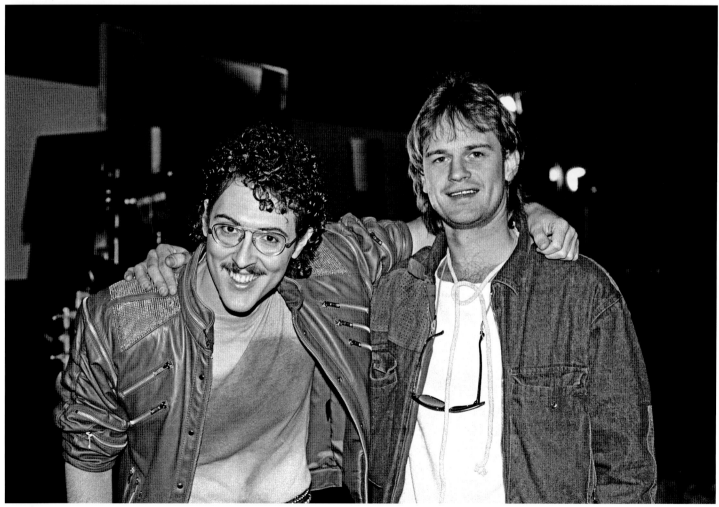

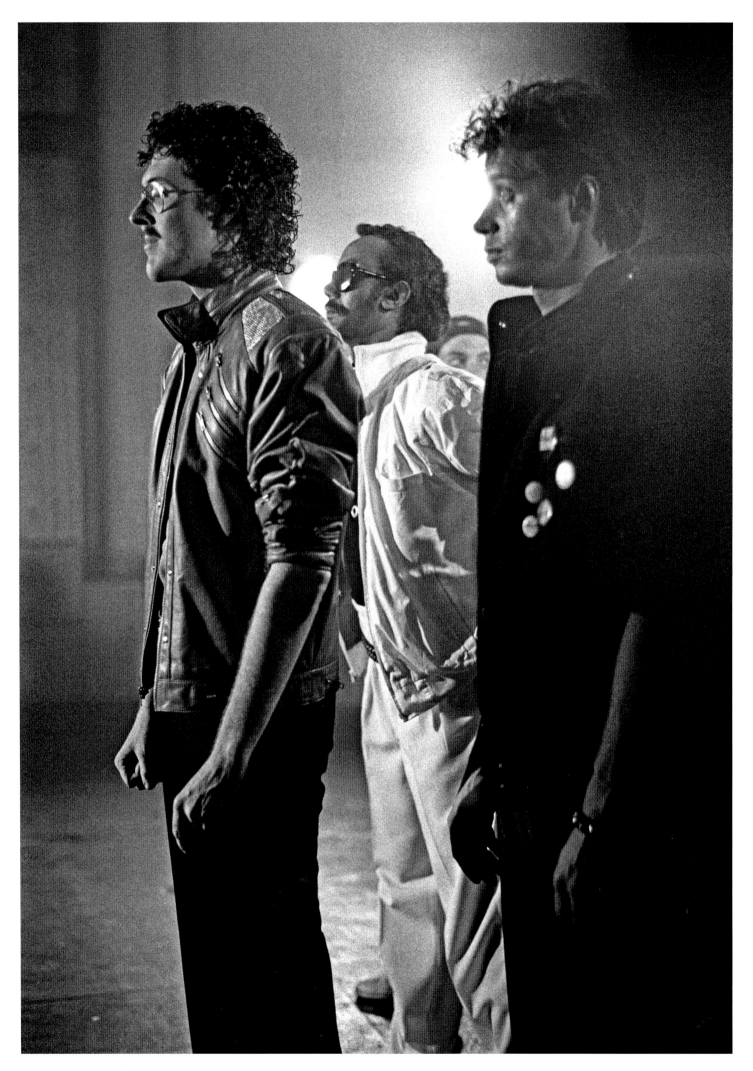

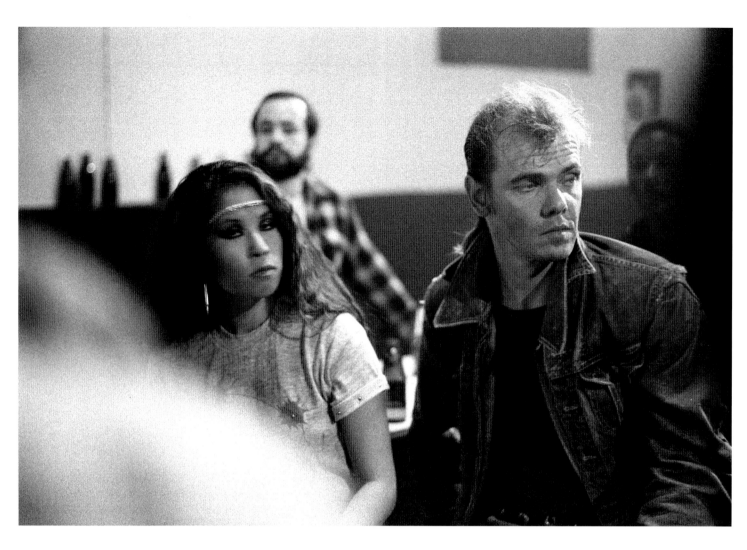

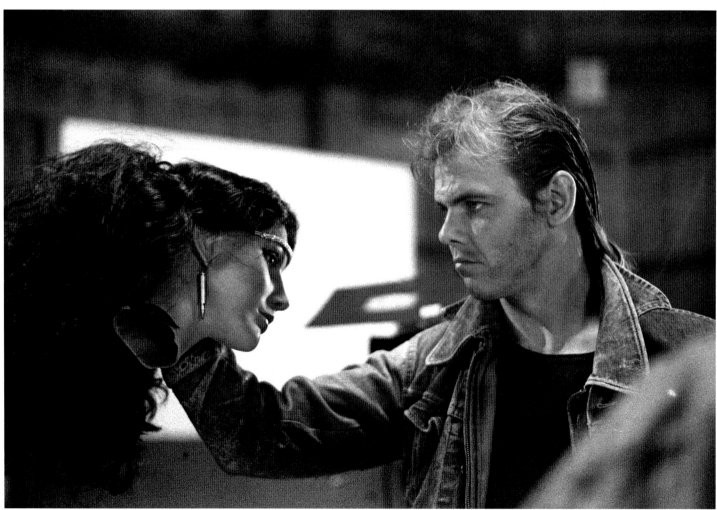

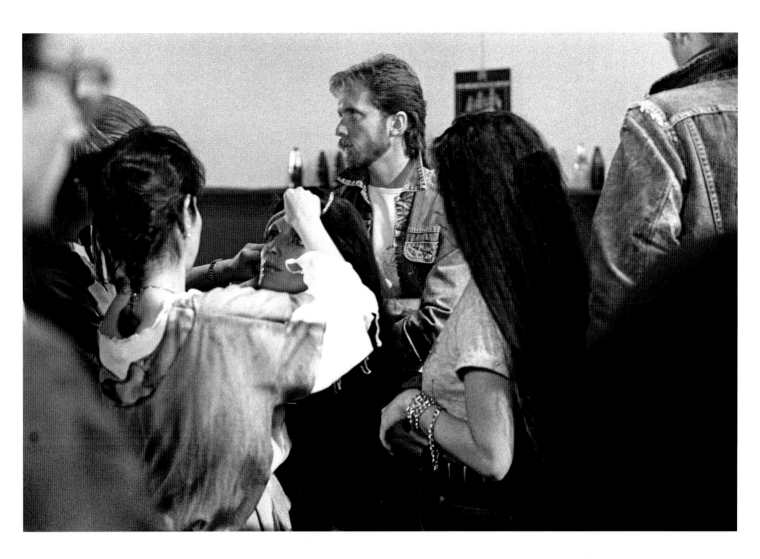

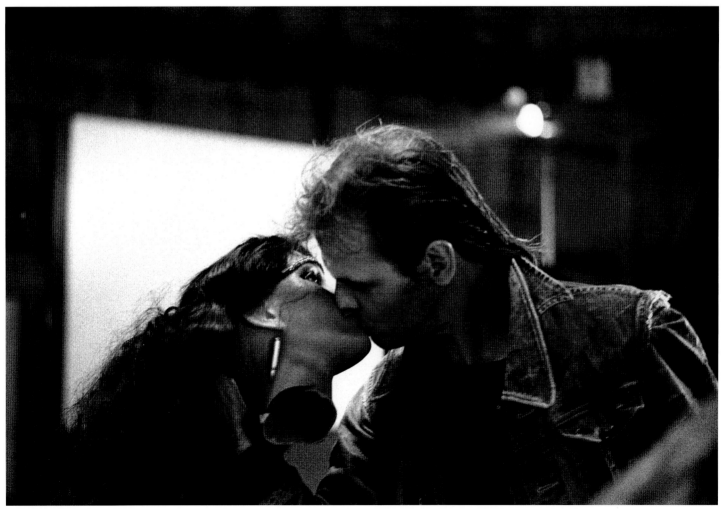

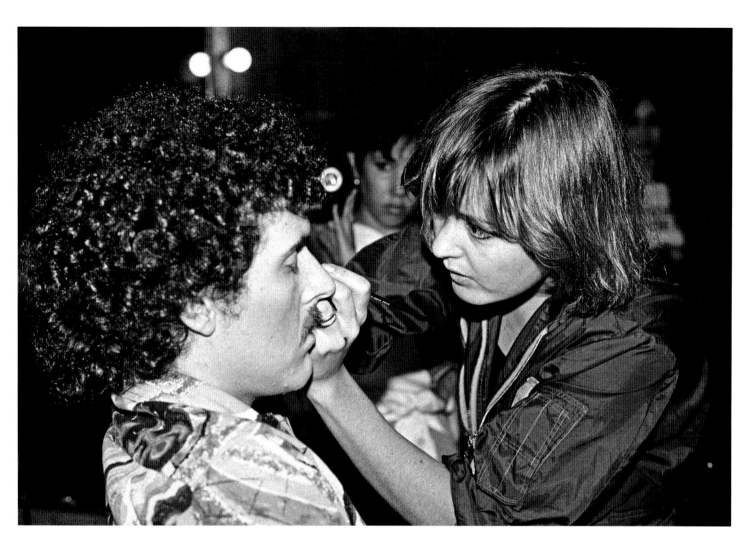

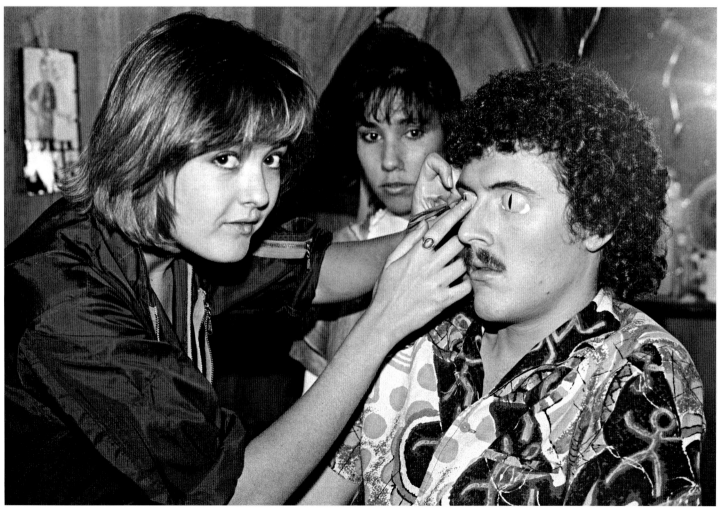

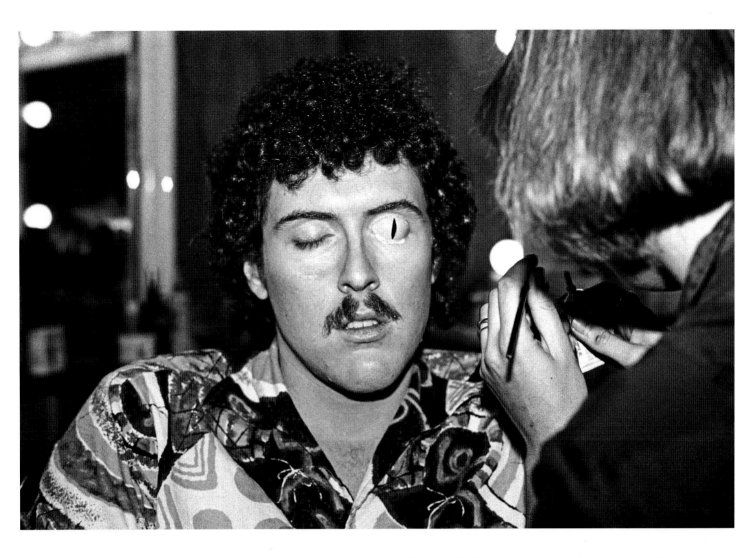

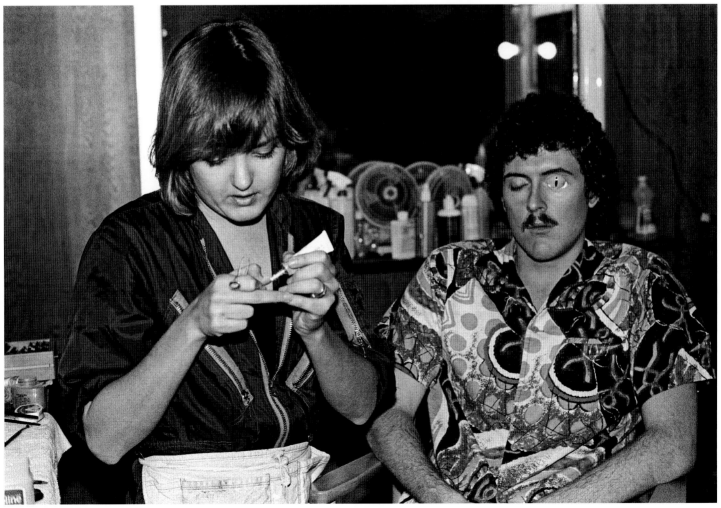

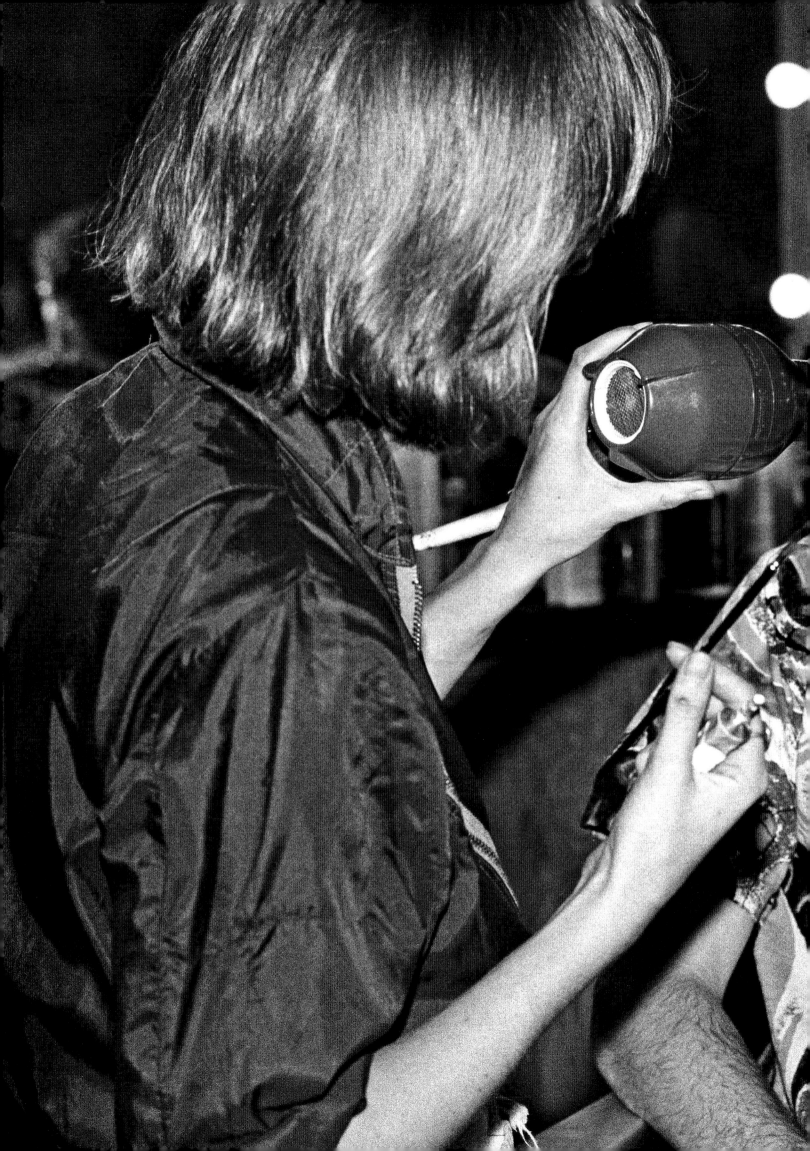

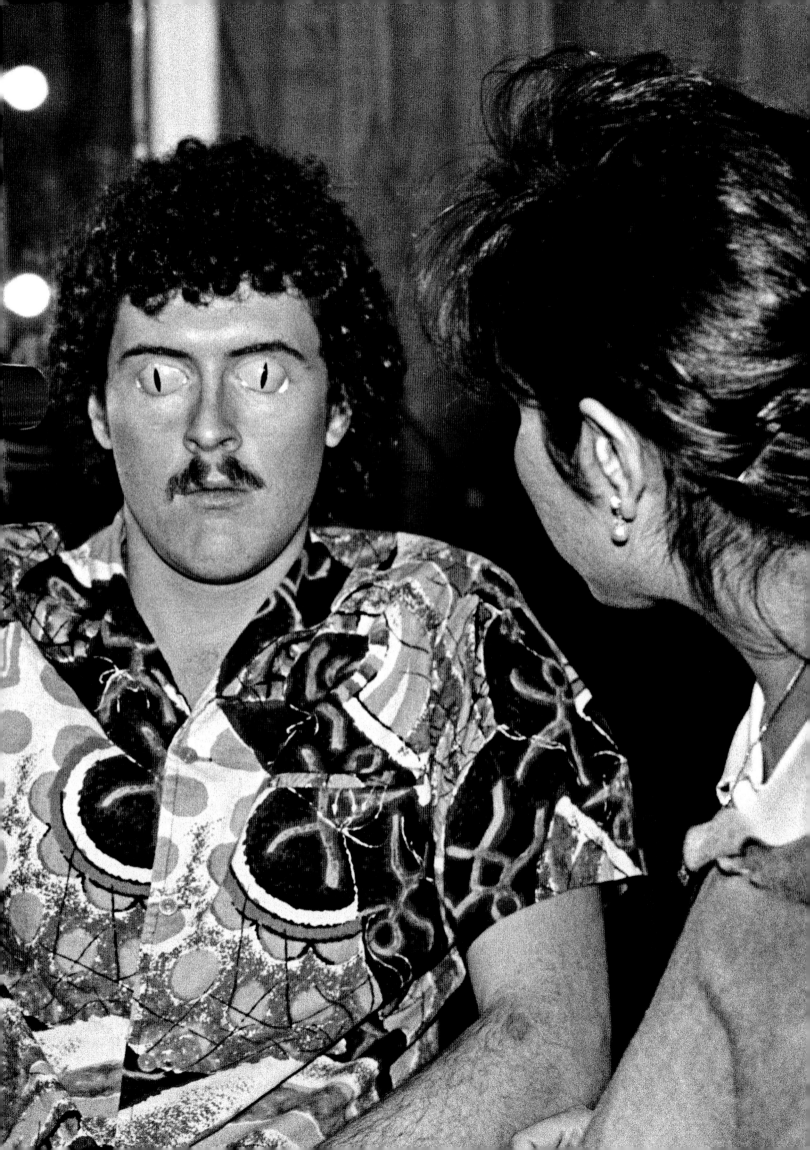

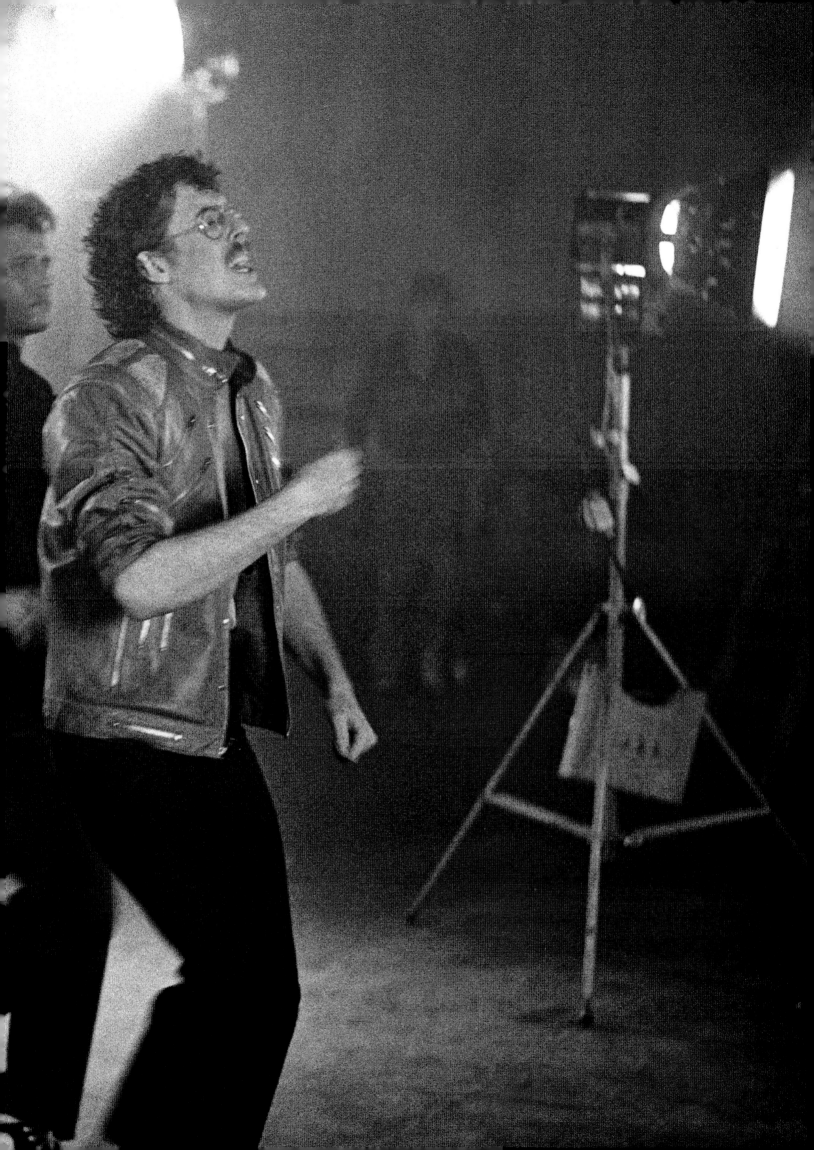

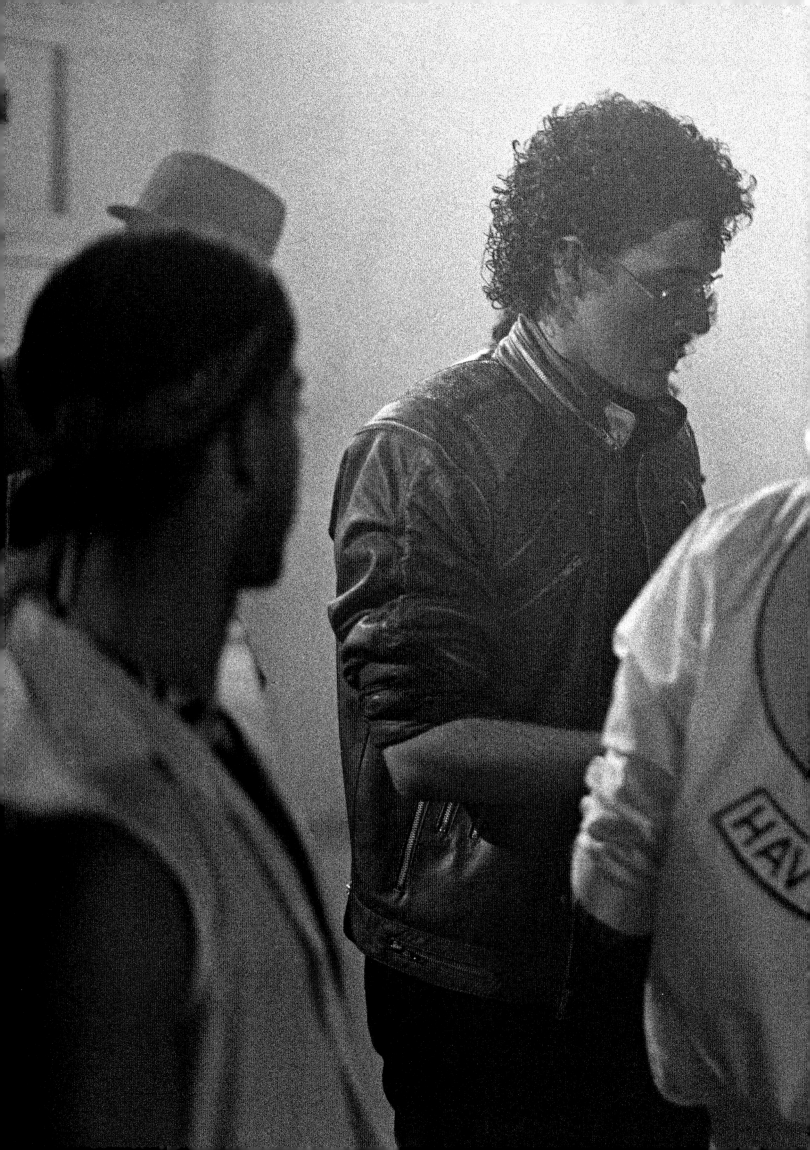

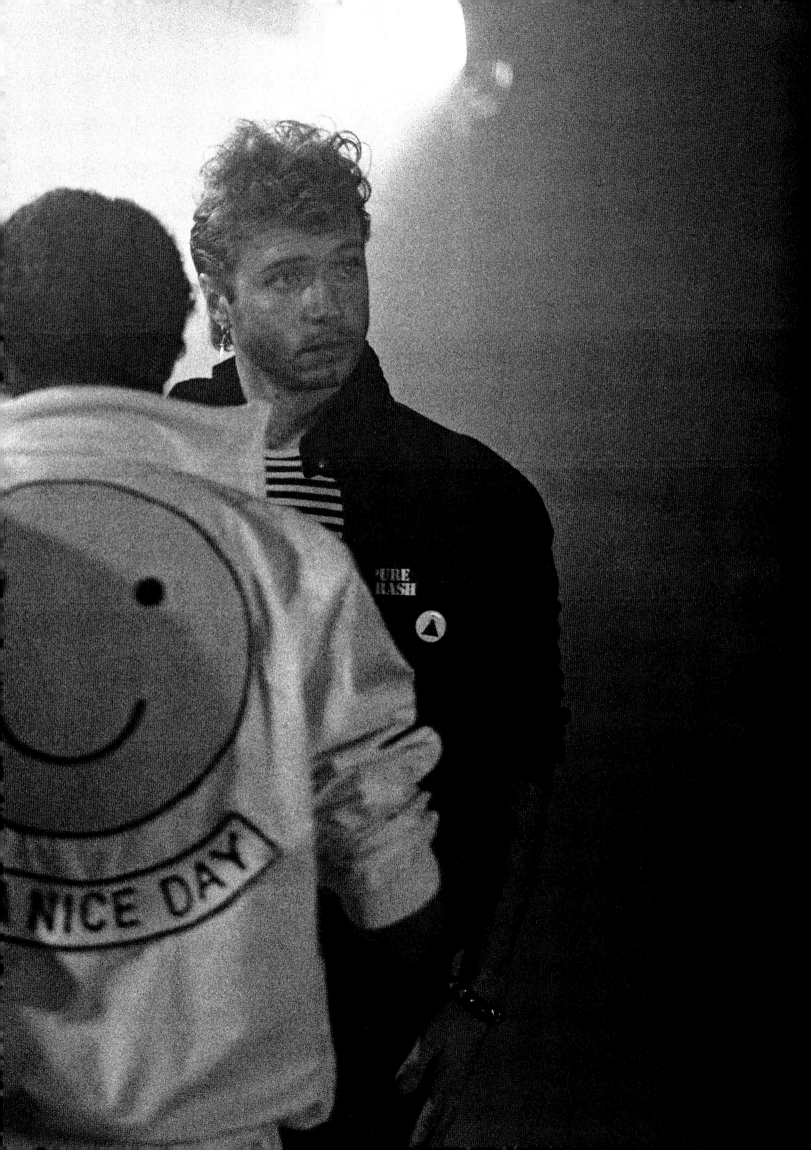

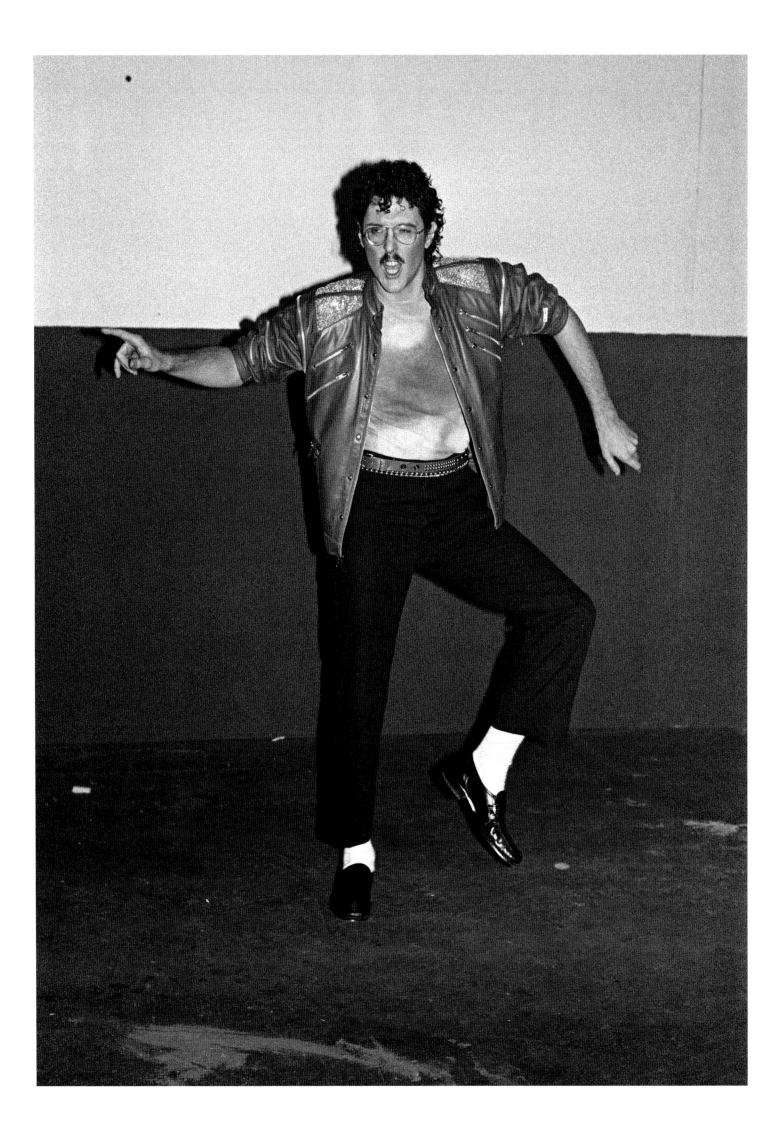

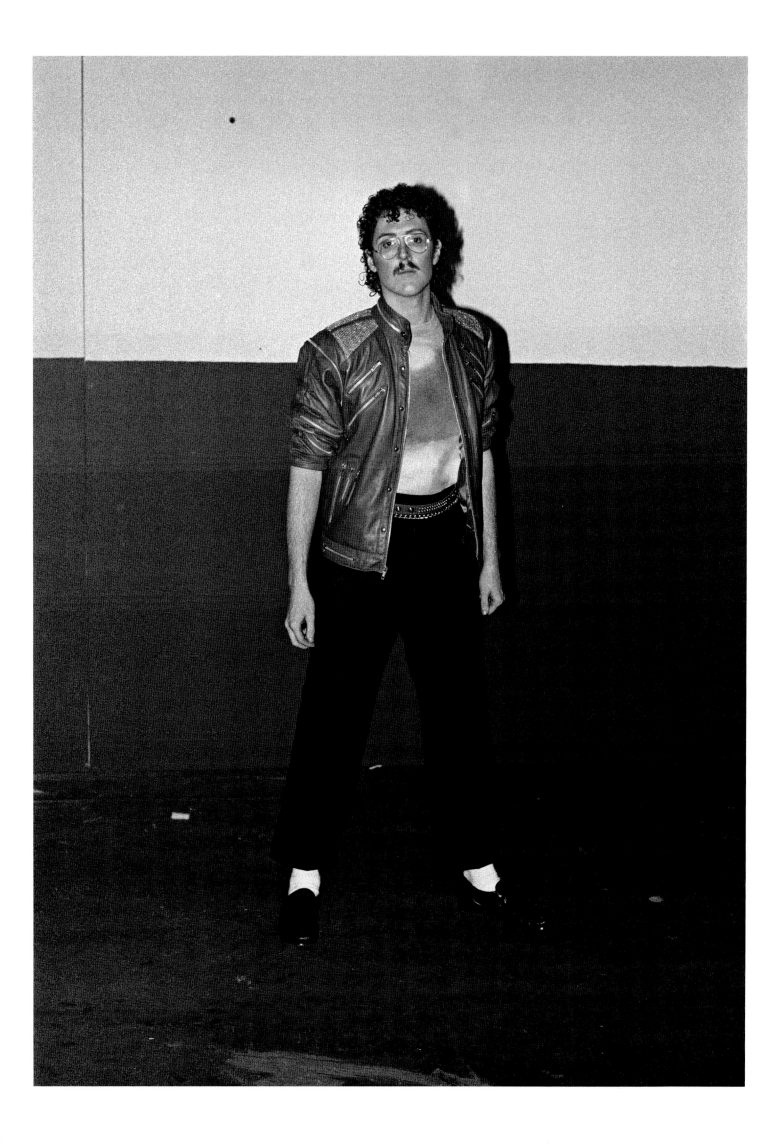

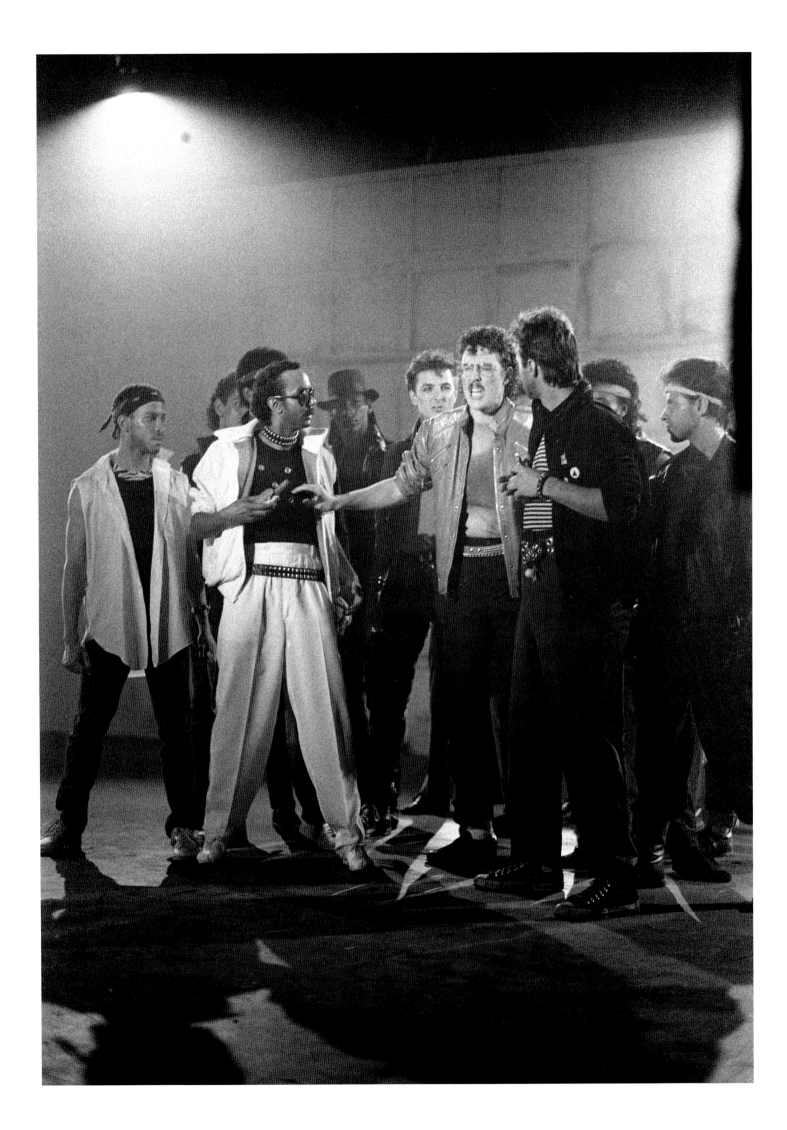

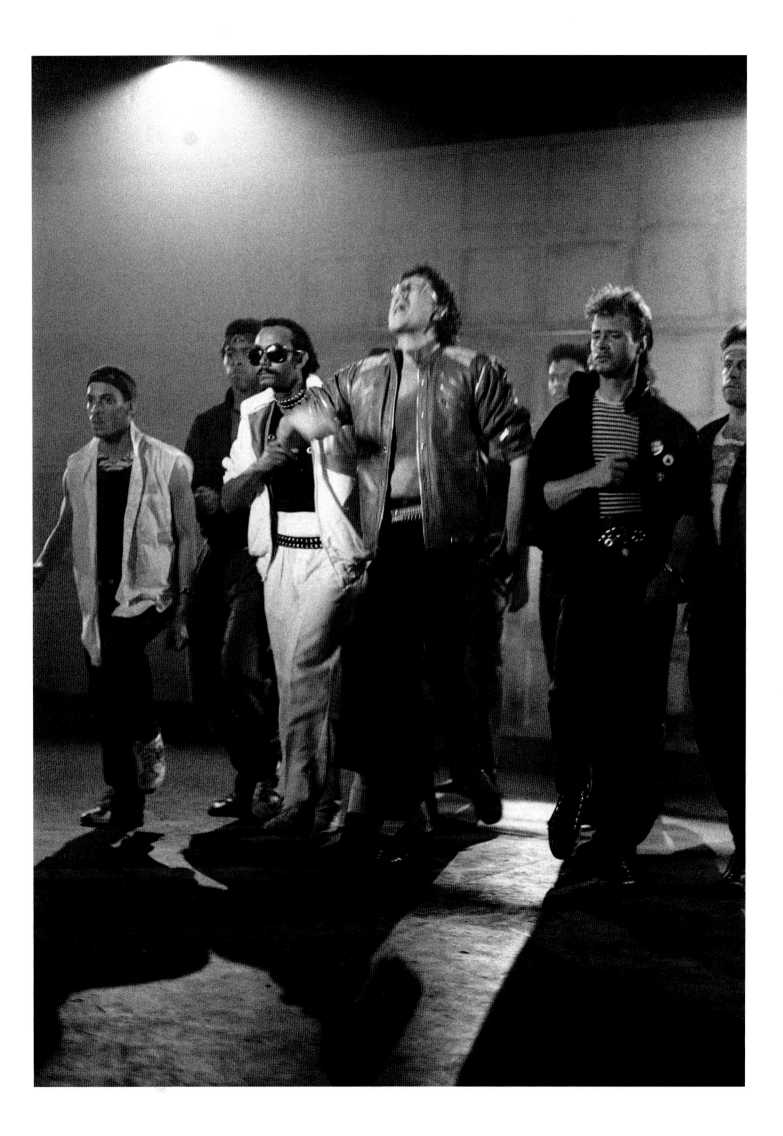

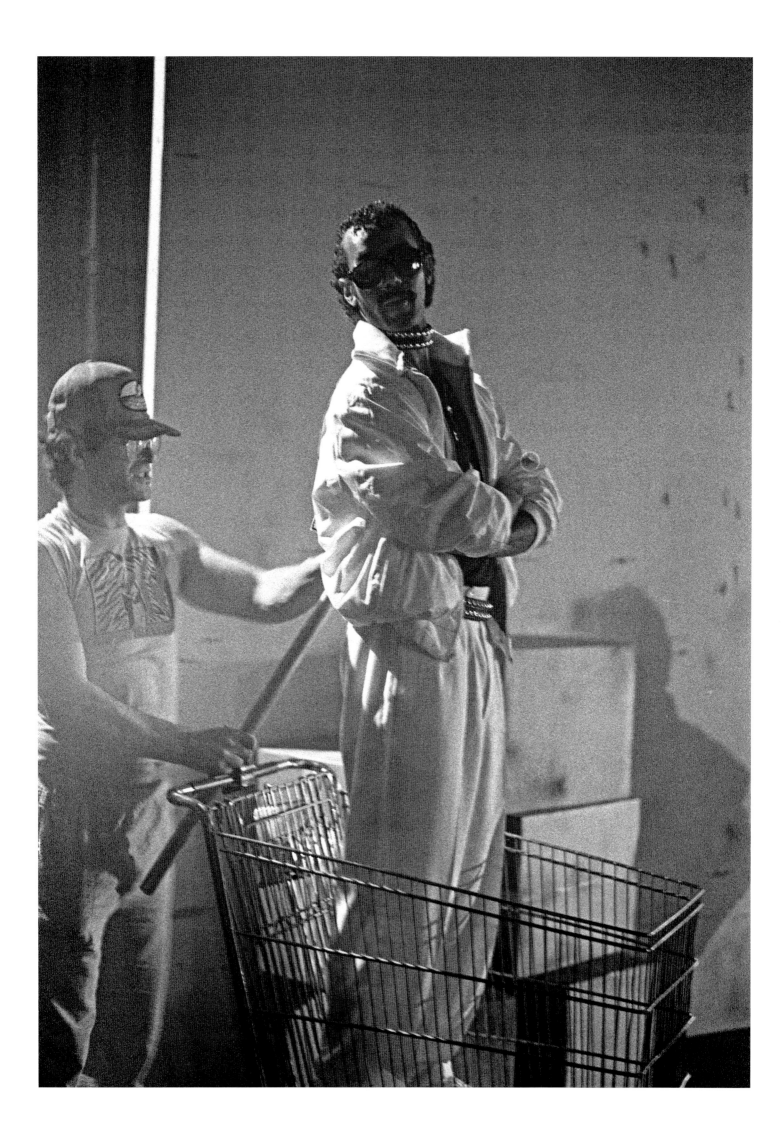

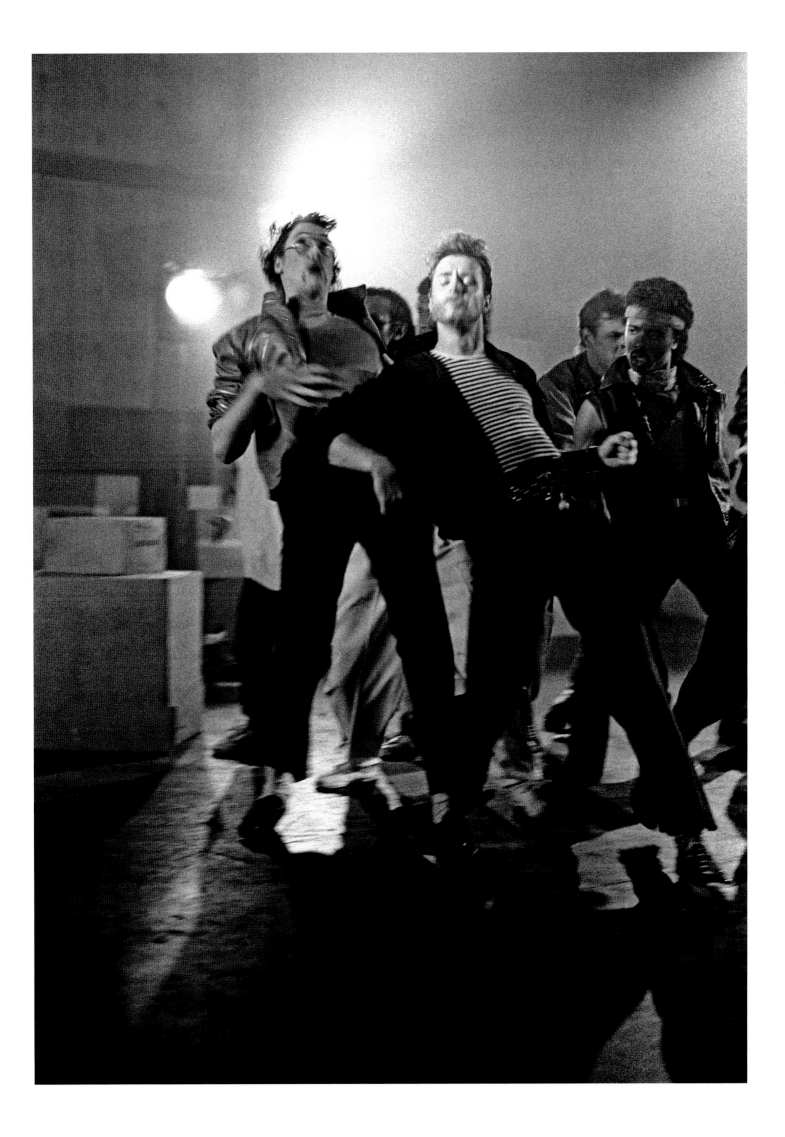

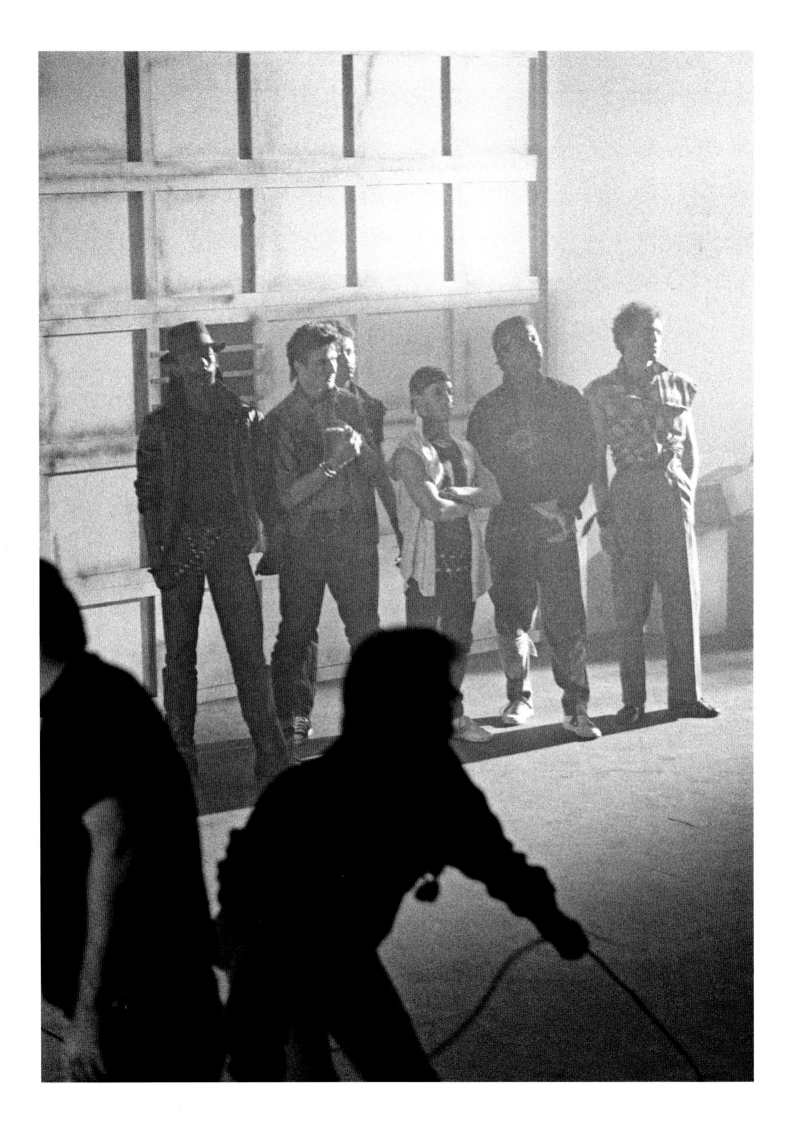

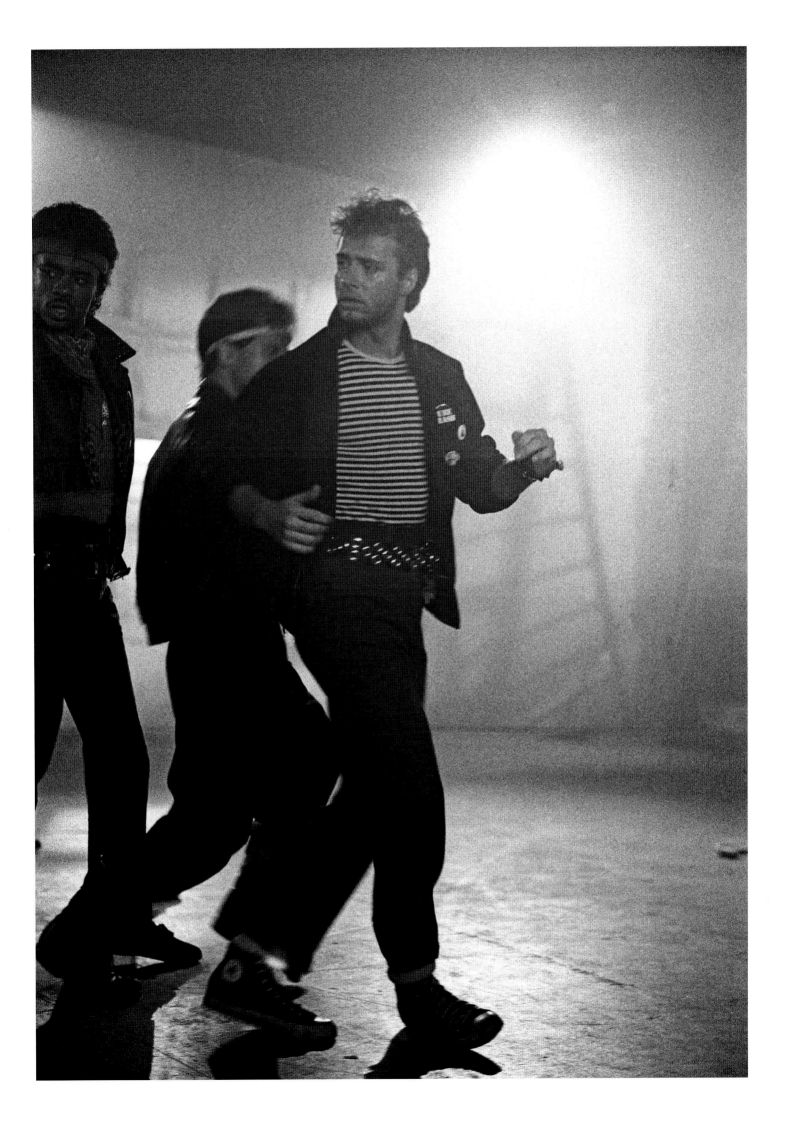

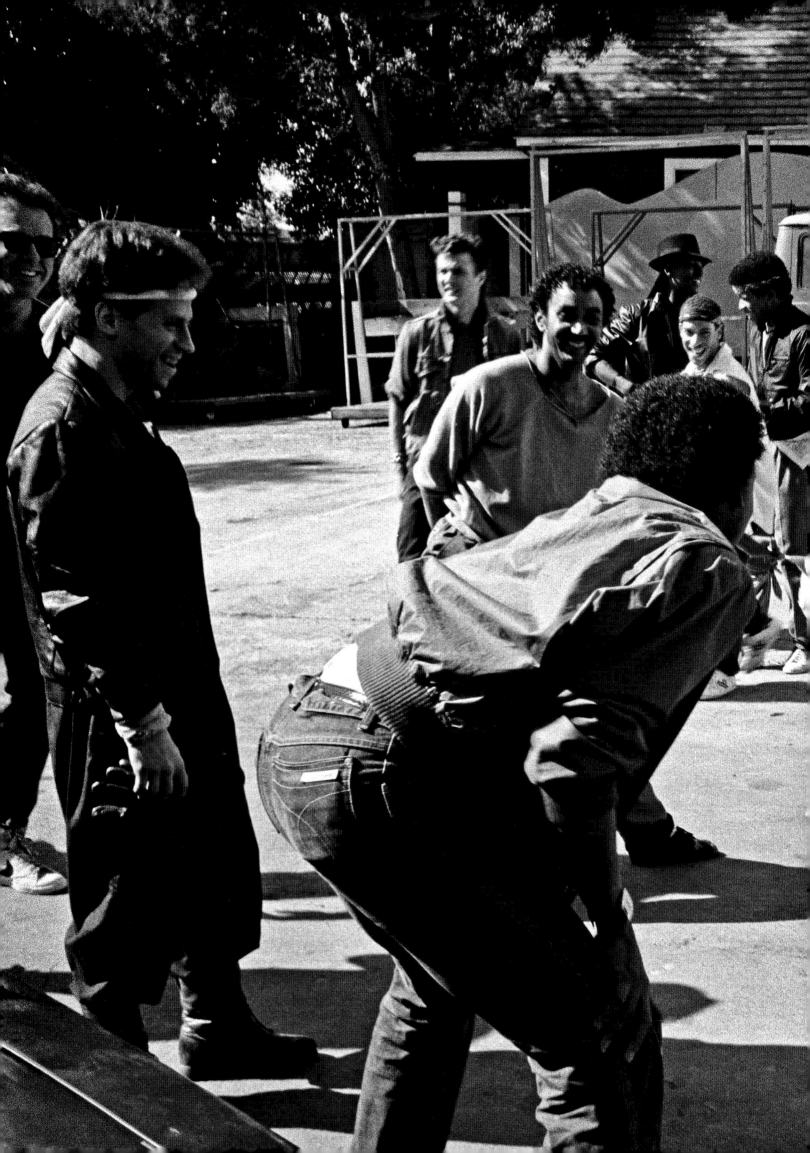

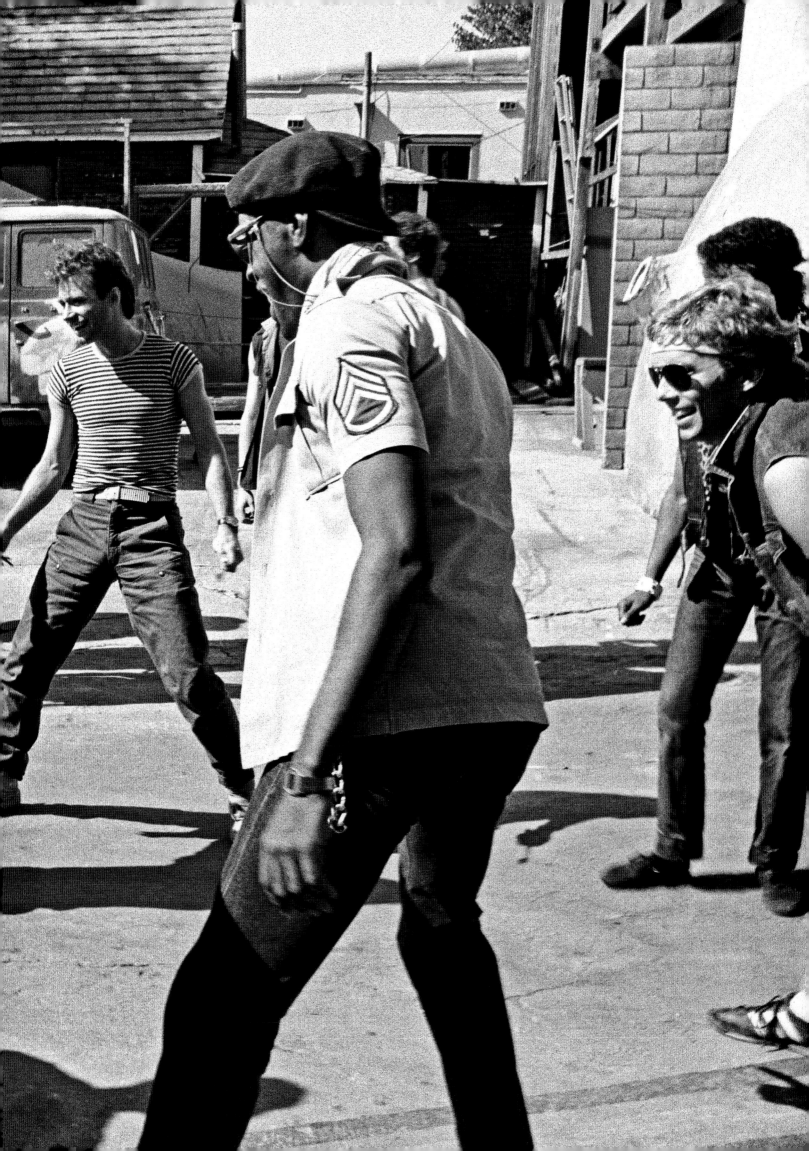

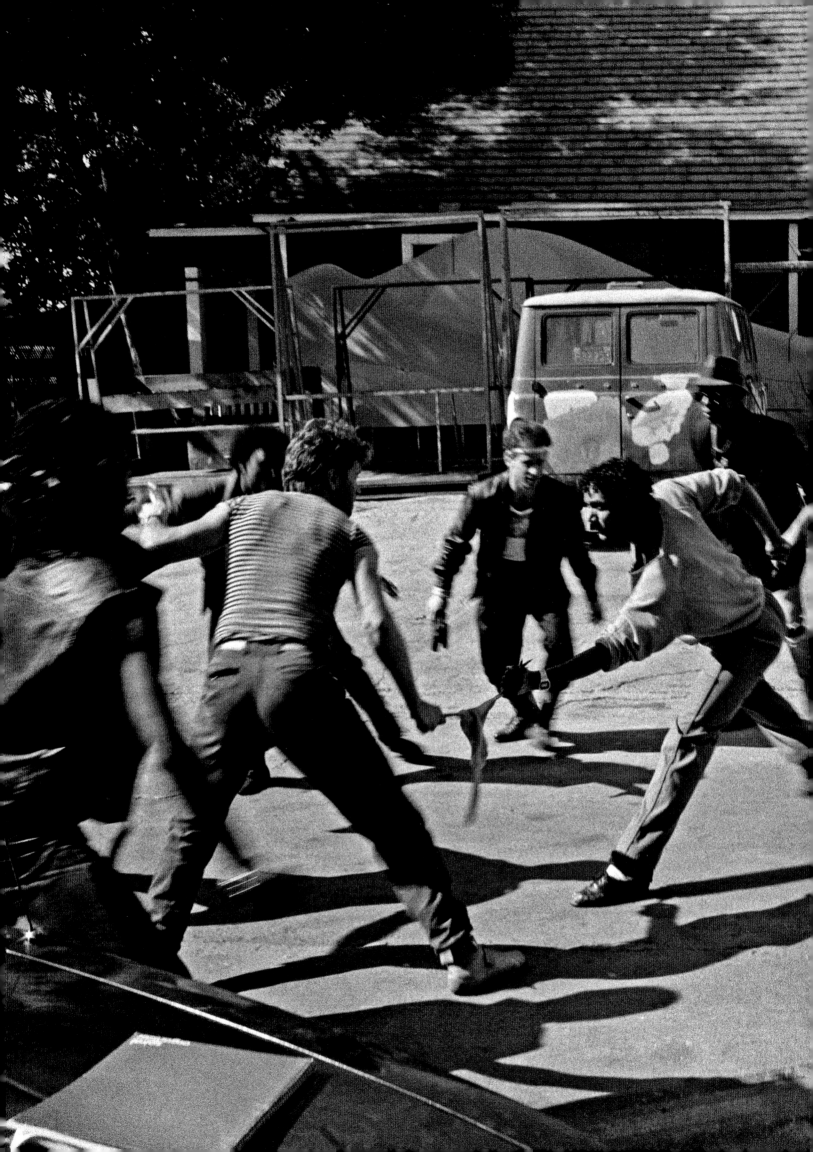

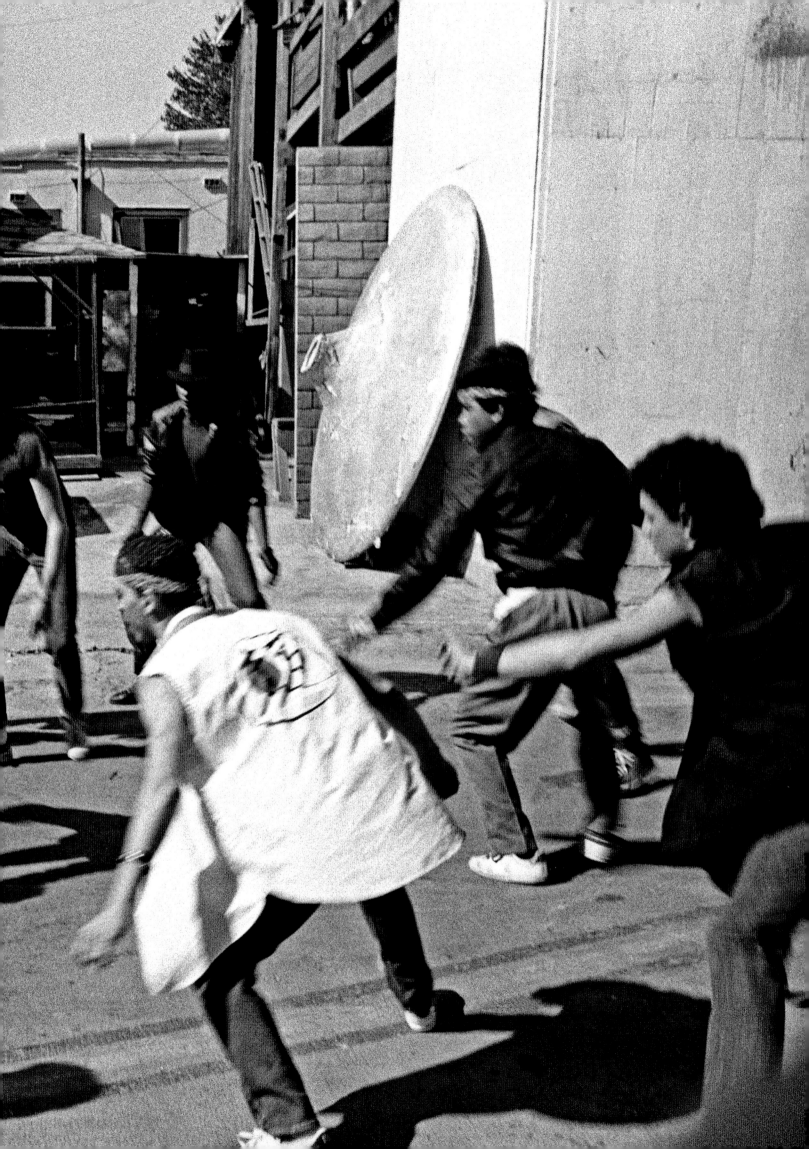

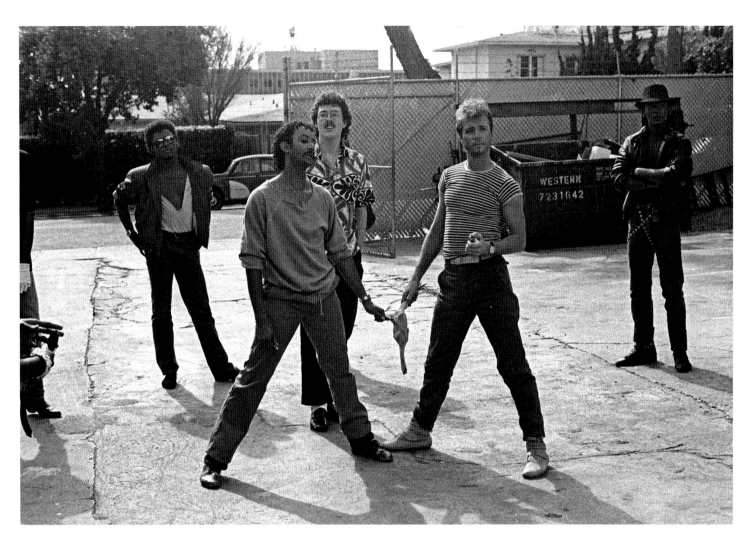
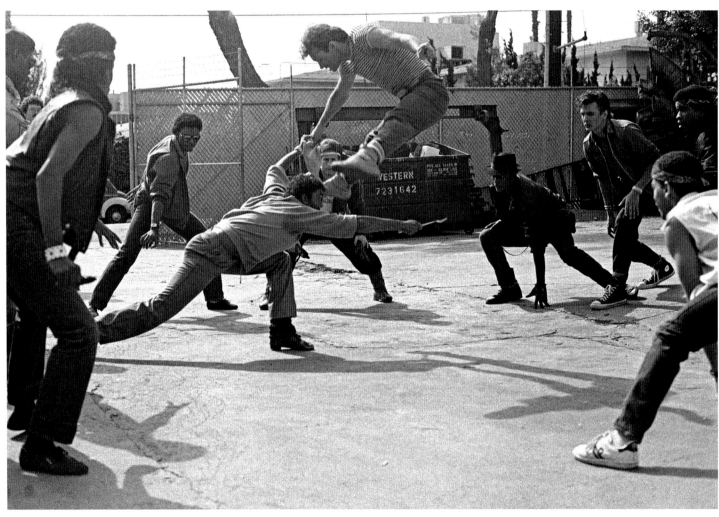

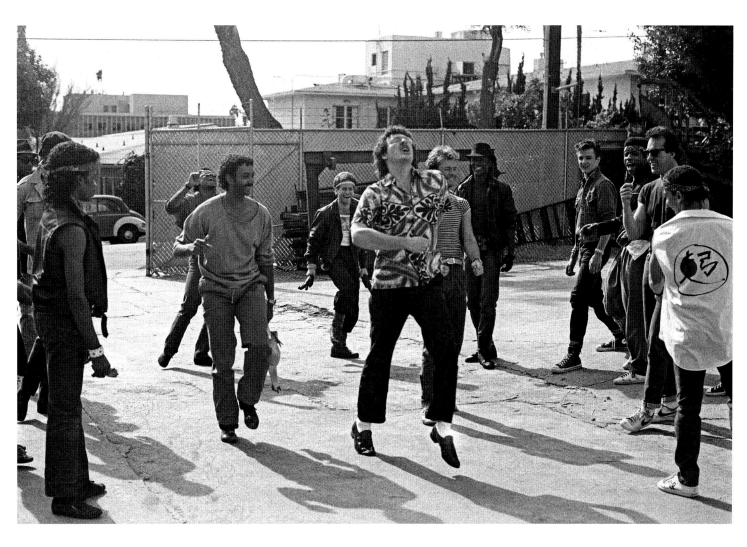

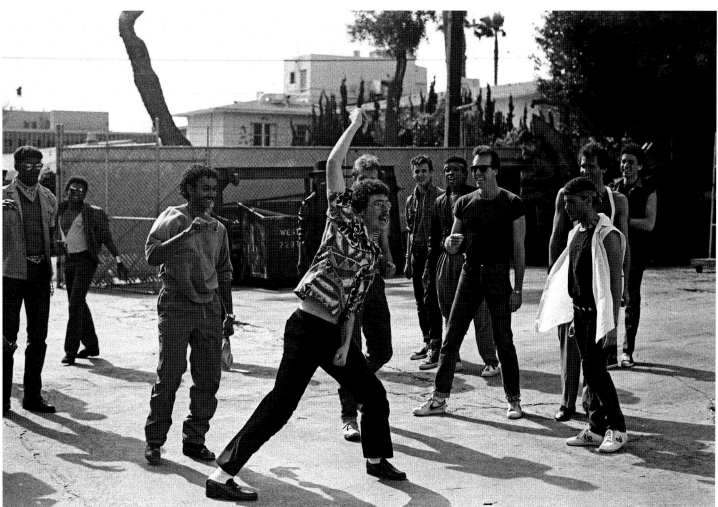

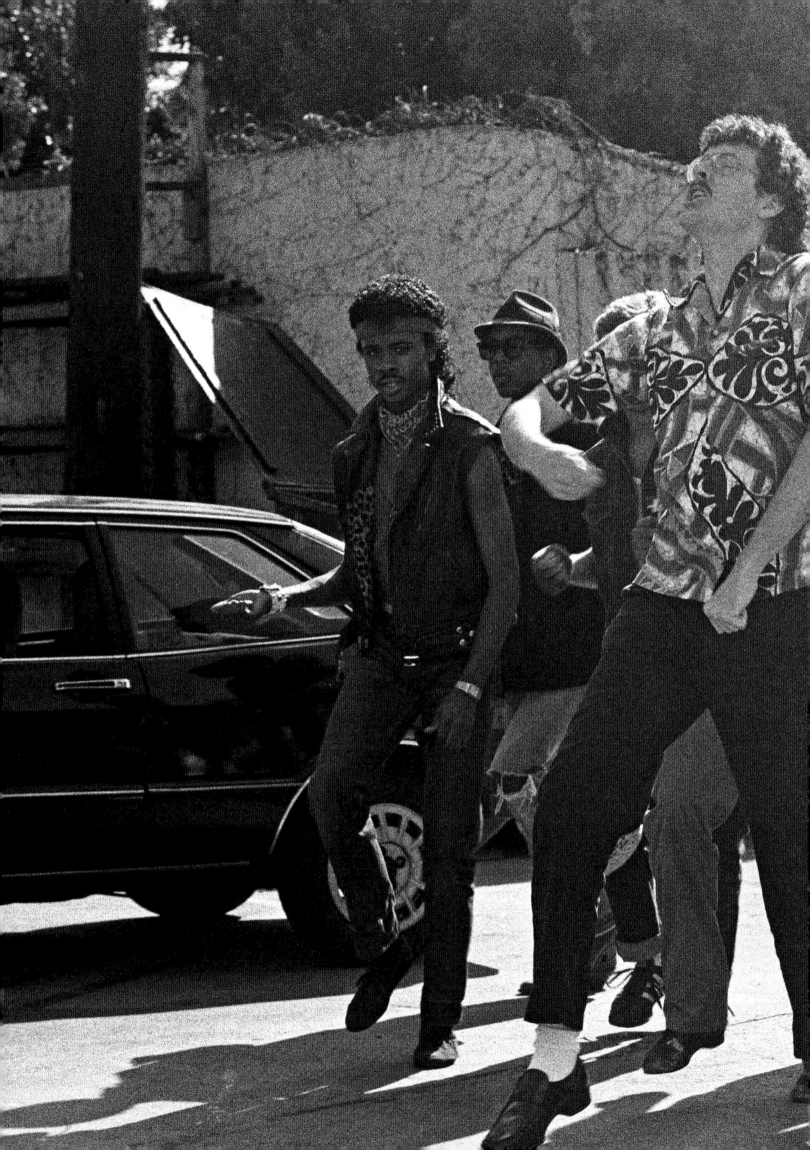

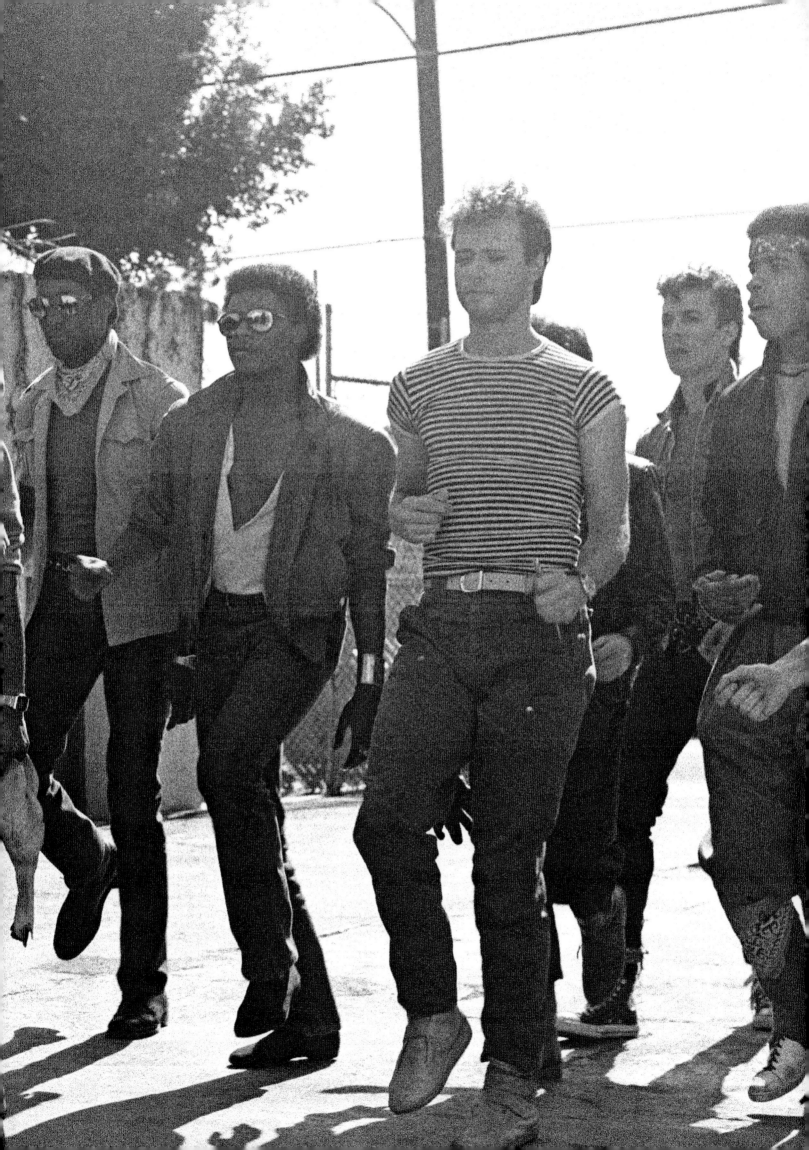

5

THE POLKA PARTY! MIXING SESSION

SANTA MONICA SOUND
RECORDERS, SANTA MONICA, CA

While mixing the "Good Enough for Now," "Toothless People" and "Polka Party!" tracks, Al and Rick took some time to show off some swag sent by Mark Jonathan Davis and the crew at KZZP-FM in Phoenix, Arizona. Davis was a fellow Dr. Demento alumnus who wrote parodies such as "The Star Wars Cantina" and "Rice Rice Baby," sang backing vocals (uncredited) on "Harvey the Wonder Hamster" and later took on the persona of lounge singer Richard Cheese, with his band Lounge Against The Machine.

You may have noticed the two-and-a-half-year gap in black-and-white photos since "Eat It." During 1984/85, we were on the road quite a bit and on the move almost every day, so I took my film to one-hour processing stores. Since they only did same-day color, black and white wasn't an option. Which is why there are no black-and-white shots at airports, on the tour bus, backstage, on stage from behind my drums, walking down the street, in restaurants...

"Why then" you may well ask, "are there no black-and-white shots from the 1985 *Dare to Be Stupid* sessions, while you were home and could easily get those processed?" I'll have to get back to you on that.

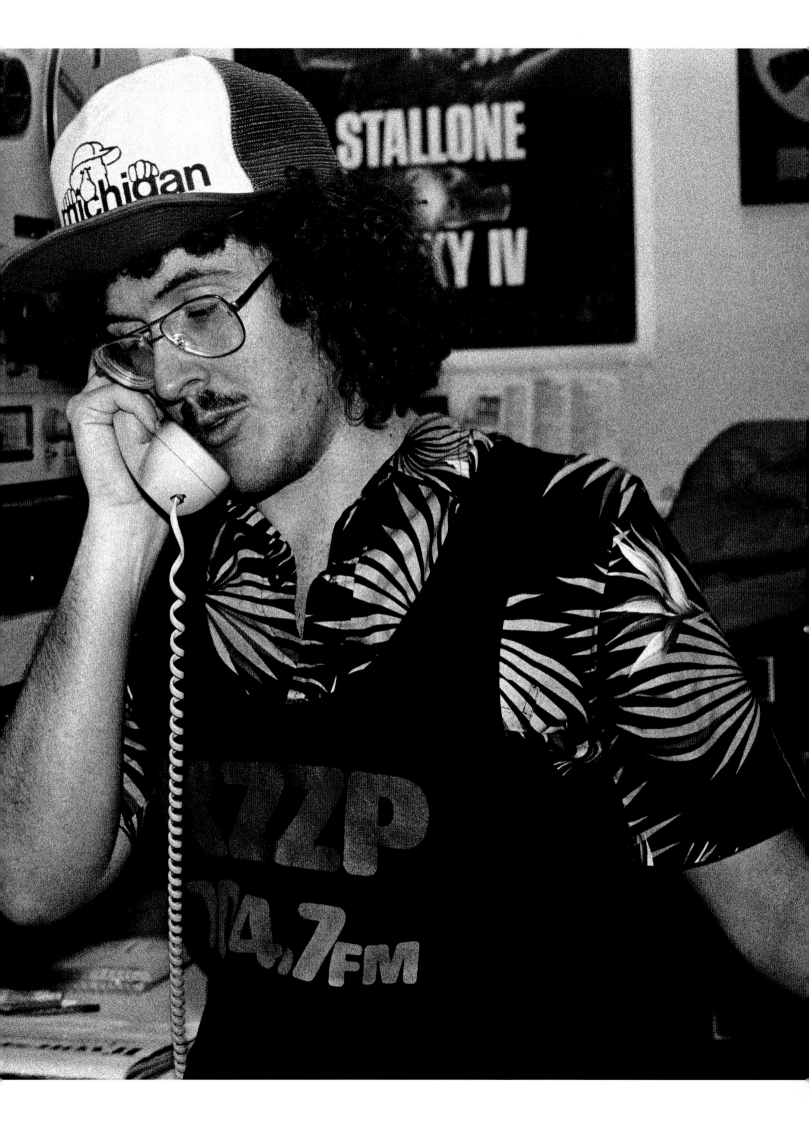

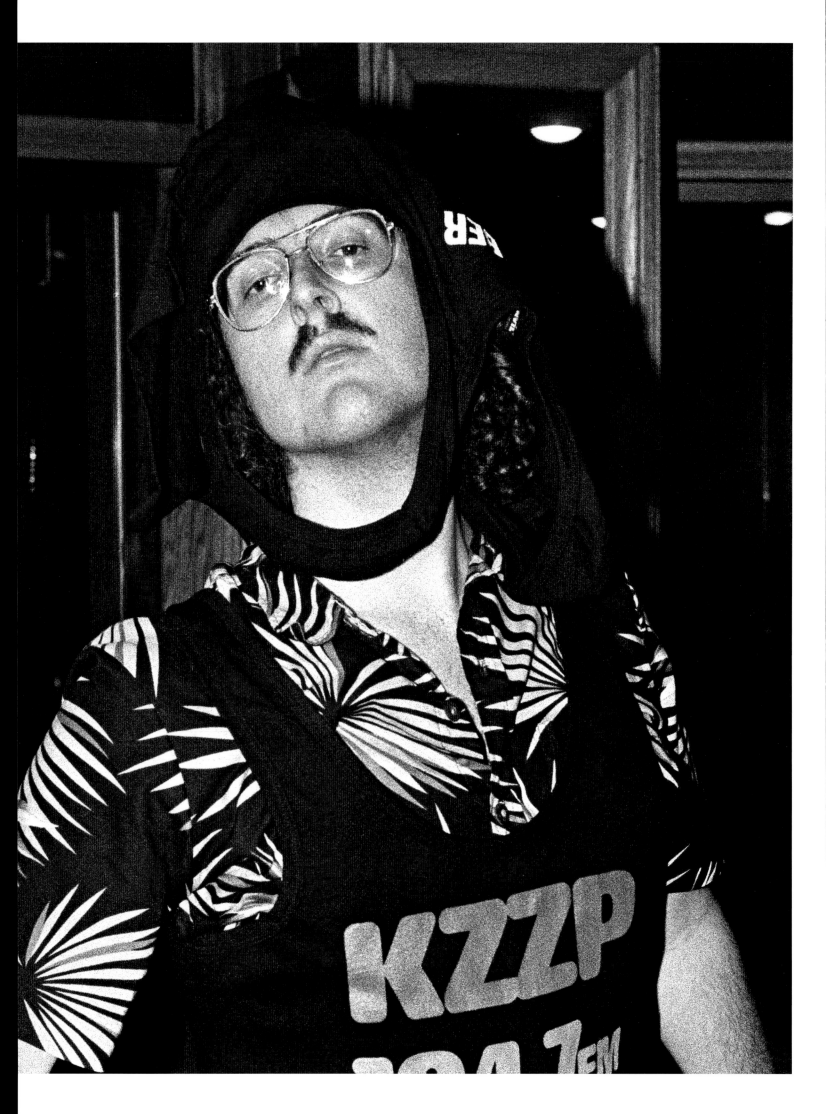

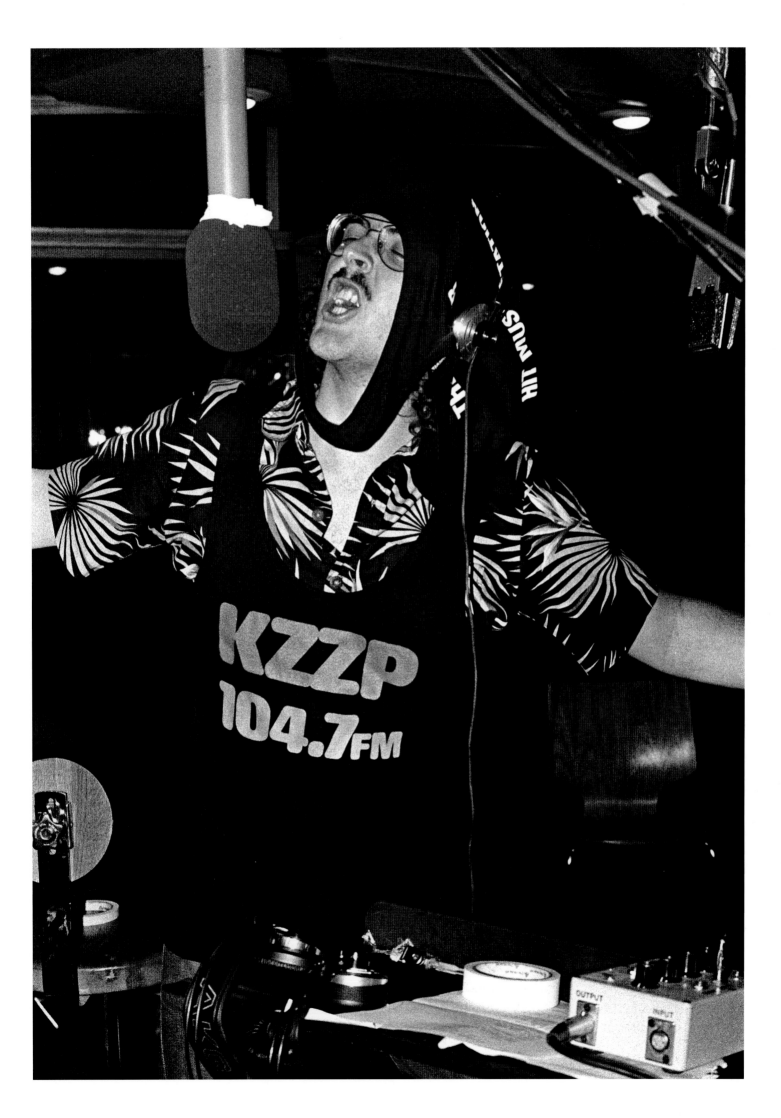

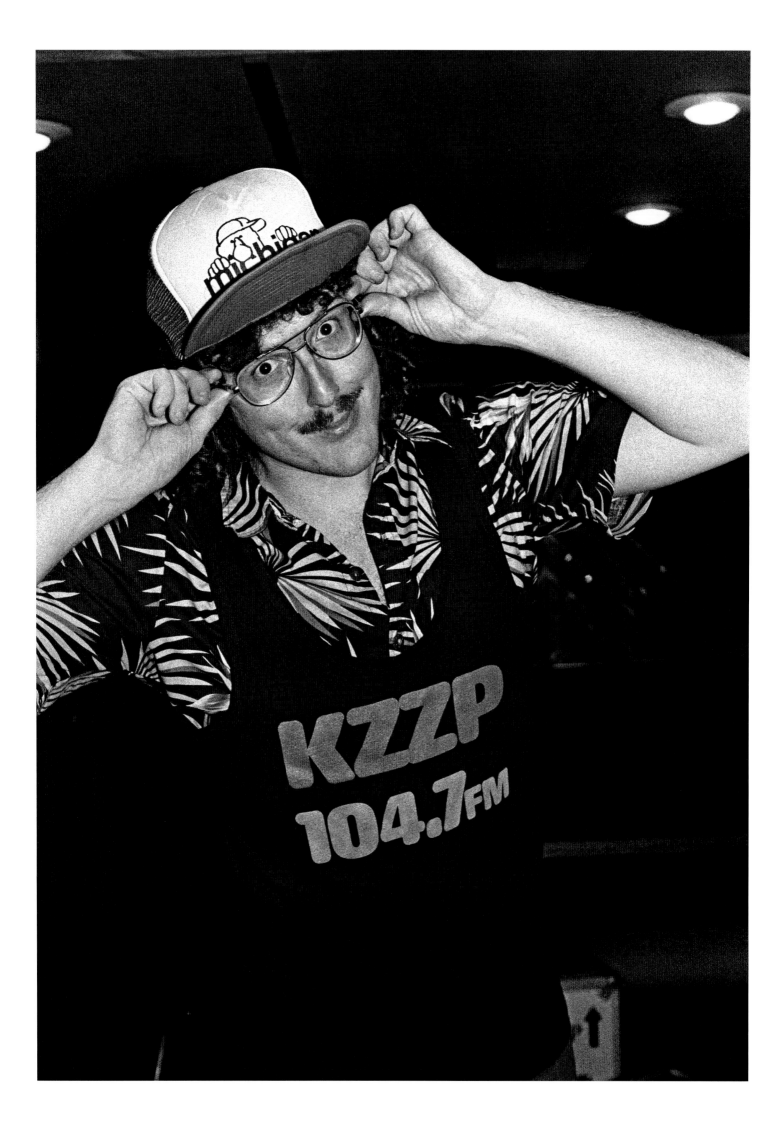

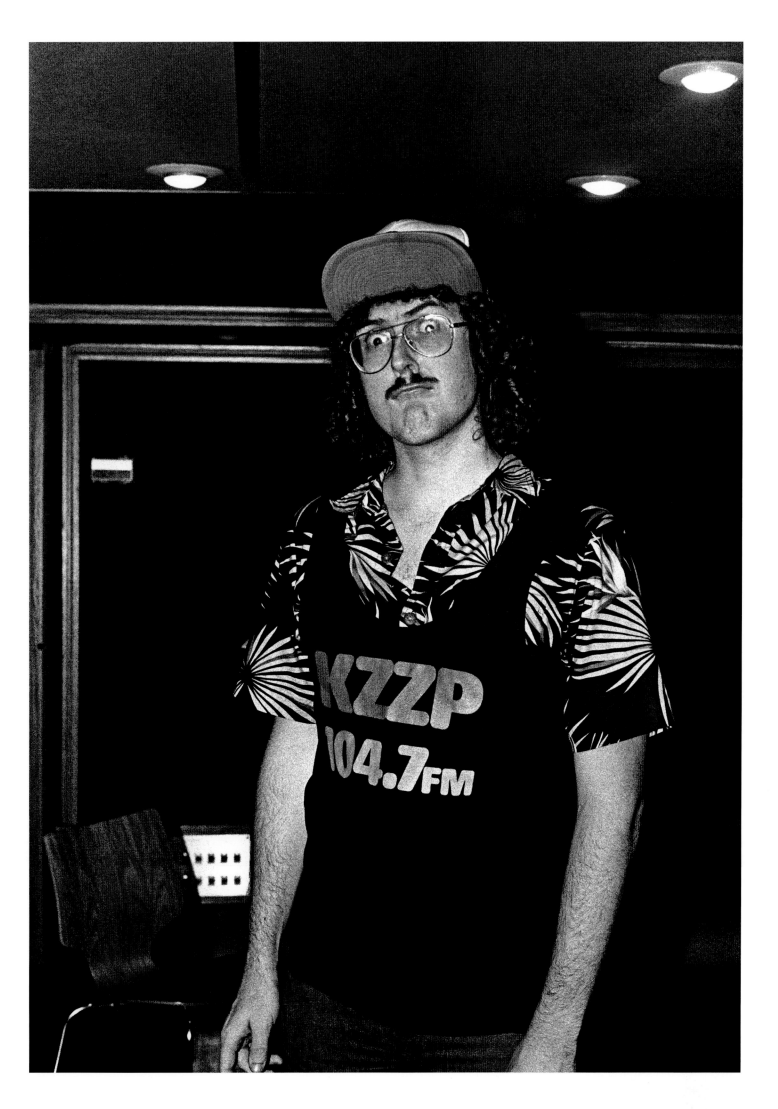

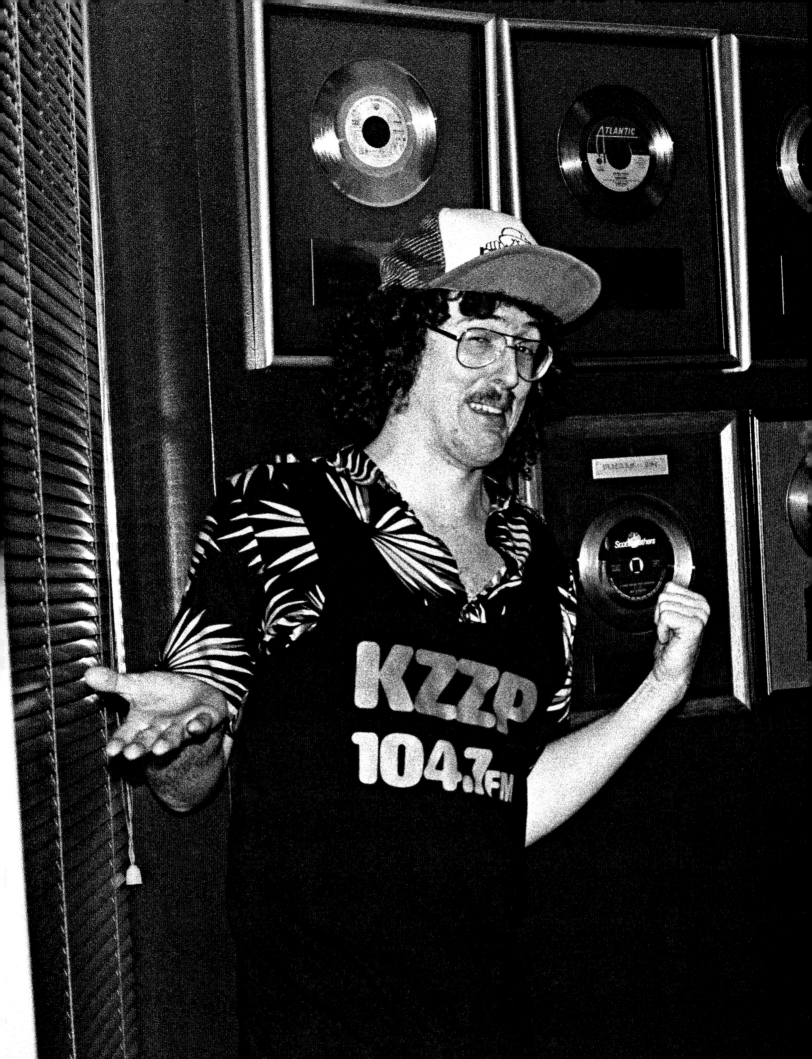

6

LIVING WITH A HERNIA VIDEO SHOOT

JUBILEE THEATER,
BALLY'S LAS VEGAS,
LAS VEGAS, NV

The "Hernia" video was shot on the same Vegas showroom stage as James Brown's "Living in America" video, and featured the dancers from Donn Arden's *Jubilee!*, most of whom also appeared in Brown's video. Jim, Steve and I appear in the band, and legendary dancer and choreographer Chester Whitmore and his dancers were also featured. That's Chester putting the cape on Al near the end of the video, a la James Brown. Chester also portrayed one of the Nicholas Brothers in Al's "This Is the Life" video.

I shot only one-and-a-half rolls of black and white for "Hernia" compared to multiple rolls (including color) for the other videos. I could have shot more but felt I had already captured enough photos of Al and the show girls.

That was also the last time I shot in black and white.

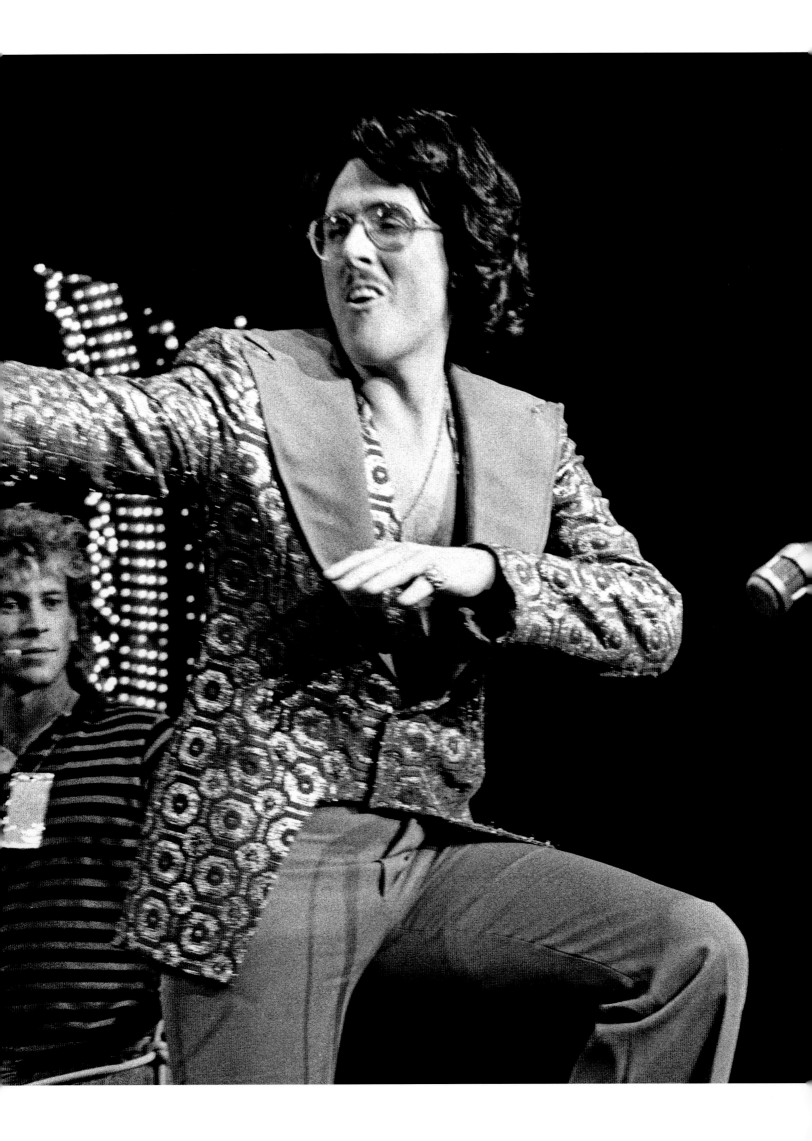

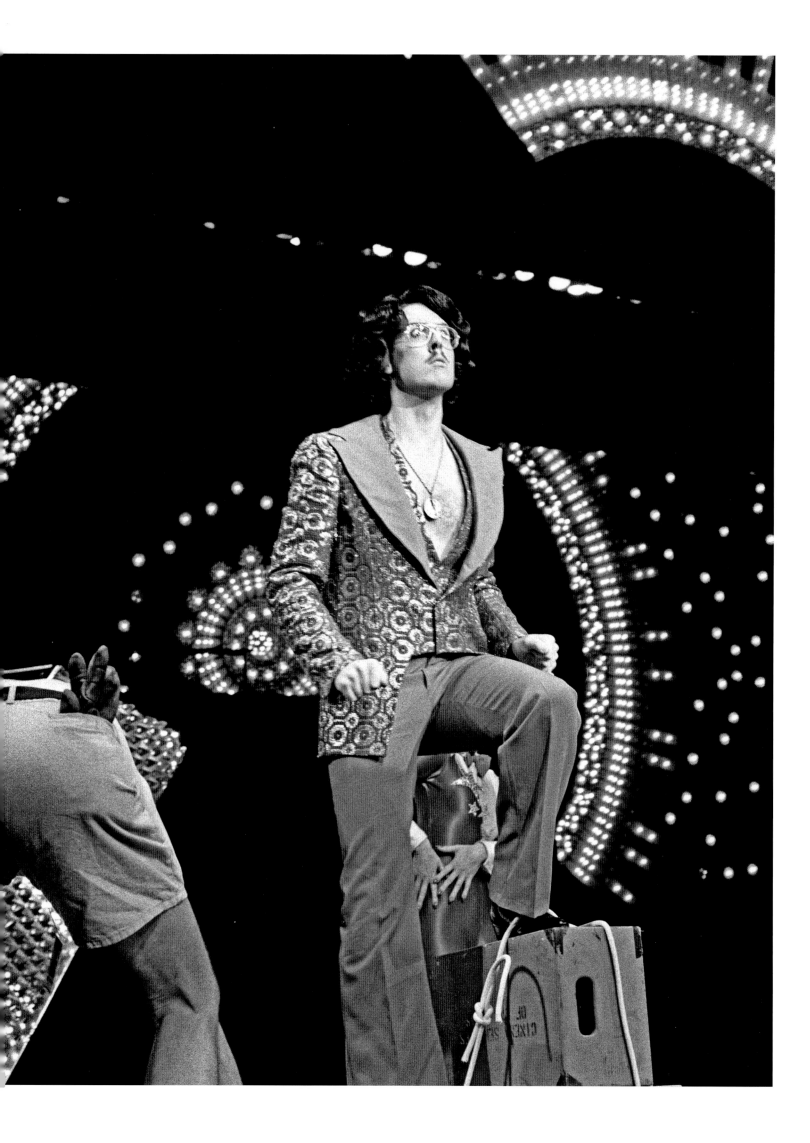

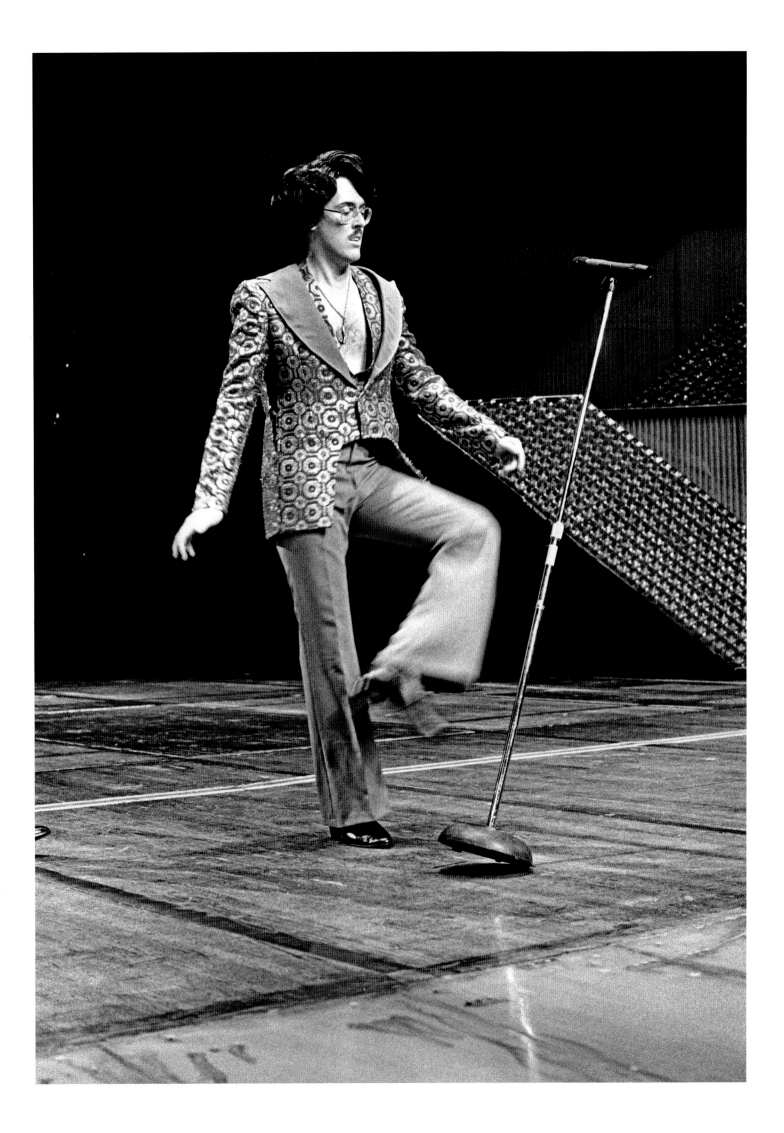

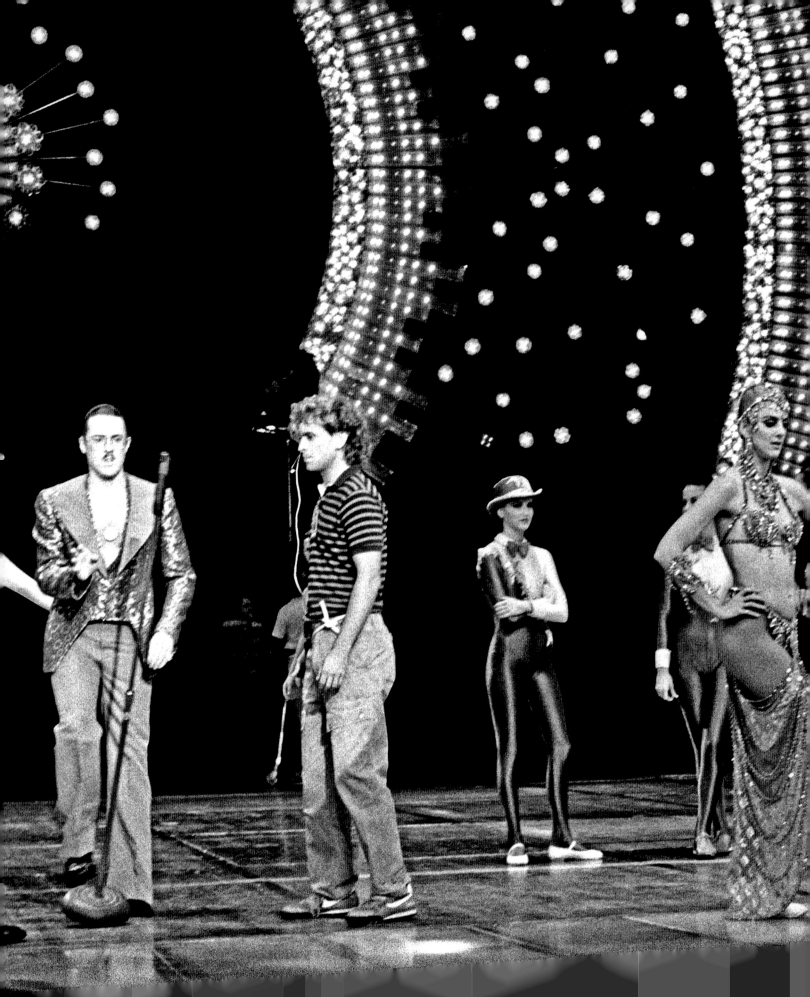

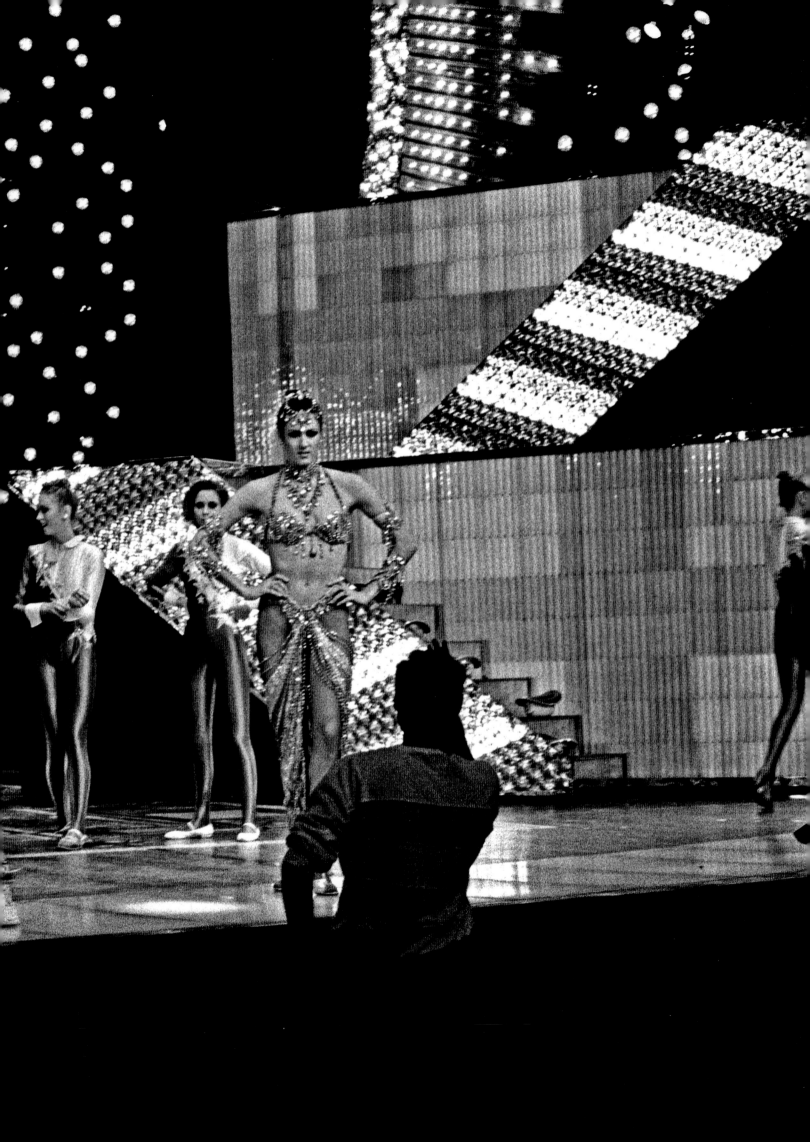

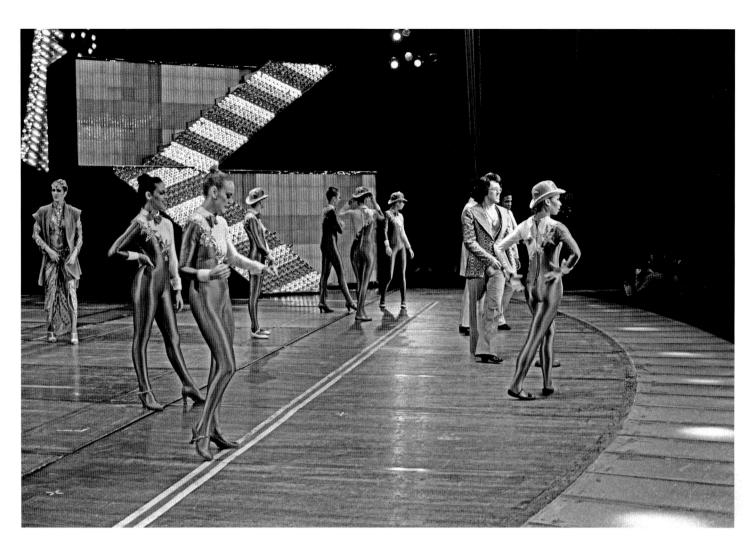

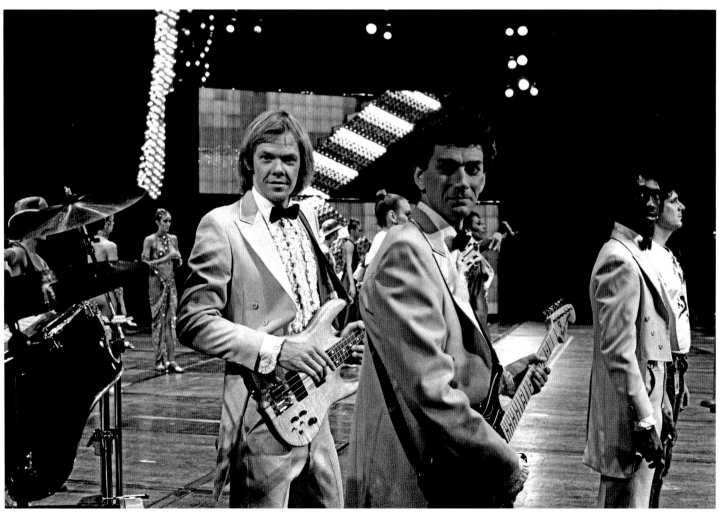

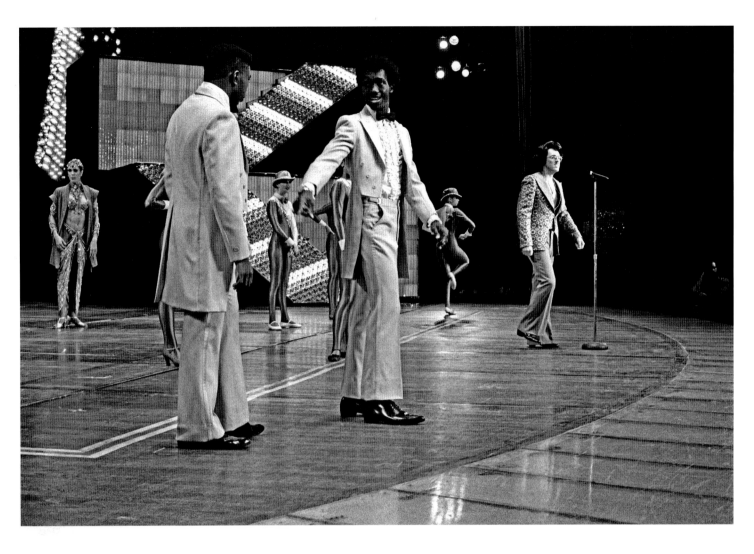

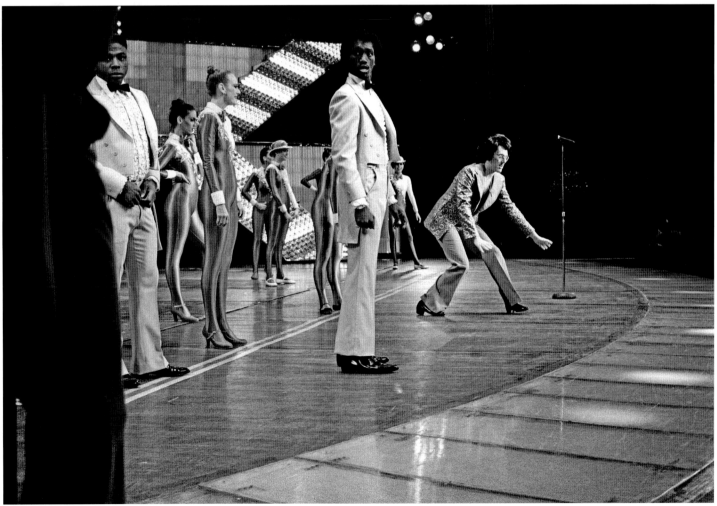

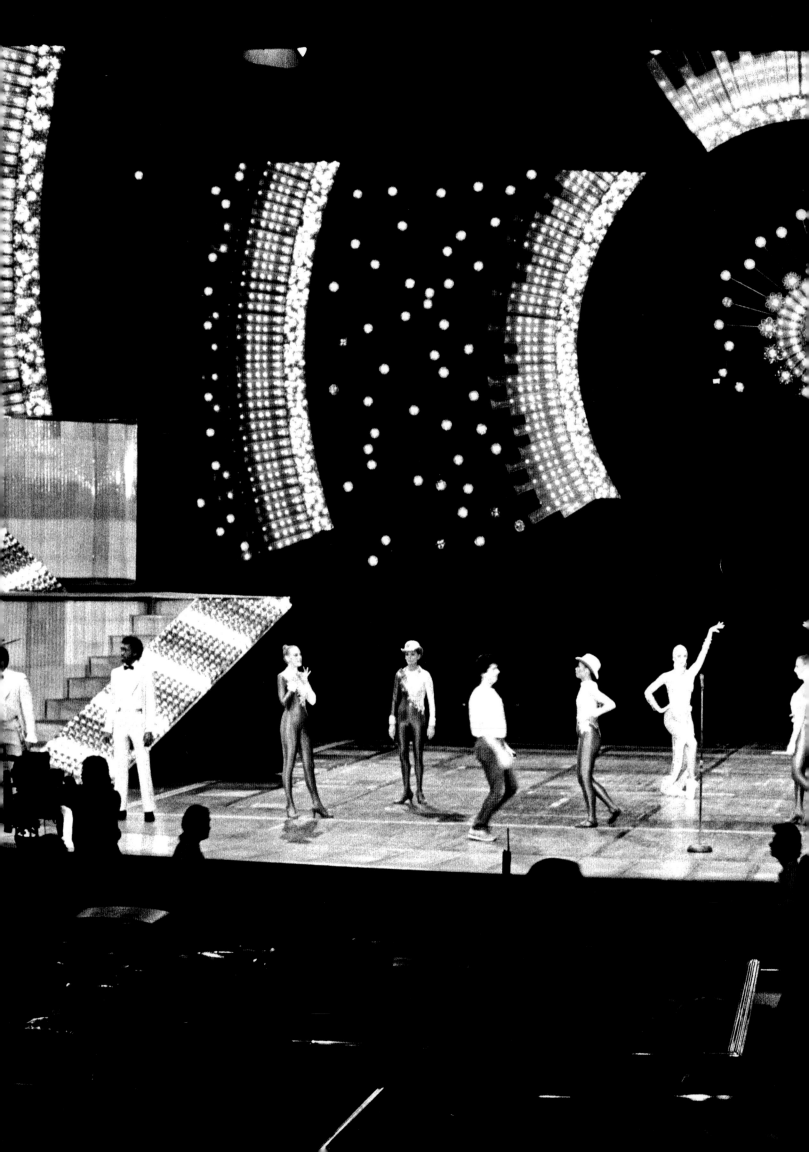

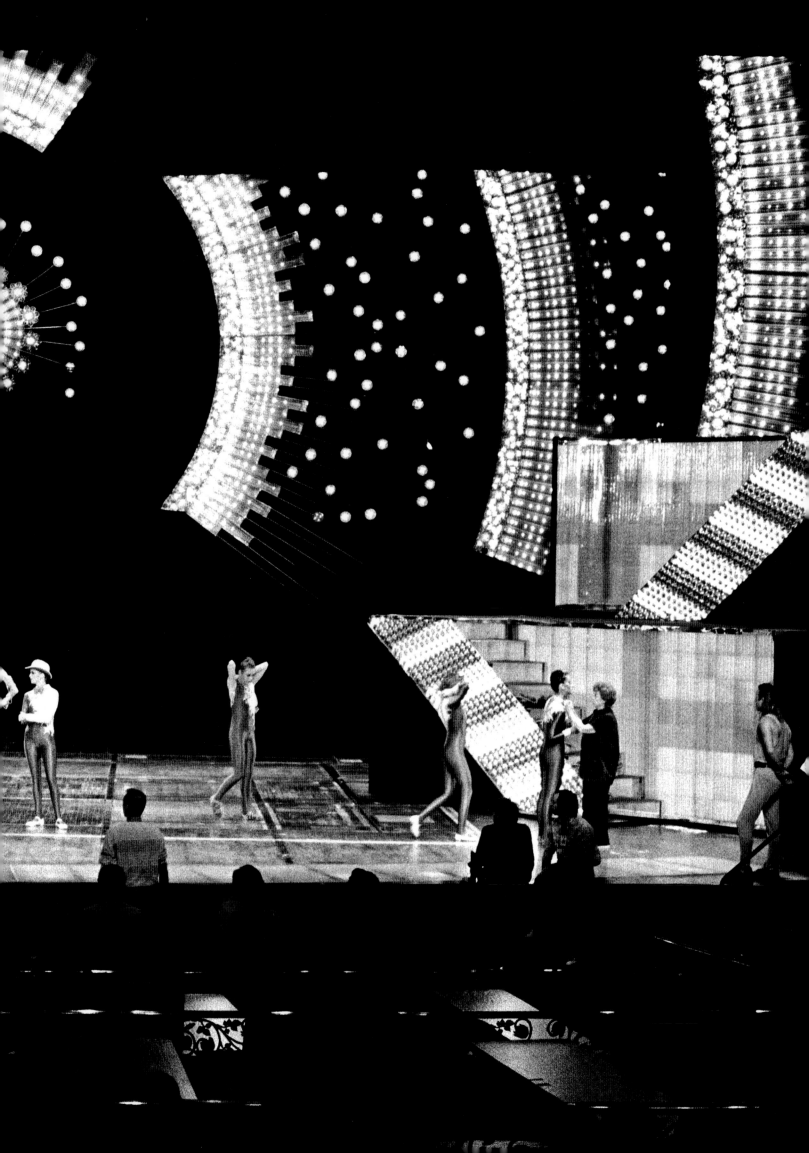

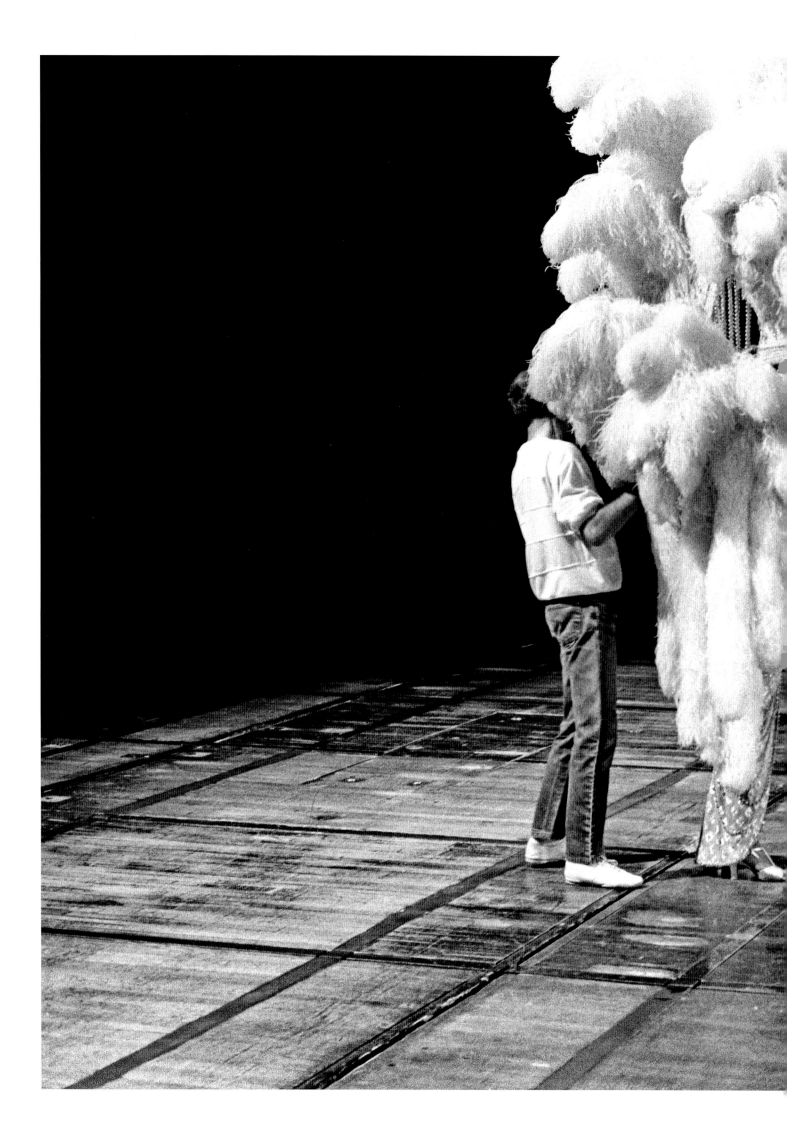

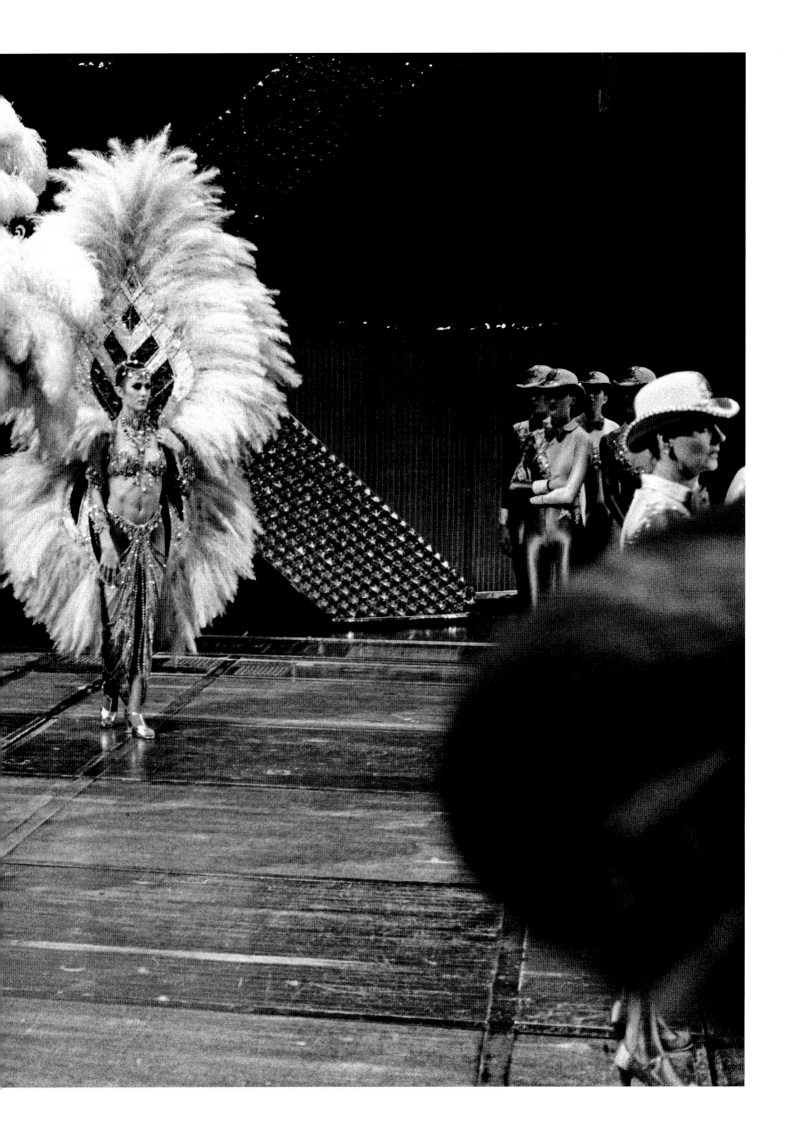

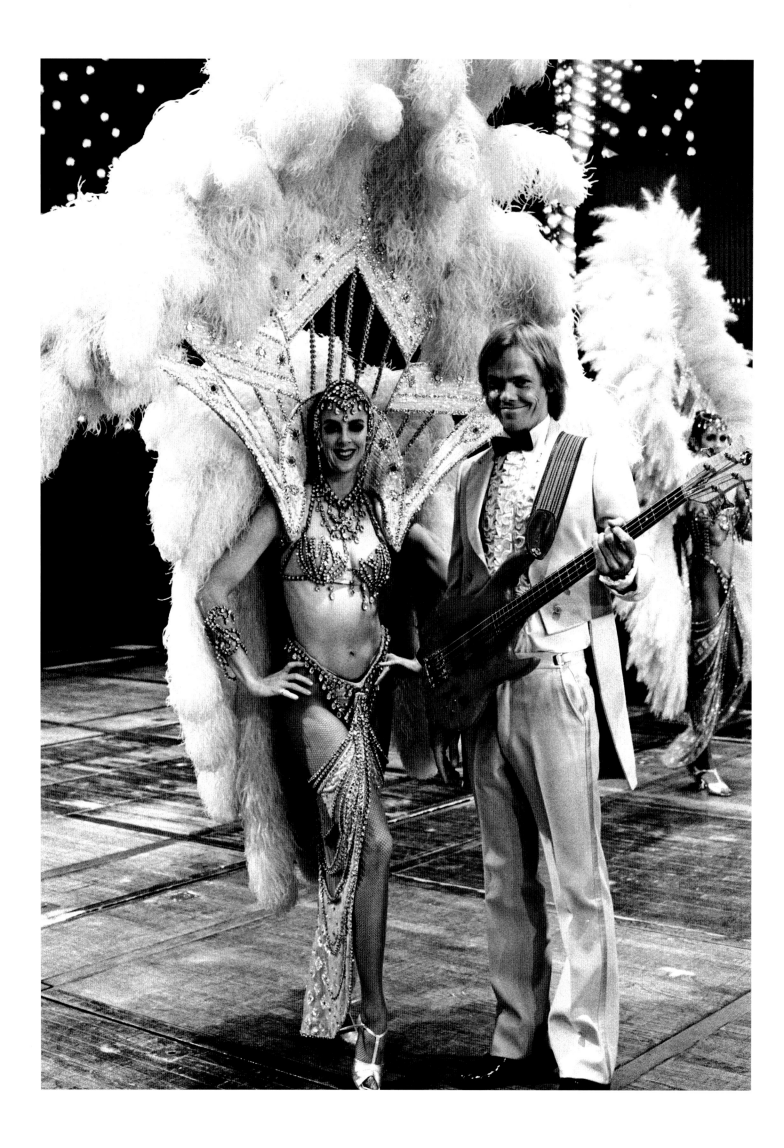

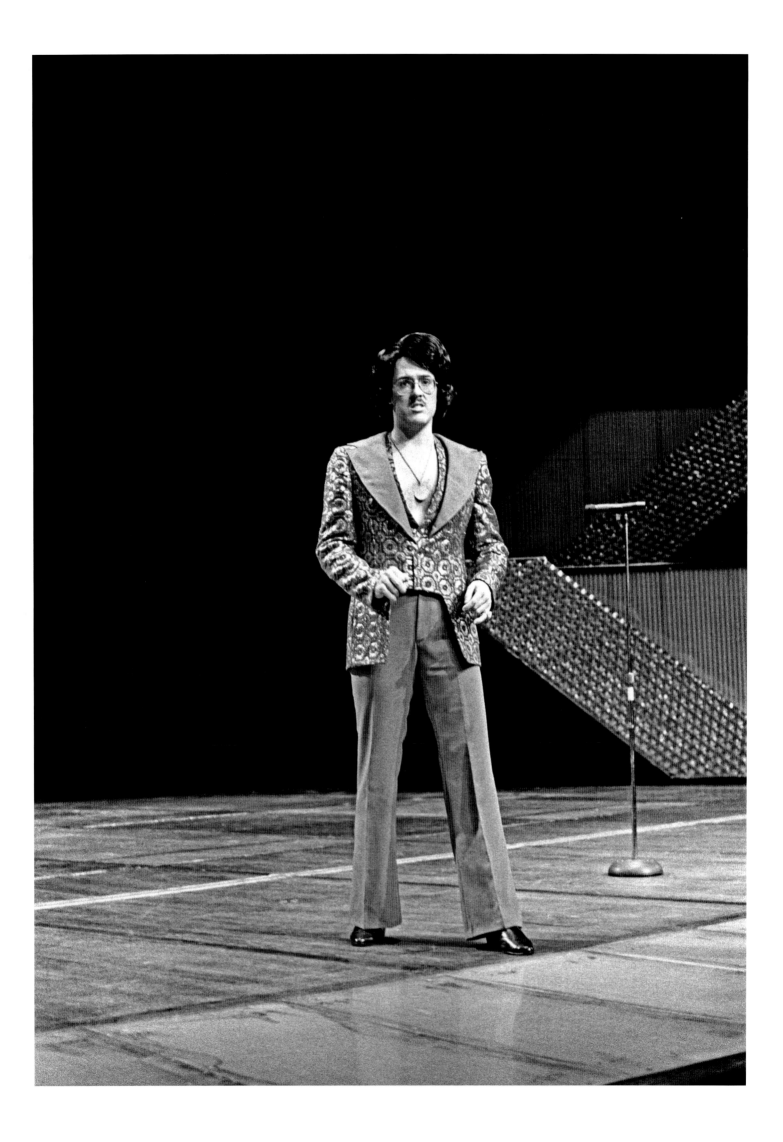

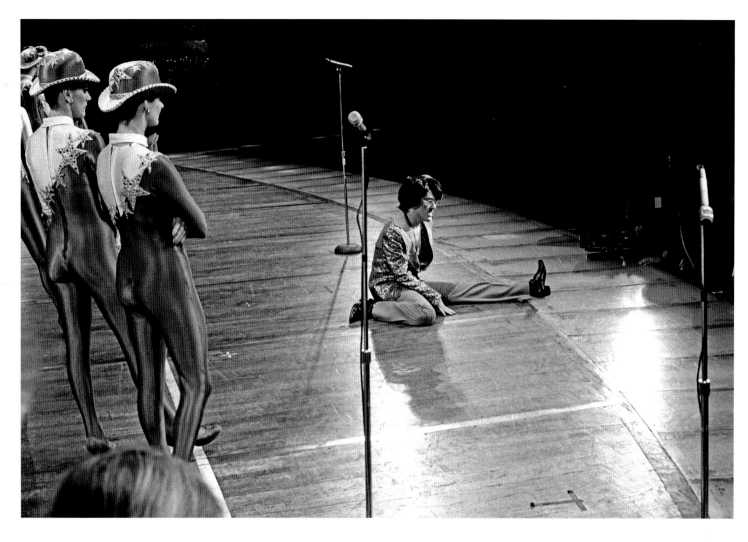

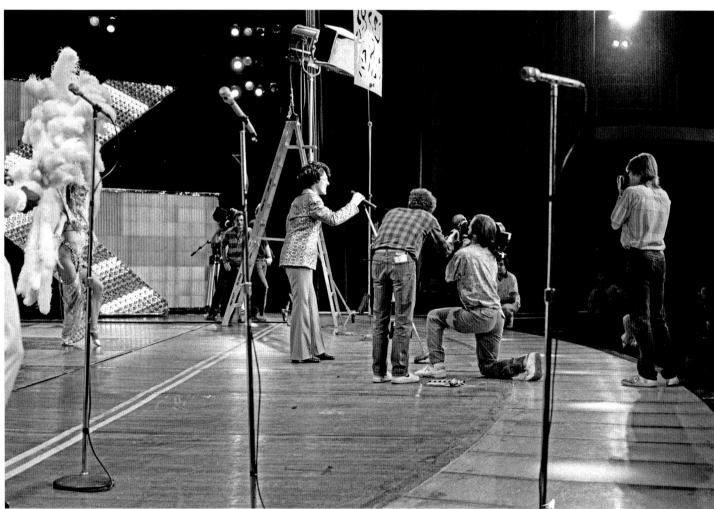

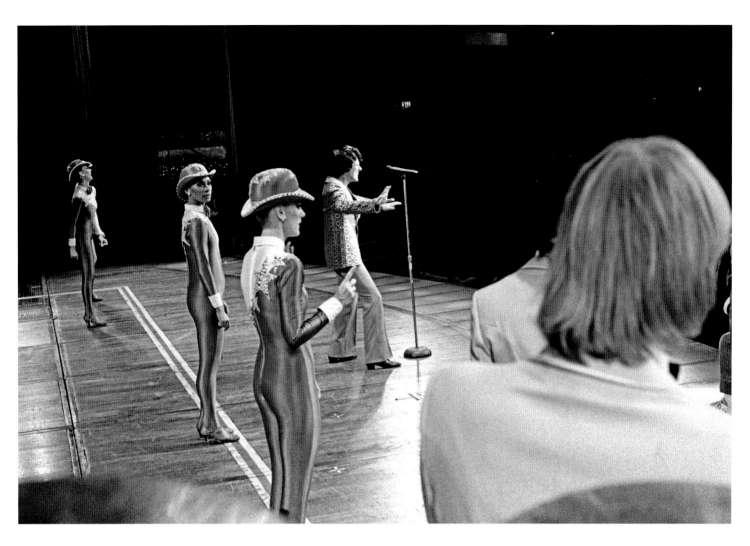
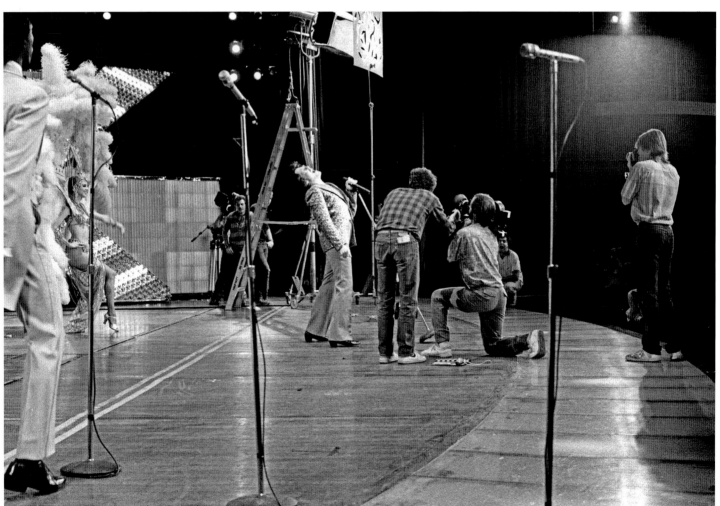

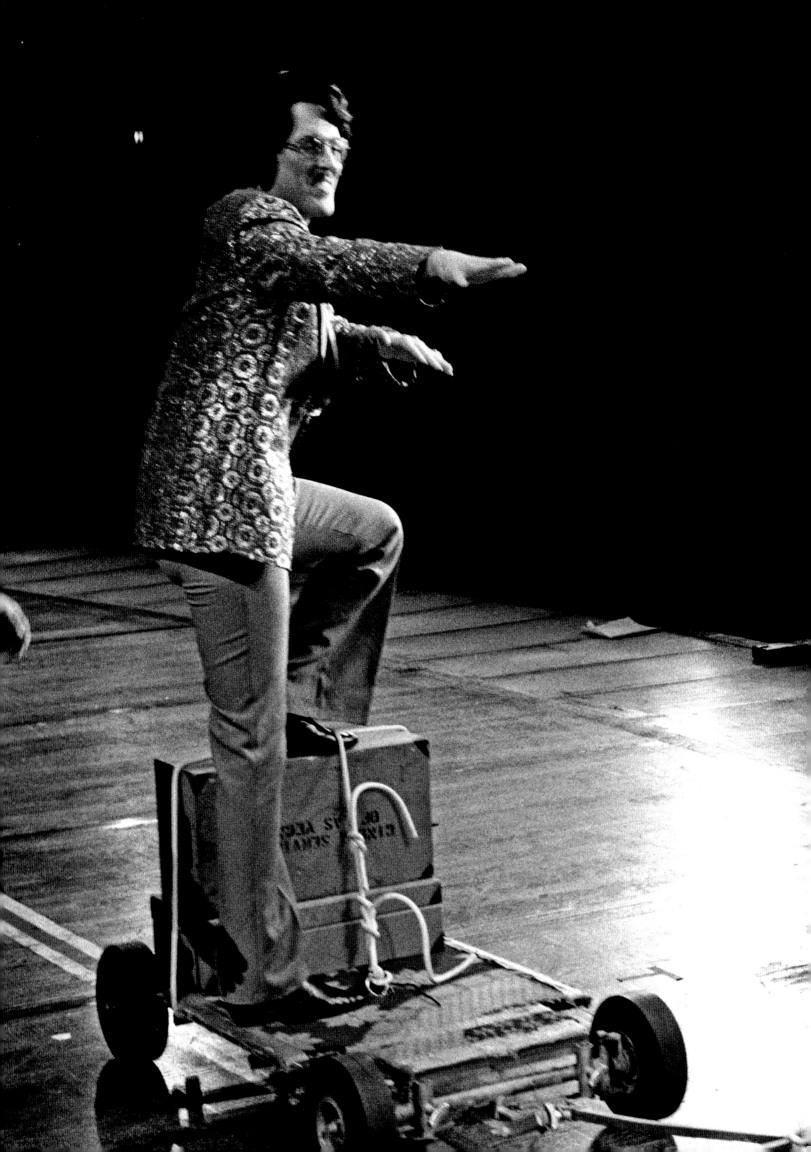

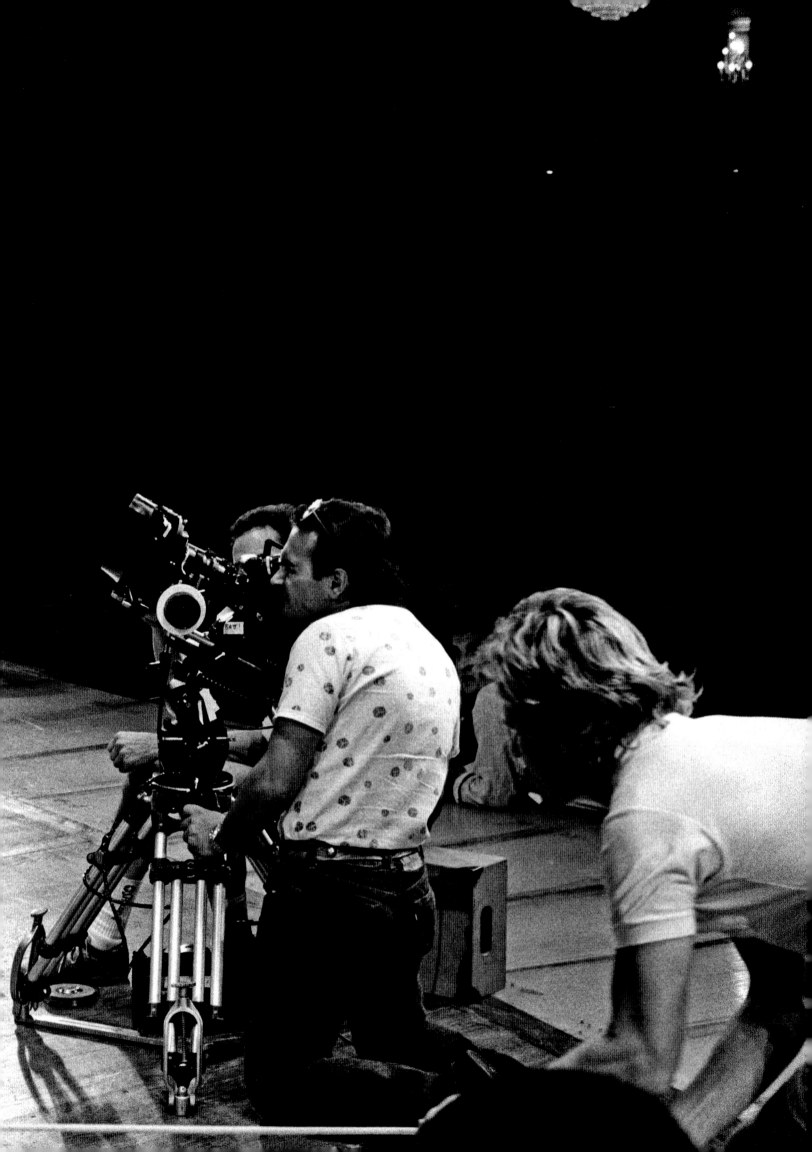

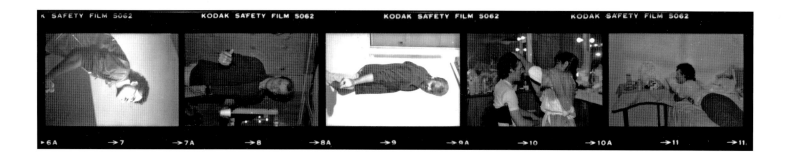

►6A →7 →7A →8 →8A →9 →9A →10 →10A →11 →11

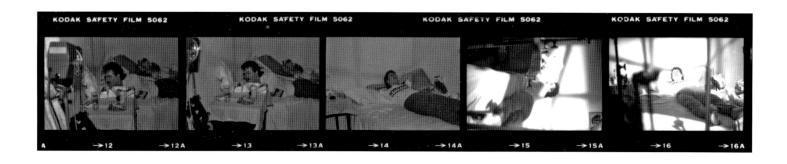

A →12 →12A →13 →13A →14 →14A →15 →15A →16 →16A

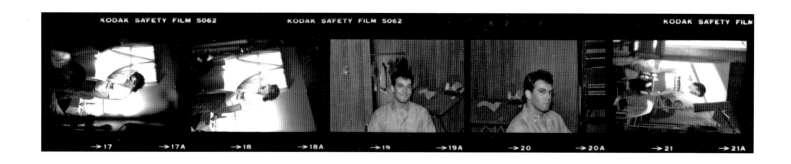

→17 →17A →18 →18A →19 →19A →20 →20A →21 →21A

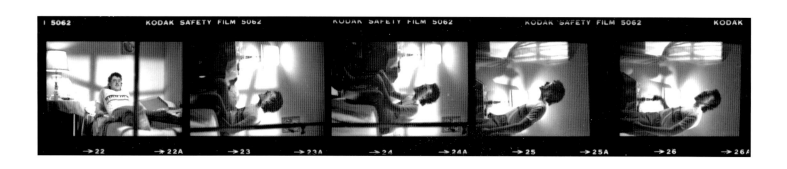

→22 →22A →23 →23A →24 →24A →25 →25A →26 →26A

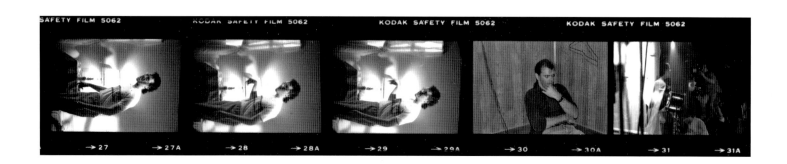

→27 →27A →28 →28A →29 →29A →30 →30A →31 →31A

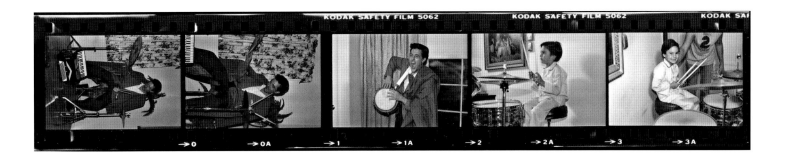

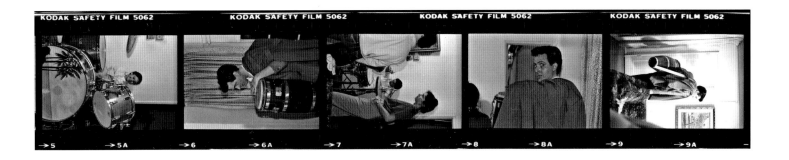

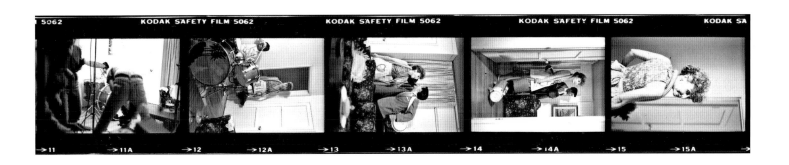

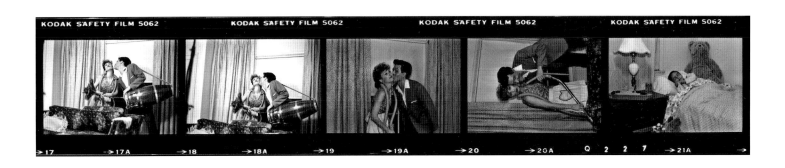

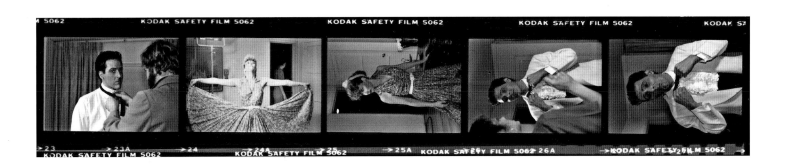

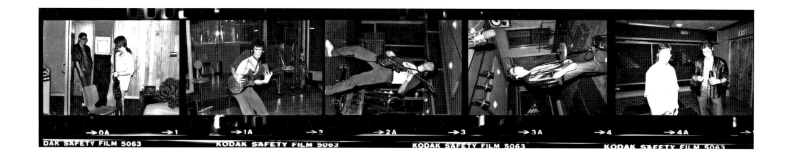

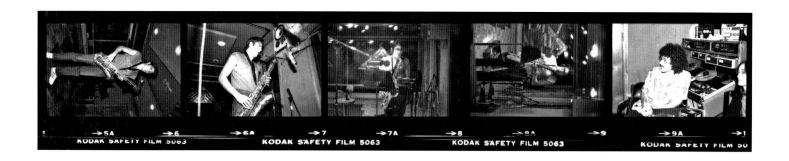

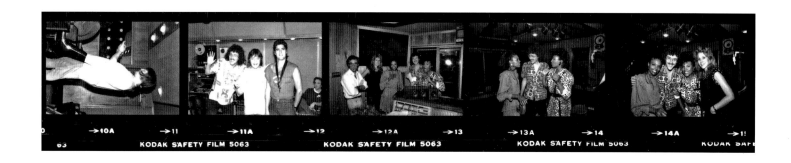

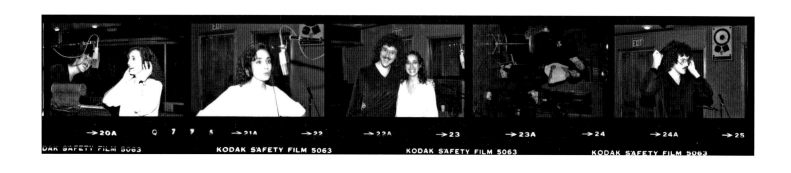

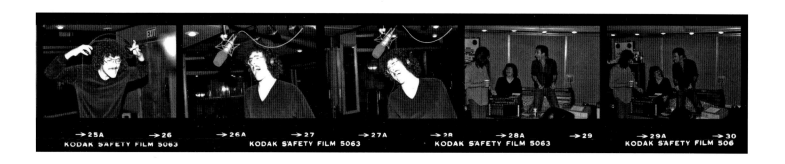

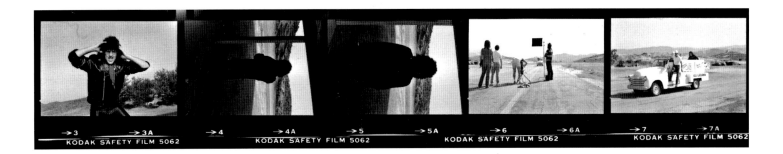

→3　　　→3A　　　→4　　　→4A　　　→5　　　→5A　　　→6　　　→6A　　　→7　　　→7A
KODAK SAFETY FILM 5062　　KODAK SAFETY FILM 5062　　KODAK SAFETY FILM 5062　　KODAK SAFETY FILM 5062

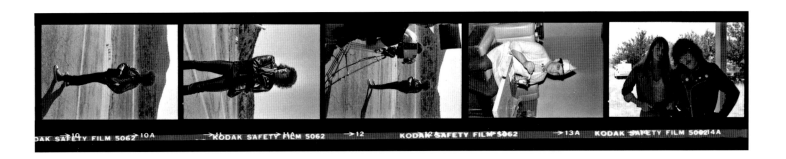

DAK SAFETY FILM 5062 10A　　→KODAK SAFETY FILM 5062　→12　　KODAK SAFETY FILM 5062　→13A　KODAK SAFETY FILM 5062 14A

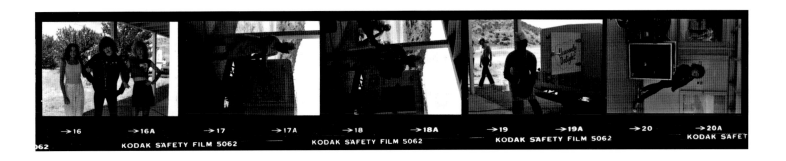

→16　　　→16A　　　→17　　　→17A　　　→18　　　→18A　　　→19　　　→19A　　　→20　　　→20A
062　　KODAK SAFETY FILM 5062　　KODAK SAFETY FILM 5062　　KODAK SAFETY FILM 5062　　KODAK SAFET

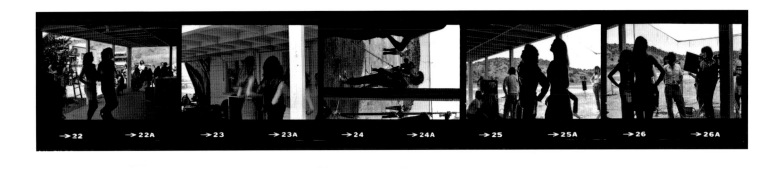

→22　　　→22A　　　→23　　　→23A　　　→24　　　→24A　　　→25　　　→25A　　　→26　　　→26A

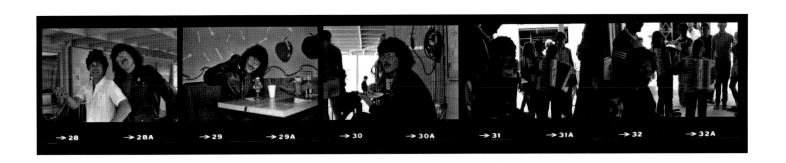

→28　　　→28A　　　→29　　　→29A　　　→30　　　→30A　　　→31　　　→31A　　　→32　　　→32A

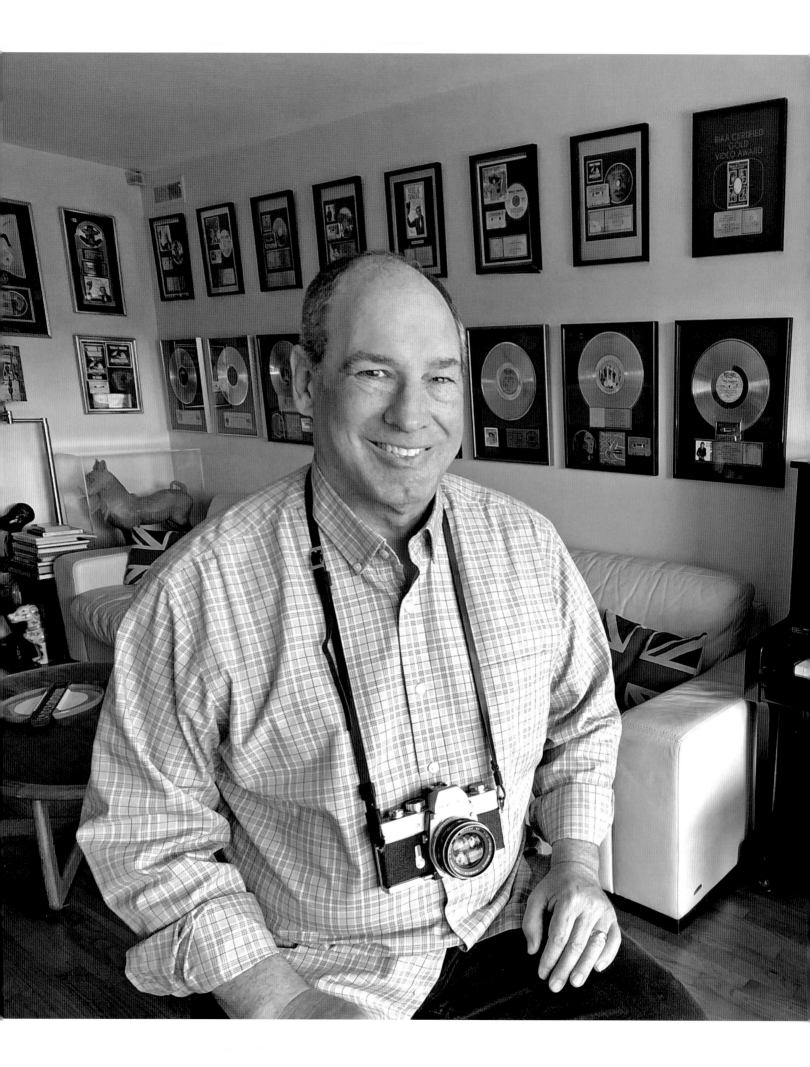

Bermuda has been the drummer with "Weird Al" Yankovic since 1980 and is seen and heard on all of Weird Al's albums, videos, and concert and television performances. He is also the group's archivist with an unmatched collection of memorabilia, audio & video releases from around the world, and photos.

ACKNOWL EDGMENTS

I am thankful for everyone who helped make this book a reality: Matthew Chojnacki, Shane and Desiree Lewis, and 1984 Publishing, Michael Duquette at Legacy Recordings, Annie Zaleski, Mark Jonathan Davis, DVDYourMemories. com, "Musical Mike" Kieffer, Tonya Duus, Jay Levey, Vincent Paterson, Steve Jay, Eddie Baytos, Joel Miller, Lisa Jahant Neidert, Dave Stephenson, Jeff Rona, and "Beefalo Bill" Burk (for his perfect timing taking that photo of me with my camera in Al's face)!

My deep gratitude and appreciation to my wife Leslie for her patience while I devoted long days and late nights to these photos and trying to make every word count.

And a standing ovation for Al… a great friend, a great boss, and the tolerant but gracious subject of thousands of my photos. This book would be much thinner without him!

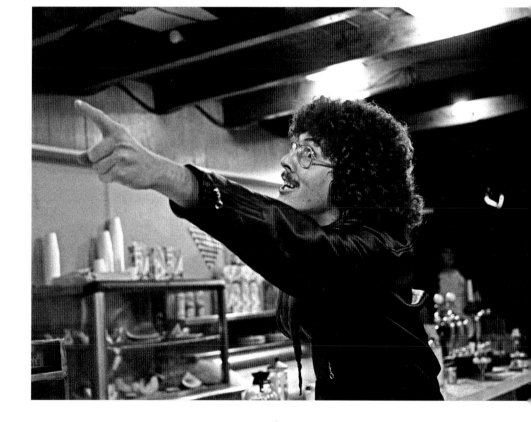

BLACK & WHITE
& WEIRD ALL OVER

THE LOST PHOTOGRAPHS OF
"WEIRD AL" YANKOVIC '83 – '86

AUTHOR: Jon Schwartz
FOREWORD: Al Yankovic
PHOTOGRAPHY: Jon Schwartz
ADDITIONAL PHOTOGRAPHY: Michael Kieffer / Bill Burk
ART DIRECTION & LAYOUT DESIGN: Shane Lewis / Desiree Lewis
PUBLISHER: Matthew Chojnacki

Published by 1984 Publishing. All rights reserved.

LIBRARY OF CONGRESS CONTROL NUMBER: 2020939354
ISBN: 978-1-948221-16-0

1984 Publishing logo is © and ™ of 1984 Publishing, LLC.

1984 PUBLISHING
Cleveland, Ohio / USA
1984Publishing.com
info@1984Publishing.com